Reading the Pre-Raphaelites

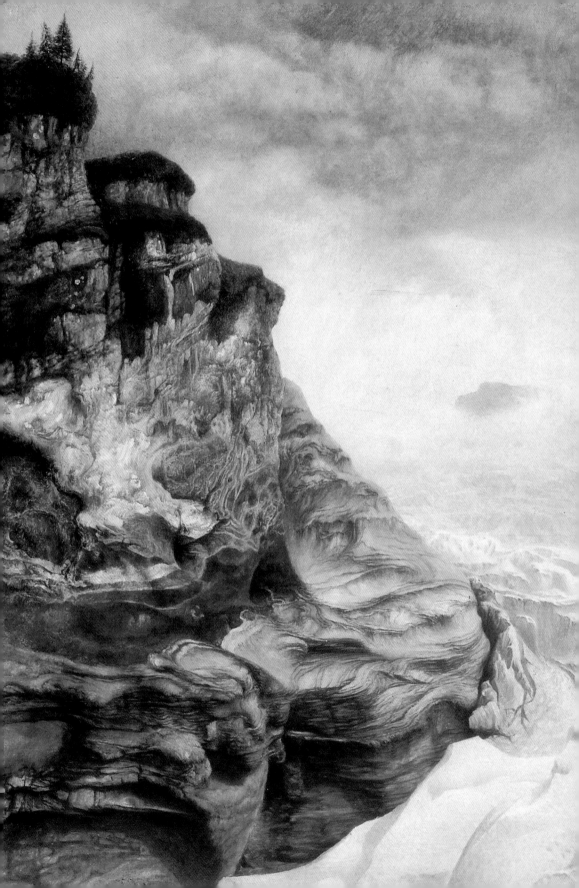

Reading the
Pre-Raphaelites

Tim Barringer

YALE UNIVERSITY PRESS
NEW HAVEN AND LONDON

To Rebecca

Acknowledgments

A book of this kind inevitably relies on the scholarship of others: my debts in this regard are gratefully acknowledged in the bibliography. My view of the visual culture of the 1850s has developed through a creative dialogue with many people, among them Caroline Arscott, Paul Barlow, Nicola Bown, Rafael Denis, Lynn Nead, Marcia Pointon, Colin Trodd, Will Vaughan and Clive Wainwright. The text has benefited from close readings by three Pre-Raphaelite specialists who are also generous friends: Liz Prettejohn, Jason Rosenfeld and Michaela Giebelhausen. Brian Lukacher also made helpful suggestions on the manuscript.

At Calmann and King, Lee Ripley Greenfield has always been a delight to work with; Kara Hattersley-Smith, model editor, and Sue Bolsom-Morris handled delays and changes with stoical patience.

The chapters were first delivered as public lectures at the Barber Institute of Fine Arts and many points were developed in lively debates with the members of my final-year 'Pre-Raphaelitism' seminar at the University of Birmingham. The book could not have been completed without the warm support of my colleagues at Birmingham, David Hemsoll, Paul Spencer-Longhurst and Yvonne Locke. Shearer West, an ideally supportive Head of Department, took upon herself a monstrous administrative burden, allowing me time to write.

Long periods in Birmingham were enlivened by the hospitality, repartee and ample cellar of Prof. A. A. M. Bryer. But my greatest debt, as always, is to the dedicatee of this book, Rebecca McGinnis.

First published in Great Britain in 1998 by
Weidenfeld and Nicolson
The Orion Publishing Group, Orion House
5 Upper St Martin's Lane
London WC2H 9EA

Published in the United States in 1999 by Yale University Press
Copyright © 1998 Calmann and King Ltd
This book was produced by Calmann and King Ltd, London

Library of Congress Cataloging-in-Publication number 98-60960
ISBN 0-300-07787-4
A catalogue record for this book is available from the British Library
10 9 8 7 6 5 4 3 2 1

Frontispiece JOHN BRETT *The Glacier of Rosenlaui,* page 74 (detail)

Contents

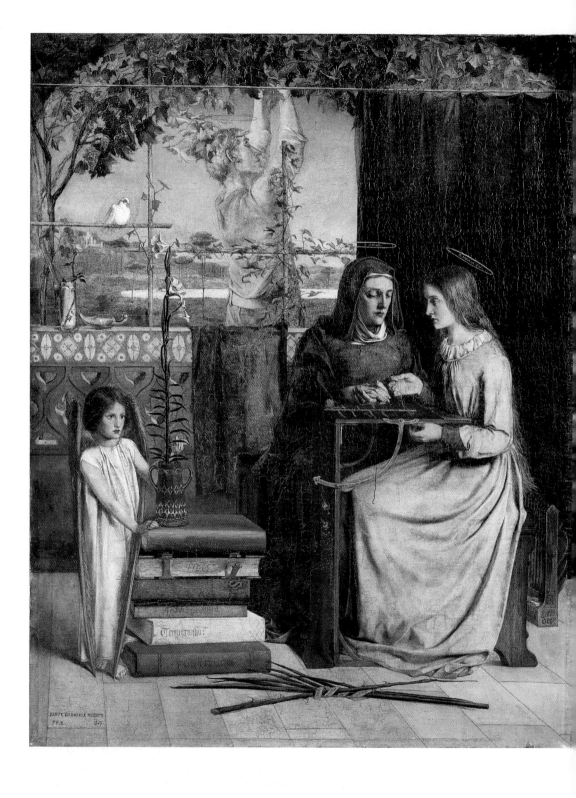

Introduction

T he initials 'P.R.B.' were seen in public for the first time on 24 March 1849. Plainly inscribed in red paint, they appeared below the signature in the lower left corner of *The Girlhood of Mary Virgin* (FIG. 1) by the twenty-year-old Dante Gabriel Rossetti (1828–82). There is no evidence that public or critics at the Free Exhibition in London, where it was shown, noticed this subversive inscription, but the phrase it denoted, 'Pre-Raphaelite Brotherhood', is still resonant a century and a half after it was first coined. Rossetti's painting has the qualities of a manifesto, a declaration of intent. As the name suggests, the Pre-Raphaelites aimed to revive aspects of art from before the time of Raphael (1483–1520), in order to reform British painting. They had recently studied at the Royal Academy Schools in London, and the adoption of the 'PRB' label was a gesture of defiance against their teachers. But more importantly, it signalled the rejection of centuries of accumulated tradition which revered Raphael and his contemporary Michelangelo (1475–1564) above all other artists as models for emulation. The Pre-Raphaelites' preference was for the bright colours, flat surfaces and what they thought of as the simple honesty of fifteenth-century Italian (then known as 'Early Christian') art.

Past and Present

Evidence of the Pre-Raphaelites' reformist zeal can be seen in *The Girlhood of Mary Virgin*. The painting is emphatically 'historicist', by which I mean that it self-consciously revives an archaic style to achieve a particular effect. Many devices are adapted from medieval and early Renaissance art, such as the thin, golden haloes, inscribed with the Latin forms of the names of the Virgin, St Anne and

1. DANTE GABRIEL ROSSETTI *The Girlhood of Mary Virgin*, 1848–9. Oil on canvas, 32¾ x 25¾″ (83.2 x 65.4 cm). The Tate Gallery, London.

The first Pre-Raphaelite painting to be exhibited comprehensively rejects the academic conventions of the period, deliberately adopting an archaic style. A friend of the artist recalled that the luminous colours were achieved by 'painting in oils with water-colour brushes … on canvas which he had primed with white till the surface was as smooth as cardboard, and every tint remained transparent'.

(in the garden outside) St Joachim. The pale, chalky colours, arranged in simple blocks, seem to recall fresco, while the awkwardness of the composition, which can partly be attributed to the artist's inexperience, suggests the confined spaces and bold arrangement of medieval manuscript illumination.

Just as striking for the Victorian viewer would have been the elaborate use of symbols, referring to the character and future life of the Virgin. Some of them were explained in a sonnet which Rossetti (already an accomplished poet) published in the catalogue. It reveals that the red cloth draped over the ledge symbolises Christ's robe during his Passion, thus prefiguring the death of the Virgin's son. Suddenly we become aware of the cross formed by an ivy-clad trellis above the red cloth – a real object but also a symbol of the crucifixion. In the garden, the dove encased in a golden mandorla is a traditional symbol of the Holy Spirit, also glossed in the sonnet: 'Until the time be full, the Holy One/Abides without'. This points to the Annunciation, when Mary learns that she will be the mother of Christ. Such symbols require a careful and informed decoding, one form of 'reading' demanded by Pre-Raphaelite paintings.

But even this most Gothic of Pre-Raphaelite images has a strikingly lifelike quality: each object has been carefully painted from nature. The faces are those of real people and do not merely replicate the idealised Raphaelesque features which conventionally personified the Virgin and her mother. The Virgin is described in a second sonnet, inscribed by Rossetti on the original frame, as 'An angel-watered lily, that near God/Grows and is quiet', and in the painting we see this metaphor made flesh: an angel tends the flower which symbolises the Virgin. But the lily is not (as in much early art) a stylised sign or symbol: rather, an actual flower has been painted with minute, botanical fidelity: leaves, petals and stamens are clearly visible. This way of looking belongs to the nineteenth century, to the era of photography, of empirical science and of botanical classification. It is unmistakably modern, a variety of realism specific to the historical period which produced it. In a detail impossible to imagine in a Renaissance painting, the Virgin herself is copying the lily through a similar process of close observation, producing in her embroidery an exact replica. The trellis (crucifix), the lily (purity) and the dove (the Holy Spirit) are both symbols and real objects in the physical world: they belong to a time-honoured iconography and yet they have an independent existence as modern things. In this combination of a yearning for the past with an intensely modern, mid-nineteenth-century realism lies the paradox at the heart of Pre-Raphaelitism.

2. JOHN EVERETT MILLAIS *Isabella*, 1848–9. Oil on canvas, 3'4½" x 4'8¼" (1.03 x 1.43 m). Walker Art Gallery, Liverpool.

The doomed lovers Isabella and Lorenzo share a fateful blood orange, while one of her murderous brothers furiously cracks a nut and tries to distract her dog with the extended foot that makes such a dramatic horizontal feature.

This paradox emerges even more starkly from another work, exhibited at the Royal Academy only a month after Rossetti's. *Isabella* (FIG. 2) by John Everett Millais (1829–96) is striking for the vivid, almost hallucinatory, intensity of drawing. The faces, especially, testify to a heightened scrutiny of the individual model: there is a scientific rigour to these sharply etched profiles. Yet despite these markers of realism, this painting, too, is aggressively historicist. The characters occupy a very constricted space, as if Millais had chosen to ignore or disrupt the rules of perspective which he had mastered as a prize-winning and precocious student at the Royal Academy Schools. The costumes indicate that the subject belongs to the period before Raphael, though Millais's source was the retelling by John Keats (1795–1821) of the tale of

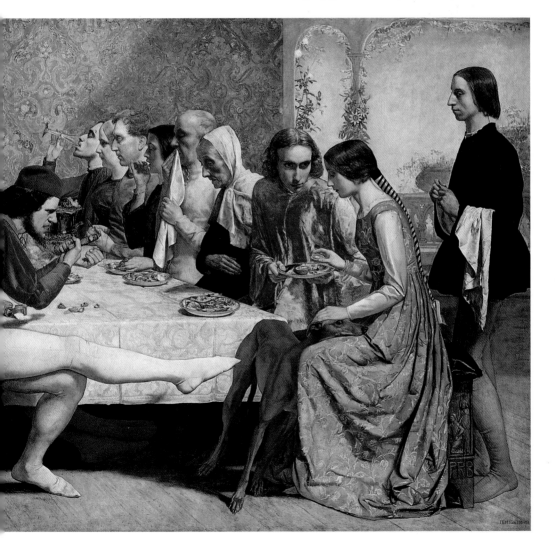

Lorenzo and Isabella from *The Decameron* by Boccaccio (1313–75). This links the Pre-Raphaelites not only with Florence and the fourteenth century but also with early nineteenth-century Romanticism. Isabella has fallen in love with Lorenzo, a lowly employee of her brothers. Millais captures the brothers' fury at the thought of this preventing the lucrative marriage they proposed for Isabella. Later in the poem, the brothers behead Lorenzo and bury his body in a forest. But his ghost appears to Isabella to reveal the truth; whereupon she exhumes the body and removes the head, burying it in a pot of basil. This tragic denouement is present in several ways in the painting: not only do passion flowers and a large pot appear in the background; one of the maiolica plates is decorated with the subject of a biblical beheading, probably Salome decapitating John the Baptist. Images retelling such complex narratives are characteristic of Pre-Raphaelitism.

The paradox of historicism and modernity, revivalism and realism, was resolved by the Brothers through the belief that early Italian painters had themselves observed the natural world rather than merely repeating conventional forms like their successors. While remaining a revivalist movement, Pre-Raphaelitism was accordingly free to produce images of real life and of the mod-

3. WILLIAM HOLMAN HUNT
The Hireling Shepherd, 1851–2. Oil on canvas, 30 x 43" (76.4 x 109.5 cm). Manchester City Art Galleries.

Hunt went to great lengths to transcribe nature with perfect fidelity, painting the marshmallow and elecampane in the foreground with botanical precision (the painting was purchased by the prominent naturalist W. J. Broderip). Yet the work also operates at a narrative level, demonstrating the chaos which results from neglecting one's duty.

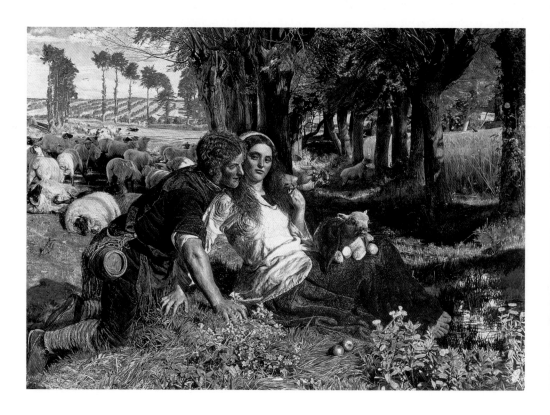

ern world, searing in their honesty. The landscape setting in *The Hireling Shepherd* (FIG. 3) by William Holman Hunt (1827–1910) is startling in its brilliance: every object is meticulously observed, as if Hunt were cataloguing, one by one, every blade of grass and every ear of wheat. Even more striking is the realism of the figures: sunburnt, probably the worse for drink, and on the brink of a sexual encounter, they proved deeply disturbing to Victorian critical opinion.

Describing the picture, Hunt later wrote: 'My first object was to pourtray [sic] a real Shepherd and Shepherdess…sheep and…fields and trees and sky and clouds instead of the painted dolls with pattern backgrounds called by such names in the pictures of the period [the 1850s].' But this strikingly naturalistic image is clearly not solely an exercise in observing the natural world and the inhabitants of the countryside. It is elaborately charged with meaning, often expressed through a symbolic language akin to that of *The Girlhood of Mary Virgin*. The narrative of the painting is apparently straightforward: a newly hired shepherd is neglecting his flock – one of the sheep has already strayed into the corn – preferring to dally with a shepherdess. A critic noted his 'over-attention to the beer or cyder keg' and the painting could be read as a warning about the effects of intemperance. However, Hunt later acknowledged that, at a symbolic level, this painting referred to contemporary controversies concerning the Church of England. In 1851, John Ruskin (1819–1900), the critic of art and society who was to be a decisive influence on Pre-Raphaelitism, published a pamphlet, *Notes on the Construction of Sheepfolds*. The sheepfold was an elaborate metaphor for the Church, which he accused of wasting its energies on factionalism and thus neglecting the flock, rather than combining to confront the enemy, a resurgent Catholicism. The parallels with Hunt's painting are clear. We shall return to these religious controversies, which deeply preoccupied the Pre-Raphaelites, in Chapter Four. As *The Hireling Shepherd* demonstrates, even the most apparently naturalistic Pre-Raphaelite image can simultaneously operate at a symbolic level.

Pre-Raphaelite Identities

Nearly all the figures in *The Girlhood of Mary Virgin* and *Isabella*, so carefully individualised, were modelled by friends and members of the artists' families. In the former, Christina Rossetti, the painter's sister, sat for Mary, while in the latter, Millais's doting father was the model for the older man with a napkin, pre-

sumably Isabella's father. This insistence on painting from personal friends and acquaintances more than from professional models resulted in the scrupulous fidelity which particularises each face, endowing each painting with freshness and vigour.

In the case of *Isabella*, there are clearly parallels between the fictional family circle and the social circle surrounding the young artist. It is perhaps not surprising that in a work which, like Rossetti's was something of a manifesto for Pre-Raphaelitism, Millais chose to declare in paint his allegiance to brothers of a more wholesome character than those of Isabella. In his representation of the carving on the end of the bench on which she sits, Millais depicted the initials 'PRB', repeating them next to his signature underneath. The Pre-Raphaelite Brotherhood, formed in London in September 1848, consisted of seven young men, among whom the painters Rossetti, Millais and Hunt can unreservedly be identified as the most significant. It also included the sculptor Thomas Woolner (1825–92) and the painter James Collinson (1825–81). The final members modelled for figures in *Isabella*: to the left, with a glass of wine, is Frederic George Stephens

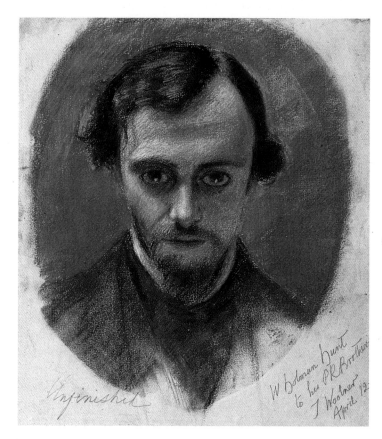

4. WILLIAM HOLMAN HUNT *Portrait of Dante Gabriel Rossetti*, 1853. Pastel and coloured chalks, 11¼ x 10¼" (28.6 x 25.9 cm). Manchester City Art Galleries.

(1828–1907), who began as a painter but became an important art critic. William Michael Rossetti (1829–1919; brother of Dante Gabriel), also a critic and later historian of Pre-Raphaelitism, posed for Lorenzo. Something of the atmosphere of the Brotherhood towards the end of its existence can be discerned from a letter written by Dante Rossetti to his friend William Bell Scott on 7 May 1853: 'On 12 April, the PRB all made portraits of each other, which have been forwarded to Woolner. Millais did Stephens – Hunt did Millais and myself – Stephens did Millais – I did Hunt and William....' This scene of jovial, collective art-making includes only five of the PRB: Collinson had resigned from the PRB as early as 1850 and Woolner had emigrated to Australia. Hunt's portraits of Rossetti (FIG. 4) and Millais (FIG. 5), executed at Millais's Gower Street studio that day, vividly encapsulate the two artists. Rossetti is portrayed as a visionary genius, a concept of artistic identity central to the Romantic movement. Later, Hunt recalled the work as 'a representation of what he was when youth and its hunger of inspiration was glowing in his face', an effect achieved through the drawing's emphasis on his shadowed and soulful eyes. Perhaps influenced by such images, art history continues to construct Rossetti as the genius of the movement. Millais, more conventional in appearance, appears gentlemanly rather than bohemian: Hunt characterises him by his level, penetrating gaze. The bonds of friendship among the group are clear, but there is no blurring of individual identities.

Although the membership of the Brotherhood, which effectively lasted from 1848 to 1853, is clearly defined, 'Pre-Raphaelitism' is a much more diffuse and elusive phenomenon. One artist in particular, Ford Madox Brown (1821–93), a few years older than the others and never a member of the Brotherhood, was nonetheless intimately connected with the Pre-Raphaelites and his work is integral to its output. Trained in Antwerp and familiar with Italian and French culture, Madox Brown links Pre-Raphaelitism with other currents in nineteenth-century art. Many other individuals also played an important role in the development of Pre-Raphaelitism, without belonging to the Brotherhood. Most important of these was Ruskin, whose writings provided a vital theoretical underpinning for the Pre-Raphaelites' ideas of truth to nature, and who became closely involved with Millais and

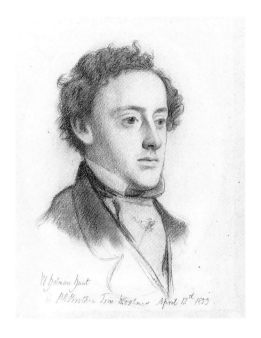

5. WILLIAM HOLMAN HUNT *Portrait of John Everett Millais*, 1853. Pastel and coloured chalks, 12¾ x 9¾" (32.7 x 24.8 cm). National Portrait Gallery, London.

The portrait is dedicated by the artist 'to his PR Brother Thomas Woolner'. Woolner had emigrated to Australia, hoping to make his fortune gold-digging, and the portrait drawings made on 12 April 1853 (see FIG. 4) were sent to him as a gesture of friendship. Rossetti is portrayed here as the epitome of youthful genius.

Rossetti. After the dissolution of the Brotherhood, Rossetti became the centre of a different circle of artists, including the designer William Morris (1834–96) and the painter Edward Burne-Jones (1833–98), both popularly identified as Pre-Raphaelites but connected with the Brotherhood only through Rossetti.

All the names mentioned so far are male: masculinity is a prerequisite for membership of a Brotherhood and art history has, in any case, tended to suppress the achievements of women. But of course there were women in the Pre-Raphaelite circle. Christina Rossetti (1830–94), sister of Dante and William, is recognised as an important poet. The role of the artist Elizabeth Siddall (1829–62) as model, lover and eventually wife of Dante Rossetti has been allowed to overshadow her identity as an artist. Jane Morris (1836–1914), wife of William Morris and muse and lover of Rossetti, was an accomplished embroiderer. The full contribution of these artists, and a number of women less directly connected with Pre-Raphaelitism, has only recently been acknowledged.

The mutually supportive camaraderie of the PRB and the complicated sexual histories of most of the protagonists have formed the basis for numerous biographical accounts. But the Brotherhood as a social formation is of more than anecdotal interest: it raises important questions about artistic identity. The image of the genius, the lone, alienated, creative individual (invariably male), was central to Romanticism, and remains to this day a standard subject for art historical writing, one which clashes with the idea of a group or Brotherhood. The members of the Brotherhood promoted notions of the artist-as-genius themselves: and although they identified closely with each other socially, the following pages will demonstrate that there never was, in fact, a single identifiable Pre-Raphaelite style.

Contexts

Pre-Raphaelitism is, *par excellence*, the art of mid-Victorian Britain (1848–c. 1875). The historian E. J. Hobsbawm has described this period as 'the age of capital', an era of economic and political stability after the upheavals of the 1840s. Across Europe 1848 was a year of revolutions, while in Britain the birth of Pre-Raphaelitism coincided with the last great political convulsion of the 1840s, a demonstration mounted by the Chartist movement. Chartism, the first mass movement of the industrial working class, demanded a series of political reforms including manhood suffrage. The young Hunt and Millais, as fascinated middle-class spectators, joined a procession of Chartists marching through cen-

tral London to Kennington Common, narrowly avoiding a scuffle at Bankside. Although Chartism was non-violent it was considered enough of a threat for the government to place riflemen on the roofs of neighbouring houses, as Hunt noticed. While the Brotherhood had no shared political agenda, and certainly had little sympathy with the Chartists, it could be that the Chartist zeal for reform, and the possibilities of historic changes which it raised, found some echo in the Pre-Raphaelites' rejection of academic traditions.

Manifestations of popular unrest were less frequent in the 1850s, and this decade can be understood as a time of ascendancy for the middle classes. An economic boom was ushered in by the spectacular display of machinery, manufactured goods and raw materials from Britain, its colonies and the rest of the world in the Great Exhibition of the Industry of All Nations. It was held in the specially built iron and glass 'Crystal Palace' in Hyde Park in 1851, a temple to modernity, capitalism and international trade. The exhibition enshrined a particular form of materialism which placed a high value on categorising objects; its massive catalogues are just one of the many examples of the taxonomic spirit of the period. This parallels the Pre-Raphaelite obsession with the meticulous recording of observed phenomena. The documentary realism of works such as *The Hireling Shepherd* also relates to contemporary developments in empirical science. Pre-Raphaelite interest, under the influence of Ruskin, in geology, botany and meteorology is well documented. Among other disciplines, ethnology (the science of the human races) influenced Holman Hunt's images of non-European peoples and the now discredited – but then important – science of phrenology, which examined the shape of the head for signs of inner character, has been linked with Pre-Raphaelite paintings, including *Isabella* (FIG. 6).

Most of all, the emergent technology of photography offered a new model for the representation of the outside world in an apparently unmediated and scientific manner. F. G. Stephens, writing in the Pre-Raphaelite journal *The Germ* in 1850, made an analogy between progress in the sciences and in the arts:

> The sciences have become almost exact within the present century … And how has this been done but by bringing greater knowledge to bear upon a wider range of experiment; by being precise in the search for the truth? If this adherence to fact, to experiment and not to theory … has added so much to the knowledge of man in science; why may it not greatly assist the moral purposes of the Arts?

6. JOHN EVERETT MILLAIS *Isabella*, 1848–9 (detail of FIG. 2).

According to the Victorian science of phrenology, the high forehead of Lorenzo indicated an intellectual disposition.

The attention which hard-edged Pre-Raphaelite naturalism of the 1850s paid to observing the individual object encapsulates this questioning, empirical spirit. It is here that the modernity of Pre-Raphaelitism can most clearly be recognised.

During the 1850s, the confidence of the middle class was everywhere apparent, and their prosperity led to an unparalleled boom in the market for contemporary art. The Pre-Raphaelites, especially Holman Hunt and Millais, were immediate beneficiaries: Hunt, for example, gained the extraordinary sum of £5,500 from the sale of his *The Finding of the Saviour in the Temple* and its copyright to the art dealer Ernest Gambart in 1860. Most of the major patrons of the Pre-Raphaelites belonged to the middle class – stockbrokers, textile manufacturers, shipping magnates, many in the newly prosperous cities of the North and Midlands, such as Manchester, Leeds and Birmingham.

While it is dangerous to generalise about so amorphous a grouping, it is possible to attribute some shared beliefs to the Victorian middle class. Respectability was a keynote, defined particularly through the separate roles considered appropriate for men and for women. Values derived from religious Evangelicalism were widely influential, notably a belief in the sanctity of marriage and the nuclear family, the merits of hard work for men, the moral value of social discipline, and the deferral of personal gratification. These ideas are prominently inscribed in the Pre-Raphaelite images of modern life, discussed in Chapter Three. In contrast with the Brotherhood's rebellion against the art establishment, the fundamental values articulated in Pre-Raphaelite images conform very closely to mainstream social and political views of the period. The idea of a necessary connection between artistic and political radicalism was promoted in France in the late 1840s by the realist painter Gustave Courbet (1819–77), an exact contemporary of the Pre-Raphaelites. This concept, which has been adopted as a paradigm for the discussion of nineteenth-century art, leads to a misreading of the Pre-Raphaelites. It was only later, in the 1860s, that Rossetti and his circle began deliberately to flout the orthodox middle-class beliefs which had been assiduously promoted in Pre-Raphaelite works of the 1850s. This later, bohemian rejection of dominant bourgeois codes of behaviour is discussed in Chapter Five.

The 1850s also saw physical changes in the face of Britain. The large-scale industrial development and urbanisation of the working population, which made possible the economic boom of the period, caused widely acknowledged damage to the environment. This made the countryside seem all the more valuable,

especially to opponents of industrialisation such as Ruskin. The Pre-Raphaelite landscape implies an industrial city as its unspoken other and the outer London suburbs, with their inter-penetration of country and city, proved a fascinating subject. Ironically, the maturity of the railway network in the 1850s, a proud symbol of modernisation, allowed an unprecedented freedom of movement which was of particular benefit to land-scape painters. It was extensively used by all the Pre-Raphaelite circle, conveying, for example, Ruskin and Millais to Scotland in search of unspoilt scenery.

Art History and Pre-Raphaelitism

Writers at the end of the nineteenth century recognised Pre-Raphaelitism as only one among several important developments in recent British art. That Pre-Raphaelitism has subsequently been celebrated as far the most important development in Victorian painting testifies to the success of members of the Pre-Raphaelite circle in writing for themselves a central role in the history of British art. Stephens and William Rossetti published exten-sively in their later lives on the history of the movement, while Holman Hunt's massive two-volume account, *Pre-Raphaelitism and the Pre-Raphaelite Brotherhood*, published in 1905, has been accepted as the definitive history. Yet, as recent scholarship has demonstrated, there are many problems with Hunt's text. It is a tendentious work largely given over to restating, and on occasion overstating, his own role in Pre-Raphaelitism. It also gives long passages of verbatim dialogue, claiming to report conversations which had taken place almost half a century earlier: in parts it is probably closer to fiction than fact.

After the First World War, Pre-Raphaelitism's critical for-tunes sank to their nadir, as the first generation of British Mod-ernists vigorously rebelled against an art they associated with the repressive and backward regimes of their childhoods: Clive Bell (1881–1964) considered Pre-Raphaelitism 'tedious and insignificant'. The first signs of reawakening interest in Pre-Raphaelitism can be discerned in a series of centenary exhibitions in 1948. It was, however, in the 1960s that a major revival of Pre-Raphaelitism took place, fuelled by a new demand in the art market. Scholarly exhibitions and catalogues of the work of the major figures in the movement, culminating in the Tate Gallery's comprehensive exhibition, 'The Pre-Raphaelites' (London, 1984), re-established a canon of Pre-Raphaelite work and made available a wealth of factual information. This has been supplemented by

scholarly editions of relevant diaries, journals and letters. The Tate Gallery exhibition was held at a crucial moment in art history: feminist and Marxist critiques had, belatedly, begun to enter the discipline. A radical attack on the exhibition by Griselda Pollock and Deborah Cherry, published in *Art History* (a journal associated with the 'new art history'), challenged its biographical focus, lack of historical context and its underlying patriarchal assumptions. A reconsideration of the role of women in Pre-Raphaelitism was also demanded. Since that time, several important publications have re-examined Pre-Raphaelite images, placing issues of gender, class and empire at the centre of the analysis. From the late 1980s onward, the application of critical theory – from structuralism, anthropology, post-colonial studies, literary theory, psychoanalysis and other disciplines – has radically reconfigured the intellectual landscape of art history, stimulating new interpretations of Pre-Raphaelite art. These have largely been made in academic journals, inaccessible to most readers, and general accounts of the movement have tended to retain a biographical and anecdotal emphasis.

Ruskin often used the metaphor of reading to describe the act of interpreting a painting. This book aims to provide a modern introduction to Pre-Raphaelitism based on readings of key Pre-Raphaelite images informed by these new art historical methods. It attempts for the first time to draw together the many strands of revisionist thought on Pre-Raphaelitism into a new and accessible synthesis. The book is not a narrative history, and includes biographical information only in those (frequent) instances where it is significant for the meaning of an image. Rather, the chapters are based on the central themes in Pre-Raphaelitism. The two elements of what I have termed the Pre-Raphaelite paradox, revivalism and realism, are discussed in the opening chapters. The first explores the relationship between past and present in Pre-Raphaelitism. It examines some artistic and intellectual precedents for the Pre-Raphaelite interest in the medieval world, and follows the revivalist theme into the 1890s. Changing concepts of the natural world and landscape underlie Chapter Two, an analysis of the radical Pre-Raphaelite creed of 'truth to nature'. Issues of class and gender in mid-Victorian Britain are central to Chapter Three which examines Pre-Raphaelite paintings of modern life. Religious painting, an area of Pre-Raphaelite endeavour somewhat neglected in recent times, is the subject of Chapter Four. Opening with a discussion of the multiple religious affiliations within the PRB, and their importance for understanding Pre-Raphaelite religious imagery, the chapter moves

on to consider Holman Hunt's works from Egypt and Palestine. These images, the result of Hunt's search for accurate representations of biblical subjects, are examined in relation to mid-Victorian concepts of race, which in turn were underpinned by the ideology of imperialism. The final chapter addresses the blending of Pre-Raphaelite ideas with those of the Aesthetic Movement, among the artists who gathered round Rossetti in the 1860s.

Ultimately, this book suggests that the dynamic energy of Pre-Raphaelitism arises through the paradoxes – the internal polarities and conflicts – which can be detected in almost every work. Pre-Raphaelite styles combine past and present, historicism and modernity, symbolism and realism, while the works represent the tensions between city and country, men and women, worker and capitalist, coloniser and colonised which characterised the Victorian era. Even the very identity of the Pre-Raphaelite artist veers between bourgeois and Bohemian, evangelical and ritualist, group member and individual. The contrast between the early Pre-Raphaelite paintings we have examined, *The Girlhood of Mary Virgin*, *Isabella* and *The Hireling Shepherd*, and the opulent and enigmatic works discussed in the final chapter indicates how various and compelling a task is reading the Pre-Raphaelites.

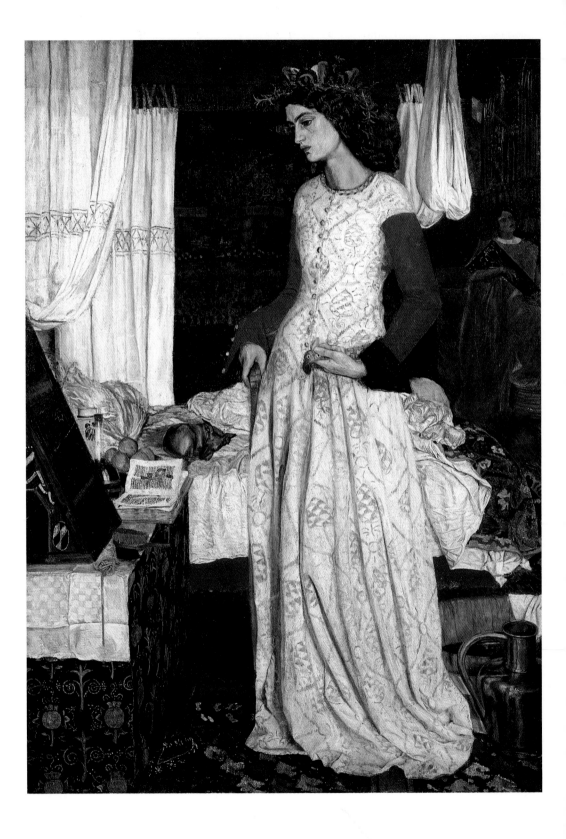

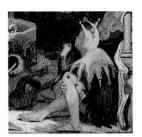

Rebellion and Revivalism

7. WILLIAM MORRIS
La Belle Iseult, 1858. Oil on
canvas, 28 x 19¾" (71 x 50
cm). The Tate Gallery, London.

Also known as *Queen
Guinevere*, this image,
based on the features of
Morris's future wife Jane
Burden, clearly alludes to
adulterous sexual activity.
The bedclothes are
crumpled and a dog curls
up on sheets recently
warmed; the wine and
oranges beside the bed refer
to pleasures of the flesh.
There is no iconographic
evidence to confirm
whether the female figure is
Iseult – who betrayed King
Mark for Tristram – or
Guinevere, who betrayed
King Arthur for Lancelot.
The image is not of a
penitent adulteress: rather,
Iseult/Guinevere, buckling
her belt as she rises from
the bed, unrepentantly
contemplates her own
beauty in a mirror. For all its
richness, the medievalising
interior has a debilitating,
claustrophobic atmosphere.

Pre-Raphaelitism's abiding concern with the art of the past grew out of the medievalism of the Romantic movement. Romanticism, the cultural movement which had dominated European thought in the first quarter of the nineteenth century, valued individual feelings and identities more highly than rationality and the following of rules, and placed the artist as an outsider and a rebel, alienated from society. Medieval art seemed to the Romantics more freely individualistic than that of classical Greece and Rome which had been viewed with reverence by Enlightenment thought. The present, too, contrasted unfavourably with the medieval past, which seemed to enshrine a lost spirituality and beauty: rejecting the realities of an increasingly industrialised Europe, many Romantic poets and artists favoured dreamy evocations of chivalry and romantic love which they discovered in the literature, art and architecture of the Middle Ages.

An early example of this combination of Romantic rebelliousness with medieval revivalism can be found in the Nazarenes, a group of German painters based in Rome from 1810 who adopted a self-consciously Gothic painting style. Their rebellion against modern life was expressed through their style of life as much as their style of painting: dressing in long, flowing gowns and growing their hair long, they lived in a disused convent. Their eccentric appearance reminded contemporaries of the image of Christ (who came from Nazareth), hence the nickname 'Nazarenes'. Unlike most visitors to Rome, they ignored the classical heritage surrounding them and instead turned for stimulus to early Renaissance art from Northern Europe as well as from Italy. A leading member of the group, Friedrich Overbeck (1789–1869), painted a portrait of his friend Franz Pforr (FIG. 8) as an artist

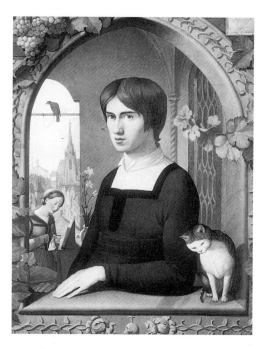

of the Northern Renaissance, with a view of a market town in the Low Countries through the window behind him. As the portrait attests, the Nazarenes also adopted a deliberately archaic style, imitating in their method as well as their iconography Northern masters from the fifteenth century such as Jan van Eyck (d. 1441). They also became expert in the revived technique of fresco painting which had been neglected for centuries. On the other hand, the Nazarenes and their wider circle also practised sketching from nature (FIG. 9), inspired by the drawings of Albrecht Dürer (1471–1528), whom they greatly admired. As the Pre-Raphaelites were later to do, they formed themselves into a brotherhood, known as the Lukasbund (Guild of St Luke), reviving the name of the medieval painters' guild. Thus organised, they planned to reform modern art with reference to the manner and methods of the early masters. While there is little evidence that the young British artists consciously emulated the Nazarenes, they were certainly aware of both the Germans' work and something of the artistic mythology surrounding it.

8. JOHANN FRIEDRICH OVERBECK
Portrait of the Painter Franz Pforr, 1810. Oil on canvas, 24½ x 18½" (62 x 47 cm). Staatliche Museen (National Galerie), Berlin.

9. JULIUS SCHNORR VON CAROLSFELD
Friedrich Olivier Sketching, 1817. Pencil, 10¼ x 7½" (26.2 x 19.2 cm). Albertina, Vienna.

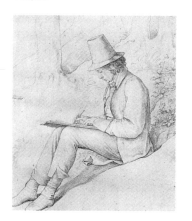

In Britain, medievalism was also gaining in popularity in the early decades of the nineteenth century. Romantic poets and novelists, especially, explored the Middle Ages as a setting for dramas of chivalry and romance. Sir Walter Scott's *Ivanhoe* (1819), with its combination of medieval atmosphere, dramatic action and romantic love, was perhaps the most successful example, and Scott surrounded himself at Abbotsford in the Scottish Borders with suits of armour and medieval relics. The spirit of Scott's work can be discerned in Charles Lock Eastlake's magnificent portrayal of *The Champion* (FIG. 10), which seems to foreshadow the famous Tournament, held at Eglinton Park in Ayrshire in 1839, in which early Victorian gentlemen donned armour and jousted. The subject is a relatively light-hearted amalgam of fashionable medieval elements but the treatment and colour of the work – luminous and rich – are pure sixteenth-century Venetian. Rather than attempting a medieval or early Renaissance style (often described at the time as 'Early Christian'), Eastlake looked to the opulent oil paintings of artists from the period immediately after Raphael, such as Titian (c. 1485–1576) and Veronese (1528–88), for his

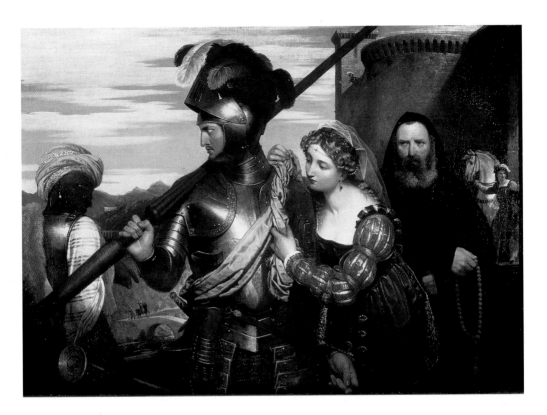

stylistic model. Romantic subjects from the Middle Ages, destined to be a Pre-Raphaelite speciality, had already taken hold, but the style in which Eastlake painted them was merely a fine example of the Royal Academy orthodoxies of the day. It was this style which the Pre-Raphaelites rejected.

Sir Edwin Landseer's *Bolton Abbey in the Olden Time* (FIG. 11) presents a more typical painting of a medieval theme. Game is being delivered to the abbot of the Augustinian priory on the banks of the River Wharfe in Yorkshire, though there is little in the image to identify the site. Landseer chooses instead to provide a highly romanticised view of everyday life in the Middle Ages. There could even be an element of anti-Catholic satire in the image: the portly abbot is clearly enjoying an opulent lifestyle off the backs of the local peasantry, in preference to apostolic poverty, and the image of a saint in the upper right corner has been summarily beheaded by the frame, offering a parallel to the iconoclastic attacks on ecclesiastical sculpture in the Reformation. The main purpose of the painting is, however, to demonstrate Landseer's mastery in the representation of fur and feathers. Overall the painting's tonality is relatively dark, in homage to the works of the old masters which Landseer copied as a student;

10. CHARLES LOCK EASTLAKE *The Champion*, 1824. Oil on canvas, 4' x 5'8" (1.22 x 1.73 m). Birmingham Museum and Art Gallery.

Eastlake, an accomplished painter who later became Director of the National Gallery and an authority on Italian art, was the author of a major historical study of the Gothic Revival. This early painting betrays his own, full-blooded medievalism. Our hero, having emerged from a medieval fortress, is about to mount a white charger and confront the challenger, crossing the bridge below, at whom he glares ferociously.

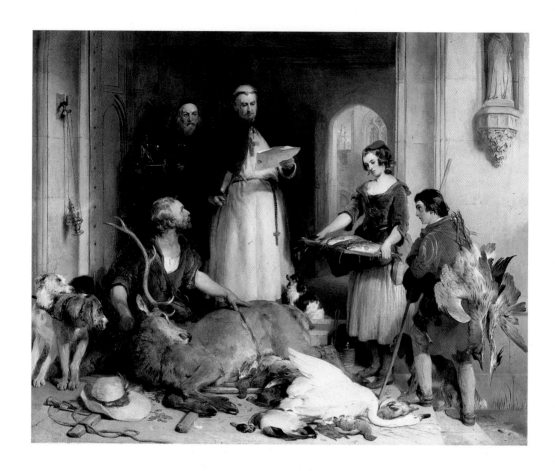

11. EDWIN LANDSEER
Bolton Abbey in the Olden Time, c. 1834. Oil on canvas, 5' x 6'4" (1.55 x 1.93 m). Devonshire Collection, Chatsworth.

Landseer's image typifies the historical genre scenes of the early nineteenth century. The historical elements of the image are almost pure confection, while the portrayal of the game and dogs demonstrates Landseer's pre-eminence as an animal painter. The colour scheme, tonality and brushwork point to his close study of the old painters, notably Peter Paul Rubens (1577–1640).

the disposition of light and shade is artfully managed rather than naturalistic. In contrast to later Pre-Raphaelite paintings, he allows the subsidiary areas of the painting's surface to remain far less finished than the highlights.

Architecture and Society

If medieval subjects for painting and the novel were gaining steadily in popularity, the Gothic style in architecture, with steeples, pointed arches and high stained-glass windows, had never really gone out of fashion. Most English towns were dominated by a Gothic parish church, symbolic of history and continuity. Even in the eighteenth century, when classical styles were dominant, the great cathedrals were considered to be picturesque as well as historic. In 1771, Horace Walpole noted in his *Anecdotes of Painting* 'It is difficult for the noblest Greek temple to convey half so many impressions to the mind as a cathedral does of the best gothic taste.' Walpole wrote a fanciful romantic novel, *The Castle of Otranto* (1765),

filled with unlikely supernatural activity, set in a world of ghostly happenings, flickering candles seen through stained glass, and animated suits of armour. He also transformed his own house, Strawberry Hill in Twickenham, near London, into a picturesque triumph of early Gothic Revival architecture, with such features as pointed arches and battlements.

This idiom, often known as 'Gothick', had gained a fairly wide popularity by the late 1820s, when the young Augustus Welby Northmore Pugin (1812–52) began his career as an architect and designer. Son of a French emigré who had become an antiquarian expert on medieval architectural detail, the younger Pugin was engaged as a teenager on designing the fashionable 'Gothick' interior of King George IV's new apartments at Windsor Castle. Pugin came to see the pointed arches and stylised patterns of the Gothic as more than an attractive architectural style, with a frisson of the age of chivalry: rather, especially after his conversion to Catholicism in 1835, he perceived in Gothic cathedrals and churches deep moral and spiritual truths. He recalled in 1850: 'I gained my knowledge of the ancient faith beneath the vaults of a Lincoln or a Westminster ... The reredoses, though defaced, and the sacraria in the walls, showed the site of numerous altars for the propitiatory sacrifice of the mass ... I indulged in a sort of Catholic Utopia.' The Protestant English were still deeply suspicious of Catholicism, though legal restrictions on the faith were lifted with the Catholic Emancipation Act of 1829. Pugin's masterpiece, in which he presented the full splendour of his Romantic vision of Christian architecture from before the Reformation, was the Catholic church of St Giles at Cheadle in Staffordshire (FIG. 12), consecrated in 1846: lavishly funded by a private commission, the interior allowed Pugin to indulge his love of rich colour and geometric patterning in stained glass, ceramic tiles, metalwork and stone. The unashamedly saturated colour schemes certainly offer a precedent for the jewel-like brilliance of Pre-Raphaelite painting. William Morris, too, was to follow Pugin's exploration of flat patterns and richly ornamented surfaces inspired by medieval examples.

Pugin added another dimension to the medieval revival in his polemical publication of 1836, *Contrasts, or, A Parallel between the Noble Edifices of the Middle Ages and Corresponding Buildings showing the Present decay of Taste*. Pugin's book was revolutionary in its use of engraved plates presenting paired images contrasting the present unfavourably with the past. Contemporary opinion favoured a view of history based on the idea of endless progress culminating in the near-perfect state of modern England, a narrative which found its finest expression in Thomas Babington Macaulay's

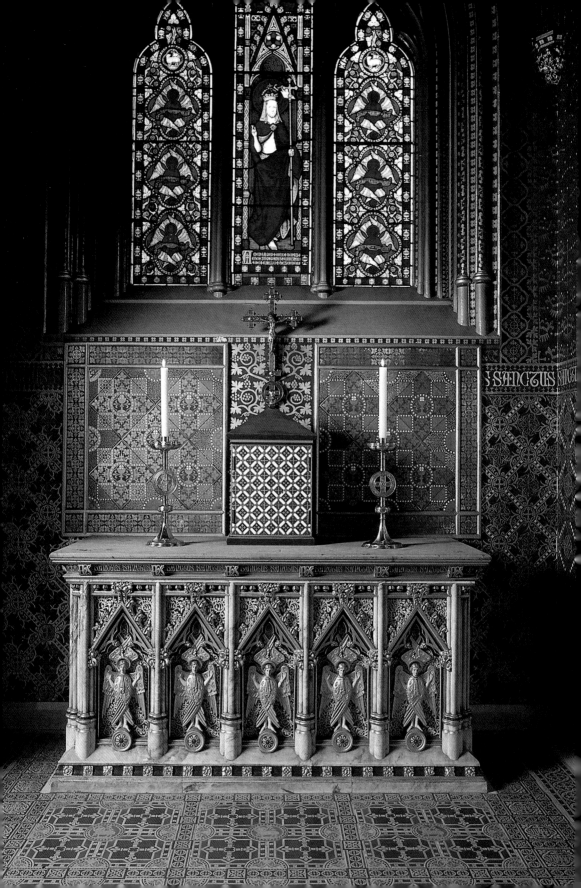

famous *A History of England* (1849). Pugin's view was precisely the opposite. In the second edition of *Contrasts*, published in 1841, he included contrasting images of a 'Catholic Town in 1440' with 'The Same Town in 1840' (FIG. 13). Modern Britain was compared with the past and found wanting. The town of 1440 is notable principally for the wealth and variety of Gothic churches, their steeples soaring heavenwards. By 1840, these have either been demolished or dwarfed by smoking factory chimneys. The common land in the foreground, with children playing, has been replaced by a large prison, in the cruel form of the 'Panopticon', in which modern scientific theories were applied to the punishment and reform of criminals. Pugin also carefully denotes a lunatic asylum: the loss of medieval virtues of communality and charity has resulted in the modern problems of crime and insanity. Religious conflict and sectarianism are evidenced by Baptist, Unitarian and Wesleyan Chapels, which have replaced the singularity of the true Catholic faith. In Pugin's account (which would not bear historical analysis), reference to the medieval world offered a social and spiritual panacea to solve the ills of modern society. Although he never acknowledged the influence of Pugin,

12. A. W. N. PUGIN
St Giles, Cheadle, Staffordshire: The Blessed Sacrament Chapel.

St Giles's (c. 1842–50) marks the climax of Pugin's career as an architect. While the exterior is based on medieval English parish churches, the elaborately decorated interior draws on such exotic sources as the Sainte Chapelle, Paris (1243–8). The polychromy of the Blessed Sacrament Chapel brought the future cardinal J. H. Newman to his knees in what he called 'a blaze of light'.

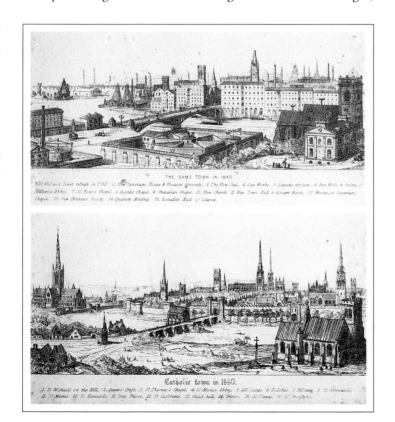

THE SAME TOWN IN 1840

Catholic town in 1440.

13. A. W. N. PUGIN
'Contrasted Towns', *Contrasts, or a Parallel between the Noble Edifices of the Middle Ages and Corresponding Buildings showing the Present decay of Taste*, 1841 edition.

Pugin's plates of an imaginary city in 1840 and the same city in 1440 form an important part of his polemic against modern architecture and the society which produced it. Inch-by-inch comparison of the two images reveals a wealth of details, all demonstrating the degenerate nature of the modern city. The restoration of Catholicism and the revival of Gothic architecture were Pugin's twin goals.

whom he cuttingly described as 'the smallest possible architect', Ruskin was to produce a similar theory in the famous chapter of his book *The Stones of Venice* (1851–3) entitled 'The Nature of Gothic', where medieval skilled work, and the life of the craft-worker in the Middle Ages, were compared favourably to their modern counterparts. Such ideas were important for the Pre-Raphaelites, through the influence of Ruskin, and other critics such as Thomas Carlyle, whose *Past and Present* (1843) had a profound influence on mid-Victorian thinking.

Ford Madox Brown and the Westminster Frescoes

Pugin's last great commission was for the decoration of the interior of the new Palace of Westminster, rebuilt by Charles Barry after the fire of 1834. It was announced in 1835 that the new building must employ either the Gothic or the Tudor style, preferred to the classical style typical of public buildings, for example, in Paris and Berlin. Pugin's gloriously detailed Gothic interiors still serve as a symbol of British national identity and pride. The Palace interiors contained spaces for paintings on a monumental scale and after some discussion fresco was chosen. (The Prime Minister, Lord Melbourne, is reputed to have asked 'Which is lightest?' 'Fresco, my Lord' came the answer; 'Then damme, I'm for Fresco' he concluded.) In 1841, a Royal Commission was appointed, with Prince Albert at its head, and Charles Eastlake as its Secretary, to investigate the matter. The Nazarene painter Peter von Cornelius (1783–1867) was consulted as an expert in the fresco medium. A series of competitions was held from 1843 onwards for designs for frescoes of 'not less than 10ft [3.04 m] and not more than 15ft [4.5 m] in their longest dimension' with life-size figures, on themes from English history, Milton or Shakespeare. Prince Albert and his colleagues believed that they could foster a national artistic revival through the competition: Albert even felt that the cartoon exhibitions could 'elevate the character and habits of the people'.

The future Pre-Raphaelites were too young to enter the fresco competitions, though Rossetti visited at least one of the exhibitions. However, one of their later associates, Ford Madox Brown, at twenty-two, began work on a cartoon, *The Body of Harold brought before William the Conqueror*, for the 1844 competition. Madox Brown had been trained in Antwerp and was based at this time in Paris; it was not until 1845 that he met Overbeck and Cornelius in Rome, providing a personal link between Nazarenes and Pre-Raphaelites. His style for the Westminster cartoons already

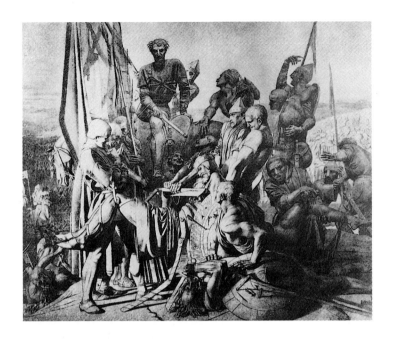

14. FORD MADOX BROWN
The Body of Harold brought before William the Conqueror, 1843. Charcoal on paper, 14'6" x 13' (4.42 x 3.9 m). South London Art Gallery. Now in fragments.

This submission to the Westminster fresco competition of 1844 is notable for its stylised portrayal of the heroic male body. Historians during the Victorian period debated the relative merits of the Saxons, often seen as the authentic English race, and the Norman invaders. Madox Brown throws William into the shadows and caricatures his obsequious followers, while the attenuated body of Harold attains a tragic grandeur.

betrayed the influence of the German painters, as can be seen from the resulting cartoon (FIG. 14). Brown, like most of the young artists who entered the fresco competitions, was unsuccessful. The Westminster commissions were mainly awarded to more experienced artists such as William Dyce (1806–64), who was asked to paint a fresco of King Ethelbert on the walls of the House of Lords.

Dyce was personally acquainted with the Nazarenes and had visited Italy, where he was deeply impressed by the work of Giotto (c. 1267–1337) and other early Italian artists. Although an Anglican, his highly personal style based on 'Early Christian' examples was an expression of his interest in the spiritual and religious qualities of art from before the Reformation. In 1847, Dyce received a further Westminster commission for a series of frescoes based on the legend of King Arthur, the most important of all medieval narratives for the Victorians. The prime literary source was Thomas Malory's *Morte d'Arthur* (first printed by Caxton in 1485), a text which inspired the Victorian poet laureate Alfred, Lord Tennyson (1809–92) and the Pre-Raphaelites to some of their finest work. For Dyce, the patriotic elements of the story, with Arthur as a national hero, and the sexual narrative of Arthur's betrayal by Guinevere (favourite Pre-Raphaelite themes), were subordinate to the religious narrative of the quest for the holy grail. He described *Morte d'Arthur* as 'a tolerably intelligible religious allegory, strongly tinctured with the monastic ideas

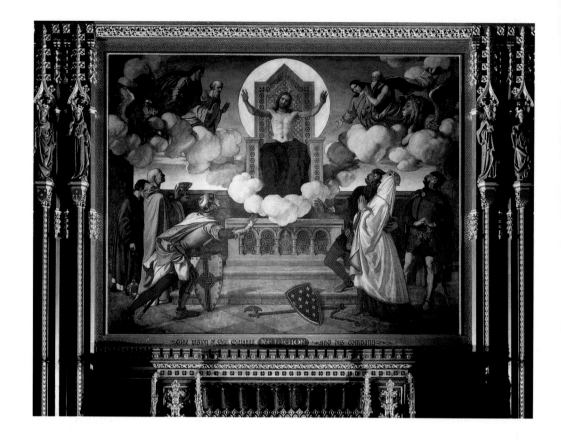

15. WILLIAM DYCE
Religion: The Vision of Sir Galahad and his Company, 1851. Fresco, 10′6¼″ x 14′ (3.21 x 4.27 m). Queen's Robing Room, Palace of Westminster, London.

Dyce's fresco combines some medieval elements with homage to Raphael. It also resembles work by the Nazarene artist Friedrich Overbeck. The powerful, hieratic composition marks it as one of the most successful in the Palace of Westminster.

of the 13th century'. Commissioned in 1847, *Religion: The Vision of Sir Galahad and his Company* (FIG. 15) was completed as a fresco in the Queen's Robing Room at the Palace of Westminster in 1851. It presents a mystic scene in which the grail appears to Galahad, seen in the left foreground, the member of the Round Table who has maintained his chastity as (in Malory's words) 'a clene virgyne above all knyghtes'. Christ appears to the assembled company, borne by clouds with the four evangelists next to him. The composition is rigidly symmetrical, recalling paintings by Raphael rather than medieval sources, and there is no attempt to make the scene appear naturalistic, as can be seen from the schematic cotton-wool clouds distinguishing the earthly from the heavenly protagonists. By the time the fresco was completed in 1851, Dyce was aware of the work of the Pre-Raphaelites. Indeed, he supported the young artists and, later, himself adopted aspects of the Pre-Raphaelite style.

The paintings of Madox Brown from the years immediately before the founding of the Pre-Raphaelite Brotherhood also seem to prefigure some, but not all, of the characteristics of Pre-Raphaelite

art. Searching the Library of the British Museum in 1845 for another Westminster cartoon subject, Brown came across a passage on Geoffrey Chaucer which 'at once fixed me, I immediately saw visions of Chaucer reading his poems to knights & Ladyes fair, to the king & court amid air & sun shine'. The subject was nothing less than the birth and flowering of the English language, though, worried about there being 'no space left' for the prose writers, he later limited the subject to *The Seeds and Fruits of English Poetry* (FIG. 16). The surviving painting – a small version of a projected large-scale work – incorporates three scenes, separated by painted Puginesque architectural elements and foliage. Mimicking the panels of a triptych, the painting is a superb example of Romantic medievalism, though the painting was completed only in 1853 (it is inscribed 'Coloravit in Hampstead 1853') and the sharpness of detail might owe something to the influence of the younger painters Millais and Holman Hunt. A large-scale version of the central scene was also completed, but Brown abandoned the wings. The resulting single canvas, more monumental but less elaborately Gothicised, was exhibited in 1851 as *Geoffrey Chaucer Reading the 'Legend of Custance' to Edward III and his Court, at the Palace of Sheen, on the Anniversary of the Black Prince's Forty-*

16. FORD MADOX BROWN *The Seeds and Fruits of English Poetry*, 1845–51, 1853. Oil on canvas, 13½ x 18¼″ (34 x 46 cm). Ashmolean Museum, Oxford.

In the outer panels are seen poets from later periods, the fruit of Chaucer's seed (Milton, Spenser and Shakespeare on the left; Byron, Pope and Burns to the right). In the central section, Chaucer appears amid colourful Gothic splendour at the court of Edward III and the Black Prince.

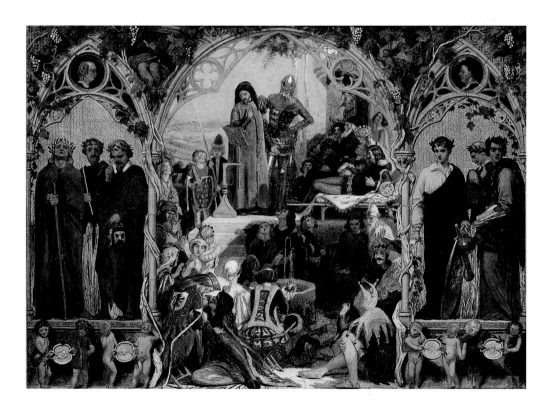

Fifth Birthday. Here the clarity and individual definition and colouring of each object, a keynote of early Pre-Raphaelitism, can be seen. In a later exhibition catalogue, Madox Brown recalled that this was 'the first in which I endeavoured to carry out the notion, long before conceived, of treating light and shade absolutely, as it exists at any one moment, instead of approximately, or in generalised style'. The same aspiration can be seen in *The Seeds and Fruits,* where Brown attempts to move away from the planned and artificial deployment of light and shade (or *chiaroscuro*) of a work like Eastlake's *The Champion* (see FIG. 10) to a more naturalistic scheme of lighting.

Another trait associated with the Pre-Raphaelites was the meticulous research of historical details, and Madox Brown was familiar with many of the printed sources which they also used, such as Camille Bonnard's illustrated book *Costumes Historiques* (first published 1829–30), which Millais probably used for *Isabella* (see FIG. 2). It is perhaps no surprise that, on 24 March 1848, Madox Brown received a letter from a complete stranger beginning 'Sir, I am a student in the Antique School at the Royal Academy'. Couched in elaborate terms of praise, its signatory, 'Gabriel C. Rossetti', implored Brown to take him on as a pupil. Brown, who was still virtually unknown, considered the letter to be a sarcastic prank and set off with a stout wooden stick to punish the perpetrator: but Rossetti, it transpired, was quite serious, and for a short time he took lessons from Brown, who proved a hard taskmaster.

The Brotherhood

With Rossetti at the Royal Academy Schools were John Everett Millais, the acknowledged prodigy whose works had already been included in the Academy's summer exhibitions, and William Holman Hunt. Although Millais, Rossetti and Hunt, like most artists, came from the broad middle class, each had a quite different background. Hunt's father was the manager of a 'Manchester house' or wholesale cotton warehouse, and was neither able nor willing to provide the unstinting support which Millais received from his wealthy family of Jersey landowners. Rossetti came from a cosmopolitan and cultured family of Italian immigrants, his father having come to England as a refugee and become Professor of Italian at King's College, London. Hunt, least advantaged of the three, worked for four years in the office of an estate agent before entering the Royal Academy Schools, and had to make his living by selling his copies of works in the National Gallery. His student

work betrayed no special radicalism, but his epiphany came in 1847 when reading the first two volumes of Ruskin's *Modern Painters*, with its invocation to young artists to reject the conventions of their teachers and to 'go to nature' (discussed in Chapter Two). It was through Ruskin's impassioned rejection of the orthodoxies of art education that Hunt and Millais discovered and adopted what Rossetti had almost as his birthright: the identity of the Romantic artist, the rebel who casts aside all he is taught and struggles against orthodoxy in a personal quest for self-expression.

During the summer of 1848, only months after he had begged Madox Brown to take him on as a pupil, Rossetti abandoned the older painter and transferred his allegiances to Holman Hunt. Soon the two were sharing a studio, which Stephens recalled as a 'large gaunt chamber', in Cleveland Street, then a slightly unsalubrious thoroughfare lined with small shops, in the West End of London. Rossetti modelled for the suitably rebellious main figure in Hunt's picture of that year, *Rienzi vowing to obtain Justice*, illustrating a passage from a novel set in fourteenth-century Rome by the popular Victorian author Bulwer Lytton. The founding of the Pre-Raphaelite Brotherhood took place between Cleveland Street (where Hunt and Rossetti gathered around them a band of followers) and Millais's family home, 83 Gower Street, in nearby Bloomsbury, a quarter of London associated with intellectual life, which was home to the British Museum and the new University College.

The Brotherhood was founded as an initially secret and closed society of seven, among whom Millais, Rossetti and Holman Hunt were undoubtedly dominant; Woolner, Collinson, Stephens and William Michael Rossetti made up the numbers. According to the standard accounts, in which myth blends seamlessly with remembered anecdote, the name 'Pre-Raphaelite' emerged after the artists criticised an engraving of Raphael's altarpiece, *The Transfiguration* (c. 1518, Vatican, Rome). They considered this work, widely regarded as a cornerstone of the European tradition, to betray a 'grandiose disregard of simplicity of truth' and condemned 'the pompous posturing of the Apostles, and the unspiritual attitudinising of the Saviour'. This amounted to sacrilege: Raphael, alongside Michelangelo, was held in the deepest awe by almost all academic artists; singled out for praise in the *Discourses* (delivered between 1769 and 1790) of Joshua Reynolds, first president of the Royal Academy. The painting by which the Pre-Raphaelites knew Raphael best was *St Catherine of Alexandria* (FIG. 17) in the National Gallery, which

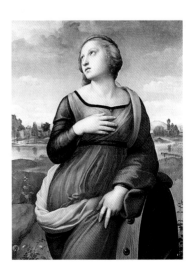

17. RAPHAEL
St Catherine of Alexandria, c. 1507–8. Oil on wood panel, 28 x 22″ (71.5 x 55.7 cm). National Gallery, London.

18. Carlo Lasinio
The Cursing of Cain, 1810.
Engraving, 18½ x 32½" (47
x 82.5 cm). British Museum,
London.

19. John Everett Millais
Lovers by a Rosebush,
1848. Pen and black ink,
10 x 6½" (25.4 x 16.5 cm).
Birmingham Museum and
Art Gallery.

in their student days shared its Trafalgar Square premises with the Royal Academy. The softened and idealised features of St Catherine, and the rich, but not insistently naturalistic, colouration of such works, were venerated by the Academicians. Yet an alternative model of Italian art was available: Millais made a point of showing his friends engravings by Carlo Lasinio after the fifteenth-century frescoes in the Campo Santo at Pisa (FIG. 18), as examples of 'sound work'. While Madox Brown had seen, and had been deeply moved by, early Italian frescoes *in situ*, the young members of the Brotherhood had seen no frescoes and only a few panel paintings were available in London. The side panels of the *Coronation of the Virgin* altarpiece by Lorenzo Monaco (c. 1370–c. 1425), then attributed to Taddeo Gaddi (c. 1300–66), the first early Italian works to enter the National Gallery, were acquired in July 1848. From 1850, as a trustee and later director of the National Gallery, Charles Lock Eastlake (1793–1865) made important purchases of early Italian painting. But in 1848, Lasinio's engravings provided the most immediate stimulus. It was, perhaps, the linear simplification and clarity, the blank spaces and small patches of shading inherent in the reproductive medium of engraving as employed by Lasinio, as much as the

bold, hieratic composition of the frescoes, which attracted the young artists.

A group of drawings which they produced under the immediate influence of Lasinio's engravings constitutes the one and only example of stylistic unanimity among the Brotherhood. Millais's *Lovers by a Rosebush* (FIG. 19) is strongly reminiscent of *Isabella* (see FIG. 2) and might even represent the same figures, with Isabella's dog, though the poem does not include a scene in the garden. The extraordinary precision of these elongated figures blends an intensity of natural observation (especially notable in Millais's rendering of the flowers) with a stylised, historicist characterisation of the human figure through angular and spiky lines. The same paradoxical blend can be found in Rossetti's *Dante drawing an Angel on the First Anniversary of the Death of Beatrice* (FIG. 20), an early example of his obsession with the tragic love of Dante and Beatrice. Many details have been carefully reconstructed; a statue of St Reparata, the patron saint of Florence, is seen at the extreme left and Dante's family coat of arms appears on the chair and above the window. But for all its attempts at realism and its Gothic spikiness, the image, like all Pre-Raphaelite works, is inalienably Romantic in character. It encapsulates both the Pre-Raphaelites' modern conception of individual subjectivity and their rebellion against the father figures Raphael and Reynolds, and the institution of the Royal Academy and its Schools. In style as well as subject these drawings move as far as possible from the concentration on generalisation and the ideal, which Reynolds had promoted. The precision and incisiveness of line in these drawings, and of the paintings produced at the same time, was a deliberate negation of the old-masterish softness and allusiveness of Reynolds's own brushwork (which gained him the Pre-Raphaelite nickname 'Sir Sloshua').

In the autumn of 1849, Hunt and Rossetti travelled on the Continent in search of artistic stimuli, making a Pre-Raphaelite pilgrimage to France

20. DANTE GABRIEL ROSSETTI *Dante drawing an Angel on the First Anniversary of the Death of Beatrice*, 1849. Pen and black ink, 15¾ x 12¾″ (39.8 x 32 cm). Birmingham Museum and Art Gallery.

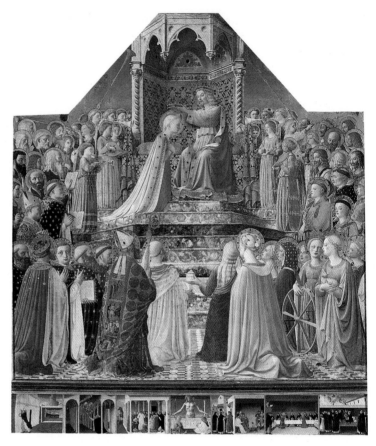

and Belgium. In the Louvre, they saw copies of frescoes by Fra Angelico (c. 1387–1455) and, in particular, his *Coronation of the Virgin* panel (FIG. 21), considered (as Hunt recalled) to be 'of peerless grace and sweetness in the eyes of us both'. Angelico's panel combined clear outlines and brilliant colours with a spiritual intensity which the Pre-Raphaelites strove to emulate. Rossetti also considered Leonardo da Vinci 'a real stunner', but it was the exposure to early Flemish painting which proved most decisive. A triptych by Hans Memling in the Hospital of St John in Bruges made a deep impression on Rossetti, a stanza from whose poem, *Antwerp and Bruges*, reflects his sense of closeness to the fifteenth-century artists:

> John Memmeling and John van Eyck
> Hold state at Bruges. In sore shame
> I scanned the works that keep their name.
> The carillon, which then did strike
> Mine ears was heard of their alike:
> It set me closer unto them.

Nearer to home, the Pre-Raphaelites could admire *The Marriage of Giovanni Arnolfini* (FIG. 22) by Jan van Eyck, which had been purchased by the National Gallery in 1842. The extraordinary fidelity of natural detail in these works indicated what was really meant by Pre-Raphaelite. In an eloquent defence of the Brotherhood in a letter to *The Times* of 13 May 1851, written before he had made their acquaintance, Ruskin noted 'their fidelity to a certain order of truth'. He continued:

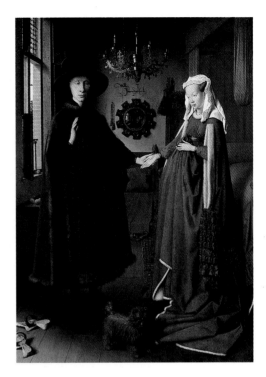

> They know very little of ancient paintings who suppose the works of these young artists to resemble them. As far as I can judge of their aim ... the Pre-Raphaelites intend to surrender no advantage which the knowledge or inventions of the present time can afford to their art. They intend to return to early days in this one point only – that, as far as in them lies, they will draw either what they see, or what they suppose might have been the actual facts of the scene they desire to represent, irrespective of any conventional rules of picture-making; and they have chosen their unfortunate though not inaccurate name because all artists did this before Raphael's time, and after Raphael's time did not this, but sought to paint fair pictures, rather than represent stern facts; of which the consequence has been that, from Raphael's time to this day, historical art has been in acknowledged decadence.

This remains the most eloquent explanation of Pre-Raphaelitism's elision of historicism and naturalism, the key text in understanding this central Pre-Raphaelite paradox. From the young Pre-Raphaelites, Ruskin expected nothing less than 'the foundations of a school of art nobler than the world has seen for three hundred years'.

Revivalism and Realism

Ruskin perceived that early promise in works such as Millais's *Christ in the House of His Parents*, exhibited in 1850 (FIG. 23), a painting as radical in its subject as in its treatment. It did, in one sense, present what Millais 'supposed might have been the

22. JAN VAN EYCK
The Marriage of Giovanni Arnolfini, 1434. Oil on oak panel, 32¼ x 23½" (81.8 x 59.7 cm). National Gallery, London.

The early Netherlandish painter Jan van Eyck's small panel provided the Pre-Raphaelites with an accessible example of brilliant realism from before the time of Raphael. Eastlake praised van Eyck's 'extraordinary capacity for seeing nature'. Hunt later recalled 'the newly acquired van Eyck' as 'most profitable for youthful emulation'.

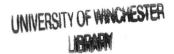

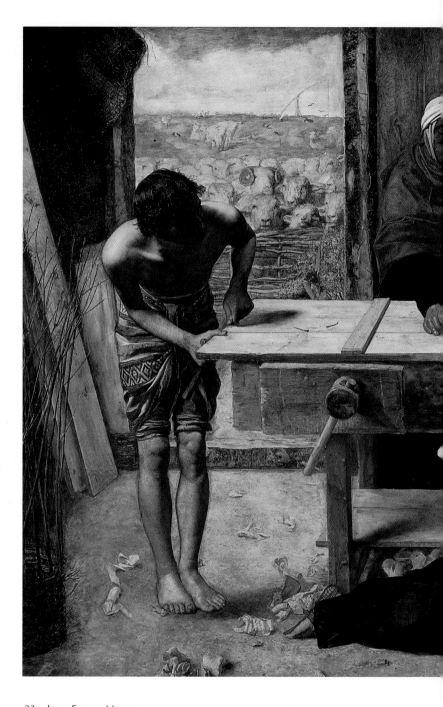

23. JOHN EVERETT MILLAIS
Christ in the House of His Parents
('The Carpenter's Shop'), 1849–50.
Oil on canvas, 34 x 55″ (86.4 x
139.7 cm). The Tate Gallery, London.

actual facts' of Christ's childhood, although there is no hint of
a real location in the Middle East. Holman Hunt was later to pur-
sue absolute historical and ethnographic fidelity in the portrayal
of biblical scenes (discussed in Chapter Four). Nonetheless,
Millais's idea of portraying the Holy Family as working people in

the minutely observed setting of a common carpenter's shop met with outrage from other critics. Most notable was Charles Dickens's splenetic attack on the painting, published in his journal *Household Words* in 1850, where he described the figure of Christ as

> A blubbering red-haired boy in a nightgown, who appears to have received a poke playing in an adjacent gutter, and to be holding it up for the contemplation of a kneeling woman so horrible in her ugliness that (supposing it were possible for any human creature to exist for a moment with that dislocated throat) she would stand out from the rest of the company as a monster in the vilest cabaret in France or in the lowest gin-shop in England.

Gender and class are the chosen terms of Dickens's attack: the Christ child is not sufficiently manly; the Virgin is too vulgar in her physiognomy, too coarse in comparison with the sweet features of the Raphaelesque madonna. Her hardened face appears working class ('the lowest gin shop') and not even English (but French). The influential journal *The Athenaeum* went even further, claiming that the PRB had misunderstood the early Italian painters: 'In all these [early Italian] painters the absence of structural knowledge never resulted in positive deformity. The disgusting incidents of unwashed bodies were not present in loathsome reality: the flesh with its accidents of putridity was not made the affected medium of religious sentiment in tasteless revelation.' Perhaps the cause of unease for Dickens and his fellow critics was the visual language through which Millais communicates with the viewer. The work operates at two levels, simultaneously realistic and symbolic. We examine the figures of a carpenter and his family, minutely drawn from life, and yet we see represented the Holy Family. The tools on the rear wall are the standard implements of the trade, and yet they also symbolise the instruments of Christ's passion; the sheep seen in the field through the window were painted meticulously one by one from sheep's heads acquired from a local butcher; yet they also symbolise Christ's flock, mankind. Most shockingly of all, a documentary, realistic style, associated with everyday objects, is applied to biblical figures: as *The Athenaeum* put it, Millais applied 'a circumstantial Art-language' to the 'higher forms, characters and meanings', adding that 'we recoil with loathing and disgust' from this offensive mis-match of style and subject. We will return to the ambiguous religious significance of the image in Chapter Four.

24. DANTE GABRIEL ROSSETTI *Ecce Ancilla Domini!*, 1849–50. Oil on canvas, 28½ x 16½" (72.4 x 41.9 cm). The Tate Gallery, London.

Another religious image from these early years presents one of the clearest examples of Pre-Raphaelitism as an attempt to revive the style as well as the spirit of early Renaissance art: Rossetti's *Ecce Ancilla Domini!* ('Behold the Servant of the Lord') is his representation of the Annunciation, exhibited in 1850 (FIG. 24). This continues the narrative of *The Girlhood of Mary Virgin* (see FIG. 1), and the embroidery which Mary was working in the earlier image is now complete and hangs on its folded stand; the dove of the Holy Spirit has entered her simple chamber. The scene was described in Rossetti's early sonnet, inscribed on the frame of *The Girlhood* in 1849:

> ... Till one dawn, at home,
> She woke in her white bed, and had no fear
> At all, yet wept till sunshine, and felt awed;
> Because the fulness of the time was come.

In *Ecce Ancilla Domini!* Rossetti quite clearly alludes to the brilliant areas of colour and chalky white surfaces of frescoes, even though he had never visited Italy. The perspective is surely deliberately askew in order to add a hypnotic charge to the encounter between a more than usually masculine Angel Gabriel and the pensive, adolescent figure of the Virgin, modelled from Christina Rossetti, the artist's sister. Striking though it is, the image points up the extreme difficulty facing the religious painter in the mid-nineteenth century, an age of intense materialism and spiritual crisis. For although Rossetti's historicist treatment of the scene seems to disavow the present, to wish to return to a purer world of the Middle Ages, the inescapable modernity of the faces, the very corporeality of the figures, makes the supernatural activity we are witnessing seem all the more unlikely. The improbably small, haloed dove, representing the holy spirit, and the half-hearted fire burning at Gabriel's heels, are not sufficient to convince the viewer that this is a spiritual, rather than a sexual, encounter.

A parallel theme can be discerned in Millais's *Mariana* (FIG. 25). The painting illustrates Tennyson's poem of the same title, based on the plot of Shakespeare's *Measure for Measure*, in which Mariana is abandoned by Angelo, to whom she is betrothed, when her dowry is lost at sea. The fundamental subject of the painting is sexual frustration and longing, a highly unorthodox notion in the context of Victorian ideas of gender; Mariana stares disconsolately at the stained-glass Annunciation scene in the window of her 'moated grange'. This seems to accentuate her predicament since Millais, like Rossetti, alludes to the fulfilment of the Virgin

as a quasi-sexual event. Mariana has probably been praying to the Virgin at the shrine with a lighted candle which stands on her dresser. Millais's recreation of the opulent colours of Tennyson's poem has none of the technical awkwardness of *Ecce Ancilla Domini!*. This is a Tennysonian recreation of the Middle Ages, and the painter's brilliantly illusionistic technique, like the poet's, exemplifies Ruskin's statement that the PRB 'surrender no advantage which the knowledge or inventions of the present time can afford to their art'.

The combination of medievalism and naturalism can be detected in one of the few sculptures from the Pre-Raphaelite circle. Alexander Munro (1825–71) worked on the sculptural decoration of the Palace of Westminster. He met Rossetti and Millais at the Royal Academy Schools and in *Paolo and Francesca* (FIG. 26) he provides a three-dimensional analogue to the style of early Pre-Raphaelite painting. Munro exchanged work on

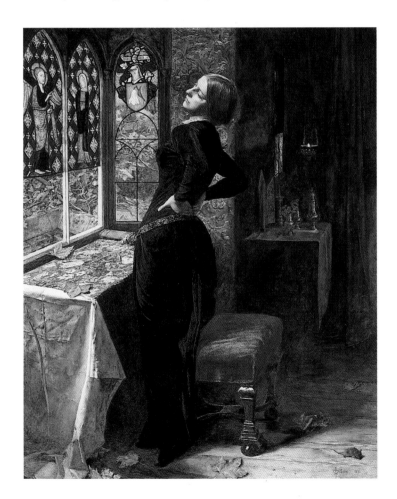

25. JOHN EVERETT MILLAIS *Mariana*, 1851. Oil on canvas, 23½ x 19½" (59.7 x 49.5 cm). Private collection.

A Ruskinian touch is added in the implicit comparison between a leaf which has blown through the window and the extremely naturalistic embroidery which Mariana is working. The opulent colour and sensuality of the image anticipates some of the later, Aestheticist, developments in Pre-Raphaelitism.

the theme of Paolo and Francesca with Rossetti, who completed a watercolour of the subject in 1855.

Sexuality is again an explicit theme in Holman Hunt's *Valentine rescuing Sylvia from Proteus* (FIG. 27), a scene from *Two Gentlemen of Verona*. As in Millais's *Isabella* (see FIG. 2), the subject of the painting is charged with sexual tension and personal animosities. Here again we see Holman Hunt attempting, to paraphrase Ruskin, to paint what he supposed might have been the actual facts of the scene, irrespective of artistic convention. In the depiction of a stage play, this leads to curious ironies: a dramatic text is pictured as real action out of doors; and actors, playing Veronese courtiers in full Shakespearian costume, are seen in woodland carefully painted in Kent. Holman Hunt, like Millais and Rossetti, faced the paradox of applying an intense realism to the representation of historical, literary or religious events. The effect of reality which Hunt achieved is even more striking than that of his friends: he was fearless in his combination of colours and hues which jar the eye, and the costumes still seem brilliant to the point of garishness a century and a half after they were painted.

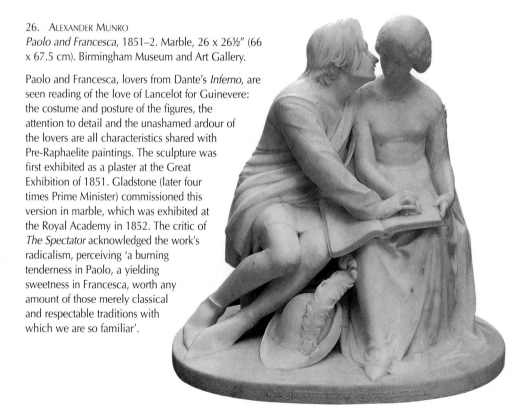

26. ALEXANDER MUNRO
Paolo and Francesca, 1851–2. Marble, 26 x 26½" (66 x 67.5 cm). Birmingham Museum and Art Gallery.

Paolo and Francesca, lovers from Dante's *Inferno*, are seen reading of the love of Lancelot for Guinevere: the costume and posture of the figures, the attention to detail and the unashamed ardour of the lovers are all characteristics shared with Pre-Raphaelite paintings. The sculpture was first exhibited as a plaster at the Great Exhibition of 1851. Gladstone (later four times Prime Minister) commissioned this version in marble, which was exhibited at the Royal Academy in 1852. The critic of *The Spectator* acknowledged the work's radicalism, perceiving 'a burning tenderness in Paolo, a yielding sweetness in Francesca, worth any amount of those merely classical and respectable traditions with which we are so familiar'.

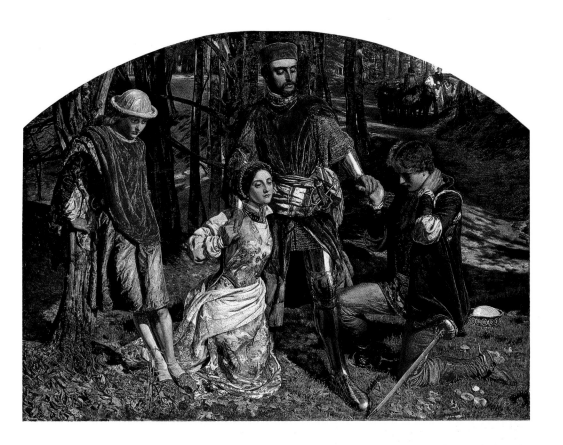

Rossetti and his Followers in the 1850s

While Millais, Holman Hunt and Madox Brown turned largely
to landscapes, modern life and religious subjects (discussed in
the following chapters), Rossetti's art increasingly retreated in-
to the medieval world. Subjects from Dante, Malory and Chaucer,
as well as from his own poetry, occupied him throughout the
1850s. Rossetti achieved little in oils at this time, and his finest
work can be found in a series of luminous and richly ornamen-
tal watercolours on medieval themes. In *The Wedding of St George
and Princess Sabra* (FIG. 28), an unusual square format has been
adopted and conventional perspective has been abandoned. The
image is constructed from flat, decorative surfaces of Puginian
richness, with saturated and jewel-like colours. *The Wedding of St
George*, whose subject derives from Thomas Percy's *Reliques of
Ancient English Poetry* (1762), can be linked directly to medieval
visual sources; the row of bells being played by the mysterious,
green-winged angels appears in several illuminated manuscripts,
including one owned by Ruskin, *The Hours of Isabelle of France*
(1260–70, now in the Fitzwilliam Museum, Cambridge). There

27. WILLIAM HOLMAN HUNT
*Valentine rescuing Sylvia from
Proteus*, 1851. Oil on canvas,
38¾ x 52½" (98.5 x 133.3
cm). Birmingham Museum
and Art Gallery, .

In place of a long summary
of the plot of *Two Gentlemen
of Verona*, one of
Shakespeare's more obscure
plays, suffice it to say that
Proteus, to the right, has
attempted to rape Sylvia,
whose lover Valentine, in
armour, has arrived just in
time to prevent this.
Meanwhile Julia, Proteus's
erstwhile lover, watches
events disguised as a boy,
while she fingers the ring
Proteus has given her as an
evidently worthless token of
his fidelity.

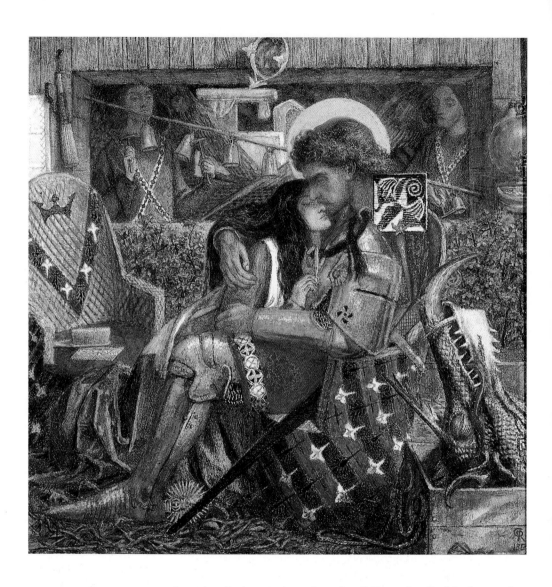

28. DANTE GABRIEL ROSSETTI, *The Wedding of St George and Princess Sabra*, 1857. Watercolour on paper, 14¼ x 14¼″ (36.5 x 36.5 cm). The Tate Gallery, London.

is an implied narrative: the splendidly scaly, Gothic dragon has been killed, its forked tongue lolling out of its mouth; St George and the Princess are now sensuously united and she cuts off a plait of her hair which she has attached to his helmet, signifying the permanence of their bond. But these narrative considerations are secondary to the painting's powerful appeal to the senses. In addition to the luscious evocation of the medieval world, key themes for Rossetti's later work can be discerned here: he concentrated increasingly on the pursuit of an ideal, sensuous beauty, in images of long-haired and languorous women; and on the relationship between art and music, sight and sound, indicated by the bell-ringing angels.

In January 1856, Rossetti was approached by the young Edward Burne-Jones, an Oxford University student determined to become an artist. Rossetti was flattered by the attention of 'a certain Jones, one of the nicest young fellows in *Dreamland*', and his friend the ebullient William Morris, who at this time was articled to the London office of the Gothic Revival architect G. E. Street. Rossetti seemed to them an exotic figure, both a medievalising Pre-Raphaelite and the very epitome of the bohemian artist. On Rossetti's advice, Burne-Jones and Morris rented a flat in Red Lion Square, in Bloomsbury, and began to furnish it with medieval bric-a-brac including suits of armour and furniture which, in the spirit of medieval artisans, they began to make and decorate themselves. A wardrobe from Red Lion Square was painted by Burne-Jones with various scenes from the ghoulish story of Chaucer's *Prioress's Tale* in a self-consciously archaising style (FIG. 29).

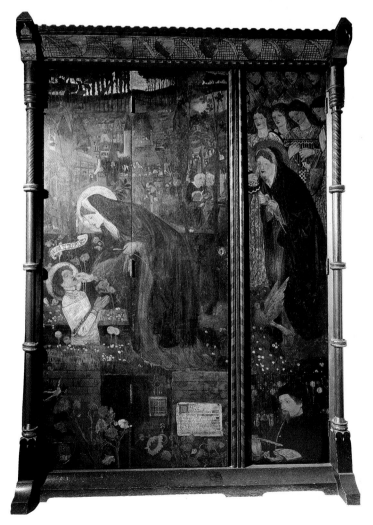

29. Edward Burne-Jones *The Prioress's Tale Wardrobe*, 1858–9. Painted wood, Ashmolean Museum, Oxford.

This wardrobe is decorated with a narrative from Chaucer's *Prioress's Tale*, which tells of a Christian boy who learned to sing the hymn 'Alma Redemptoris' at school and was murdered by resentful Jews. The Virgin appeared and, putting a grain of wheat upon his tongue, miraculously allowed him to sing again.

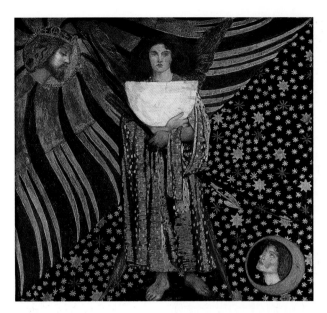

30. DANTE GABRIEL ROSSETTI
Dantis Amor, 1860. Oil on
panel, 29½ x 31¾" (74.9 x
81.3 cm). The Tate Gallery,
London.

The story of Dante's
immortal love for Beatrice
was of central importance
for Rossetti. He presents it
here in a decorative
emblem reminiscent both
of medieval manuscript
painting and of Pugin's
decorative schemes. The
central figure of an angel,
symbolising love, holds a
sundial, which was
intended to mark the time
of Beatrice's death (though
it remains unfinished). In
death, Beatrice is united
with Christ, whose profile
in the sun balances the face
of Beatrice encased in the
crescent moon.

Rossetti entered into the spirit with *Dantis Amor*, symbolising the death of Beatrice and her ascent from earth to heaven, which was originally the centre panel of a large settle designed by Morris (FIG. 30).

Thanks to Morris's connections in Oxford, Rossetti gained a commission to paint murals from the *Morte d'Arthur* in the Debating Hall of Benjamin Woodward's new building for the Oxford Union Society (FIG. 31). Burne-Jones and Morris eagerly joined the group of assistants assembled by Rossetti, which also included the artists Arthur Hughes (1832– 1915), who was capable of painting richly coloured medieval subjects in a Rossettian vein, Valentine Cameron Prinsep (1838–1904) and John Roddam Spencer Stanhope (1829–1908). The project was mostly remembered for the fun and camaraderie of the group of noisy young artists, who disturbed the scholars working in the library next door. The results, according to the poet Coventry Patmore, originally glowed 'with a voluptuous radiance of variegated tints ... colouring so brilliant as to make the walls look like the margin of a highly-illuminated manuscript'. Unfortunately, the murals were executed with such technical incompetence that little of them remains, though after restoration in the 1980s something of the original effect can be discerned.

The crucial result of this second period in Oxford for Morris was that he met the woman who was to become his wife, Jane Burden. The daughter of an Oxford stableman, she was immediately recognised, in Rossetti's favourite term, as a 'stunner'. One of the few surviving examples of Morris's attempts at painting is *La Belle Iseult* (see FIG. 7), which seems to represent his idealised vision of Jane Burden seen in a highly ornamented medieval interior. Although Morris was already keen to break free from social conventions, the difficulties of a marriage at that time between a working-class woman and a prominent and wealthy middle-class man cannot be underestimated, and indeed the relationship seems from an early stage to have been fundamentally an unhappy one. Jane Morris later had a celebrated affair with Rossetti and her distinctive features can clearly be discerned in the many sketches and paintings he made of her.

31. Interior of the Library, formerly the Debating Hall, Oxford Union, Oxford.

Rossetti's mural, *Sir Lancelot's Vision of the Sanc Grael*, completed in 1857, is visible though in a ruinous condition. Rossetti was able to produce a design which accommodated the two hexafoil windows which pierce the wall. The central figure of Queen Guinevere, an Eve-like temptress, holds up the forbidden fruit to the sleeping Lancelot.

This was all in the future, however, when William and Jane Morris were married quietly in Oxford in 1859. Morris had bought a plot of land in the then rural setting of Bexleyheath in Kent, close to the route taken by Chaucer's pilgrims to Canterbury, on which he planned to build an ideal house. The Red House, designed by the architect Philip Webb, became the centre for a circle which included Burne-Jones, his wife Georgiana, Rossetti and his wife Elizabeth Siddall and Ford Madox Brown. As at Red Lion Square, Morris began to assemble the furnishings and decoration appropriate to a modern medieval residence, and naturally his close-knit group of friends entered into this: Burne-Jones, for example, painted murals in the drawing room. In a significant development, William and Jane Morris collaborated in experiments with textiles, slowly becoming expert embroiderers. The dining room at the Red House was to be decorated with a frieze of embroidered figures, each three feet (c. 1 m) high, depicting single female figures. Jane Morris described her *St Catherine* (FIG. 32) as one of 'our first rough attempts at this kind of work'; yet it was these first steps which led to the founding of Morris, Marshall, Faulkner & Co., known affectionately as 'the Firm', which went on to become a byword for decoration of high quality and good taste, in wallpapers, textiles, furniture and ce-

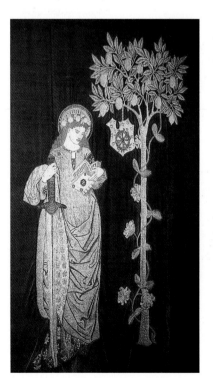

32. JANE MORRIS
St Catherine, 1860.
Embroidery for the Red House. Society of Antiquaries of London, Kelmscott Manor, Oxfordshire.

ramics, especially tiles. Rossetti, Madox Brown and above all Burne-Jones contributed designs, and 'the Firm' soon gained a reputation for stained glass, that most medieval of materials, whose revival had been pioneered by Pugin. The windows on the theme of *King René's Honeymoon* (FIGS 33 and 34) exemplify the collaboration of the circle: the designs (two by Burne-Jones and one each by Rossetti and Madox Brown) were originally made for a painted cabinet made by an associate of the Pre-Raphaelites, J. P. Seddon, shown at the Medieval Court of the International Exhibition held at South Kensington in 1862. Later, they were reworked as stained-glass windows and produced by Morris, Marshall, Faulkner & Co. in 1863. Rossetti's image of the King and his Queen kissing as she plays an organ distorts perspective and attenuates the bodies and expressions of its characters in a medievalising manner. As the century progressed, other influences permeated the productions of Morris & Co., including that of Japanese design, but the enterprise was essentially a homage to Romantic visions of the Middle Ages. Not only did Morris's early inter-

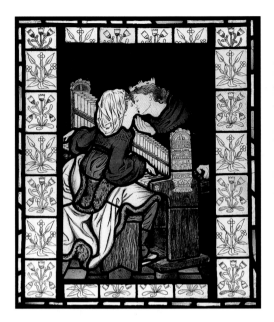

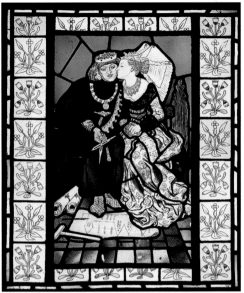

iors resemble those in Rossetti's watercolours (see FIG. 28) and his own painting *La Belle Iseult* (see FIG. 7), they were also made largely by hand rather than machine.

Pre-Raphaelitism to Socialism

It had been the influence of Ruskin's book *The Stones of Venice* (1851–3) which first focused Morris and Burne-Jones on the study of medieval art and architecture. Morris, in particular, also responded to the social critique which was so important a part of Ruskin's writings. In a passionate denunciation of industrial capitalism, Ruskin (in a book ostensibly discussing Venetian architecture) had made a direct assault on his readership:

> And now, reader, look round this English room of yours, about which you have been proud so often … Examine again all those accurate mouldings, and perfect polishings, and unerring adjustments of the seasoned wood and tempered steel … Alas! If read rightly, these perfectnesses are signs of a slavery in our England a thousand times more bitter and more degrading than that of the scourged African, or helot Greek.

Ruskin's powers of interpretation – of reading rightly – are applied to the products of modern industry, revealing the contrast between the life of the labourer under capitalism with that of the medieval sculptor:

Above left

33. After Dante Gabriel Rossetti
Music from *King René's Honeymoon*, 1863.
Stained-glass panel, 25 × 21½″ (63.7 × 54.3 cm).
Victoria and Albert Museum, London.

Above right

34. After Ford Madox Brown
Architecture from *King René's Honeymoon*, 1863.
Stained-glass panel, 25 × 21½″ (63.7 × 54.3 cm).
Victoria and Albert Museum, London.

And, on the other hand, go forth again to gaze upon the old cathedral front, where you have smiled so often at the fantastic ignorance of the old sculptors: examine once more those ugly goblins, and formless monsters, and stern statues, anatomiless and rigid: but do not mock them, for they are signs of the life and liberty of every workman who struck the stone.

Gothic art and architecture are revealed as the symbol of a pre-capitalist social structure and of creative freedom, a similar insight to that which Pugin had presented in *Contrasts*. Morris was profoundly influenced by this socialistic message in 'The Nature of Gothic', which he later described as 'one of the very few necessary and inevitable utterances of the century. To some of us when we first read it ... it seemed to point out a new road on which the world should travel.' As 'the Firm' grew and prospered, Morris was forced to compromise on the issue, as the imperative of financial survival overcame his initial, idealistic, ideas about industrial organisation. Despite, or perhaps because of, these practical constraints, Morris's ideological convictions led him in the 1880s to an active interest in revolutionary socialism. But even that vision, fuelled by his reading of Karl Marx and the work of the anarchist Kropotkin, was still grounded in a Romantic, Pre-Raphaelite medievalism. Comparison of the simple beauty of the medieval past with what he saw as the corrupt and polluted world of the present redoubled his revolutionary fervour. The medieval labourer, unlike his industrial counterpart, was able to express himself through craftwork, a freedom lost under capitalism and the division of labour.

Morris's later aesthetic and political beliefs are most vividly expressed through the poetry and literary work for which he was better known during his lifetime than for his work as a designer. These two aspects of a many-sided talent came together in the work of the Kelmscott Press, founded in 1891, through which Morris hoped to revolutionise the art of book design

35. EDWARD BURNE-JONES Illustration to Morris's *A Dream of John Ball*, Kelmscott Press, 1892. Wood engraving.

and production, once again with reference to the example of medieval illuminated manuscripts. The opening page of the Kelmscott 1892 edition of his socialist prose narrative *A Dream of John Ball* (1886–7) exemplifies the continuing collaboration of Morris, who designed the lettering and wrote the text, and Burne-Jones, whose illustration so perfectly complements it (FIG. 35). In *A Dream of John Ball* the modern narrator wakes to find himself in the Kent countryside at the time of the Peasants' Revolt of 1381. Morris describes the banner which the rebels carry, which is inscribed 'When Adam delved and Eve span/Who was then the gentleman?' By referring to the Middle Ages, Morris not only revisits an example of a working-class uprising but also challenges the Victorian stereotypes of gender – of the roles of men and women (discussed in Chapter Three). But his radical political view of the Middle Ages was always anchored in a vision of the beauty of everyday life at the time, in contrast to the ugliness of the present. It was this element of Morris's thought which always remained closest to Rossetti's Pre-Raphaelite medievalism. With its vivid picturing of colour and detail, the opening invocation of Morris's poem, *The Earthly Paradise* (1865–70), offers a perfect epitaph for Pre-Raphaelite revivalism:

FORGET six counties overhung with smoke,
Forget the snorting steam and piston stroke,
Forget the spreading of the hideous town;
Think rather of the pack-horse on the down,
And dream of London, small, and white, and clean,
The clear Thames bordered by its gardens green;
Think, that below bridge the green lapping waves
Smite some few keels that bear Levantine staves,
Cut from the yew wood on the burnt-up hill,
And pointed jars that Greek hands toiled to fill,
And treasured scanty spice from some far sea,
Florence gold cloth, and Ypres napery,
And cloth of Bruges, and hogsheads of Guienne;
While nigh the thronged wharf Geoffrey Chaucer's pen
Moves over bills of lading – mid such times
Shall dwell the hollow puppets of my rhymes.

TWO

Truth to Nature

36. JOHN BRETT
Val d'Aosta, 1858. Oil on
canvas, 34½ x 26¾" (87.6
x 68 cm). Private collection,
England.

Despite reservations about
the painting, Ruskin
purchased it for £200.
Other critics noted its
photographic qualities, and
one dismissed it as 'truly an
epitaphical gravestone for
Post-Ruskinism'.

P re-Raphaelitism appeared at a time of profound change
in the relationship between mankind and nature. Census
figures in 1851 revealed that, for the first time, the major-
ity of the population of England and Wales lived in towns and
cities. The industrialisation, urban growth and pollution which so
horrified William Morris were long-established historical factors,
but all were increasing at a dramatic pace. Towards the end of
his life, Ruskin could write of the 'storm cloud of the nine-
teenth century', a 'dense manufacturing mist' casting a gloomy
shadow which was both actual and symbolic. Ruskin's love of
nature, and horror at its destruction, like the medievalism he shared
with the Pre-Raphaelites, was deeply rooted in the Romantic
movement. Profoundly influenced by the nature poetry of William
Wordsworth and the painting of J. M. W. Turner (1775–1851),
Ruskin himself produced some of the finest prose descriptions
of nature in the English language. While many influential figures
in Victorian society proudly viewed increasing industrialisation
and prosperity as evidence of national progress, Ruskin was deeply
sceptical, arguing instead that the destruction of the natural envi-
ronment and the social problems of the modern city were too
heavy a price to pay for economic development. If we are to under-
stand the Pre-Raphaelite creed of truth to nature, it is with the
complex and polymathic figure of John Ruskin that we must begin.

Born in 1819, Ruskin was the only son of a prosperous Scot-
tish sherry importer. His solitary childhood in the suburbs of south
London, movingly described in his autobiography, *Praeterita*
(1885–9), was marked by an idiosyncratic private education rooted
in a deep study of the King James Bible. Its Jacobean rhythms and
cadences, as well as its religious teachings, echo through Ruskin's
prose. Like many children of wealthy parents in the Victorian era,
Ruskin was taught drawing from an early age, learning the con-
ventions of sketching from various teachers including the dis-

37. JOHN RUSKIN
Iris Fiorentina, 1871.
Watercolour, 11 x 7" (28 x
17.5 cm). Ashmolean
Museum, Oxford.

Ruskin's work as a critic
was based on his powers of
observation, which are
evident in his many
detailed watercolour
studies of plant forms,
landscape and architecture.

tinguished watercolourist Anthony Vandyke Copley Fielding (1787–1855). In 1884 he recalled a moment of revelation when he realised that he must reject the traditional language of art which he had been taught and revert to a child-like innocence:

> In the spring of [1841] … I made, by mere accident, my first drawings of leafage in natural growth – a few ivy leaves round a stump in the hedge of the Norwood road … I never (in my drawings, however much my writings) imitated anybody any more after that one sketch was made; but entered at once on the course of study which enabled me to understand Pre-Raphaelitism.

In a crucial development for the Pre-Raphaelites, Ruskin's early publications popularised the idea that inherited traditions of visual representation should be displaced by careful, direct drawing from the motif. 'The first vital principle [of drawing]', he wrote, 'is that man is intended to *observe* with his eyes, and mind.'

At the heart of all Ruskin's work lies a conviction that insight can best be gained through the intense observation and description of nature. This is evident in both his prose writings and the drawings and watercolours which he made throughout his life. Many of his exquisite and minutely executed drawings such as *Iris Fiorentina* (FIG. 37) record natural forms with a scientific accuracy and yet a delicacy which speaks of a profound reverence for nature seen as God's work. Ruskin was as interested in geology, botany and meteorology as he was in poetry and theology, and these interests found expression in his writings on landscape painting. He believed that the artist must understand the structure and biology of a tree in order to be able to represent it correctly, and wrote an illustrated instruction manual, *The Elements of Drawing* (1857), explaining this theory to the layman. Yet to be interested in science was not in any way to reject a more emotive, even mystical approach to landscape. Ruskin was also deeply theistic in his approach to nature, seeing it as the visible handiwork of God. He belonged to a pre-Darwinian era when it seemed possible to unite biblical narrative with scientific observation: 'Botany', he once remarked, 'is surely a clerical science.' His works are consistent in their assertion that close observation, looking and seeing, was the key to an understanding which was religious as well as merely scientific: to observe nature was, as he wrote, to 'follow the finger of God'.

Ruskin and Turner

The idea of seeing, in Ruskin's thought, goes far deeper than mere observation and notation. It was his conviction that an intense scrutiny, especially of nature, could reveal higher truths: indeed, he believed that all truth could be apprehended visually. Naturally, then, the artist occupied a privileged place in his view of the world. But for Ruskin, real insight lay in the combination of the observed and the visionary: he believed that the understanding of natural phenomena should be linked with an imaginative response. He found this ideal expressed in the landscape paintings of Turner. Ruskin's obsessive interest in Turner's works began as an undergraduate at Oxford in the late 1830s. Enraged by the widespread belief that Turner was mad and his late works were untrue to nature, the young Ruskin began work on a pamphlet defending the painter against his critics. He also encouraged his father to become a patron of Turner. After a first meeting in 1840, Turner and Ruskin developed a curious friendship in which the increasingly eccentric and anti-social artist scarcely more than tolerated his precocious but naive disciple. Ruskin described his project thus:

> For many years we have heard nothing with respect to the works of Turner, but accusations as to their want of truth. To every observation on their power, sublimity, or beauty, there has been but one reply: they are not like nature. I therefore took my opponents on their own ground, and demonstrated, by thorough investigation of the actual facts, that Turner is like nature, and paints more of nature than any man that lived.

The full complexity of Ruskin's readings of Turner can be seen in his discussion of the watercolour *Bolton Abbey* (FIG. 38), which Ruskin himself possessed. Ruskin began by acknowledging that Turner had exaggerated the scale of the Yorkshire hills. This exaggeration would seem to pose a problem for Ruskin in his quest to demonstrate Turner's truth to nature. Ruskin begins his defence with a passage of detailed description:

> The Abbey is placed ... on a little promontory of level park land, enclosed by one of the sweeps of the Wharfe. On the other side of the river, the flank of the dale rises in a pretty wooded brow, which the river, leaning against, has cut into two or three somewhat bold masses of rock, steep to the water's edge, but feathered above with copse of ash and oak.

38. J. M. W. TURNER
Bolton Abbey, c. 1825.
Watercolour 11 x 15½" (28
x 39.4 cm). Lady Lever Art
Gallery, Port Sunlight,
Merseyside.

This watercolour was made
by Turner to be engraved in
*Picturesque Views in
England and Wales,* which
appeared in 1827. Ruskin
possessed the work and
described it many times; in
old age he kept it in his
bedroom at Brantwood,
Cumbria.

However, despite the small physical scale of the features of the
landscape, Ruskin avers, 'the scene does affect the imagination
strongly': 'Noble moorlands extend above, purple with heath, and
broken into scars and glen; around every soft tuft of wood, and
gentle extent of meadow, throughout the dale, there floats a
feeling of this mountain power, and an instinctive appreciation of
the strength and greatness of this wild northern land.' It is 'the
association of this power and border sternness with the sweet peace
and tender decay of Bolton Priory', rather than the physical land-
scape, which mark it out as special. To Ruskin, Turner's water-
colour suggests 'all this association of various awe, and noble
mingling of mountain strength with religious fear'.

At this point, however, Ruskin reverts to his underlying
task of demonstrating that Turner was, after all, painting 'more
of nature than any man that lived'. Looking at the right foreground
of the drawing, Ruskin claimed that 'the waves of the Wharfe are
studied with a care which renders this drawing unique among
Turner's works, for its expression of the eddies of a slow moun-
tain stream and of their pausing in treacherous depth beneath
the hollowed rocks.' The cliffs, or scree, seen across the river,
are the particular focus of Ruskin's attention. He himself made an

engraving of this section of Turner's watercolour (FIG. 39), and provides a detailed geological analysis of the subject based on correspondence with the geologist Professor John Phillips. Comparing Turner's drawing of the rocks – which he names as Yoredale shales – with the geologist's description, noting such features as 'long straight joints dividing the rock into rhomboidal prisms', Ruskin is able triumphantly to demonstrate Turner's incomparable truth to nature. The point is reiterated in a long section on the inferior painting of rocks in the work of earlier artists, from medieval manuscript painters to Claude Lorraine (1600–82). There is no mistaking Ruskin's iconoclasm in attacking Claude, who was widely considered (notably by Turner himself) to be the greatest of all landscape painters and was strongly represented in the National Gallery in London.

While Turner was clearly capable of the most minutely detailed observation and representation, Ruskin did not suggest that, especially in his later works, Turner had made mere literal transcriptions of nature. Rather, for Ruskin, Turner had passed through a stage of realistic representation into the visionary sphere of the imagination. A lifetime of observation of natural phenomena furnished Turner's imagination with necessary raw material and skills. Ruskin remarked: 'I call the representation of facts the first end; because it is necessary to the other and must be attained before it. It is the foundation of all art; like real foundations, it may be little thought of when a brilliant fabric is raised on it, but it must be there.' He himself criticised some of the artists of the 1850s who read these words and attempted to follow his advice. The critic later argued, perhaps unfairly, that young artists paid too much attention to the element of scientific analysis and geological and botanical precision, and less to the sensitivity to poetic association and the profound emotional response to landscape which is so central to Turner's art.

Ruskin came to believe that, in order to achieve widespread recognition of Turner's true status, a body of theory was required to argue the claims of landscape painting to the status of high art. The book which began as a pamphlet defending Turner, *Modern Painters*, turned into a seventeen-year, five-volume project which mobilised scientific and religious arguments in pursuit of an aesthetics of landscape. The importance of *Modern Painters* as a contribution to the theory of art cannot be underestimated. In Britain, at least, there had been few attempts at serious revision in this area since Sir Joshua Reynolds's *Discourses*, delivered as lectures between 1769 and 1790 and widely read in published form.

39. John Ruskin after J. M. W. Turner *The Shores of the Wharfe,* from *Modern Painters* IV, *Of Mountain Beauty,* 1856. Engraved from Ruskin's drawing by T. Lupton.

Ruskin's careful copy of the right-hand portion of Turner's watercolour played an important role in his attempt to demonstrate Turner's truth to nature.

Reynolds had firmly established in Britain the Renaissance hierarchy of genres in which history painting was the most prestigious art, while portraiture and landscape were relegated to inferior status. Ruskin turned all this on its head: his attack at the level of theory was one element which made the Pre-Raphaelite rebellion possible at the level of practice.

Modern Painters *and Pre-Raphaelite Painting*

The first volume of *Modern Painters* appeared in 1843 and won for its young author immediate renown. Charlotte Brontë wrote: 'this book seems to give me eyes'. Most compelling was the exhortation in the conclusion, addressed specifically to young artists. There was, Ruskin avowed, no point in trying to reach Turner's position of 'mastery' by imitating him, or by following Claude or Rembrandt:

> They have no business to ape the execution of masters ... their duty is neither to choose, nor compose, nor imagine, nor experimentalize, but to be humble and earnest in following the steps of nature, and tracing the finger of God ... [They should] go to nature in all singleness of heart, and walk with her laboriously and trustingly, having no other thoughts but how best to penetrate her meaning, and remembering her instruction; rejecting nothing, selecting nothing and scorning nothing ... and rejoicing always in the truth.

This passage was surely crucial in inspiring the young Millais and Holman Hunt to renounce the traditional Reynoldsian, old masterish technique and style which they had been taught at the Royal Academy Schools, and to work directly from the motif, painting in a vivid style based on close observation.

The Pre-Raphaelites practised Ruskinian naturalism before they encountered the critic in person. It was Holman Hunt who read *Modern Painters I* first, and absorbed it most fully. He later recalled: 'Of all its readers none could have felt more strongly than myself that it was written expressly for him. When it had gone, the echo of its words stayed with me, and they gained further value and meaning whenever my more solemn feelings were touched.' A Ruskinian influence can be detected in the extreme fidelity to nature in the foreground of Hunt's *Valentine rescuing Sylvia from Proteus* (see FIG. 27), with every leaf meticulously and individually characterised. Naturally, Ruskin was impressed by these passages, noting such minuscule details as the damaged fungus and

grasses in the right foreground, through which Hunt indicated that a struggle had taken place. But it was another work with a seemingly historical subject, *Convent Thoughts* (FIG. 40) by Charles Allston Collins (1828–73), which particularly caught Ruskin's eye at the Royal Academy in 1851. Ruskin distanced himself from the potential Roman Catholic religious connotations of an image of a nun, but in his letter to *The Times* he questioned the paper's critic, who had claimed that the Pre-Raphaelites 'sacrifice *truth* as well as feeling to eccentricity'. Ruskin's response was characteristically idiosyncratic:

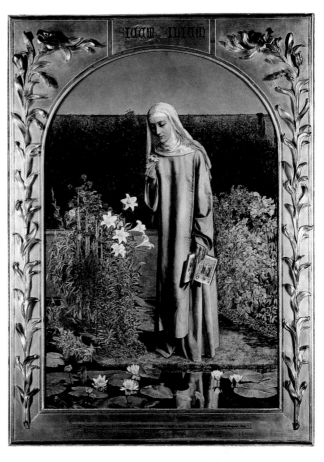

> I happen to have a special acquaintance with the water plant Alisma Plantago ... and ... I never saw it so thoroughly or so well drawn. ... For as a mere botanical study of the water lily and Alisma, as well as of the common lily and several other garden flowers, this picture would be invaluable to me, and I heartily wish it were mine.

Through this intervention, and whenever else he could, Ruskin aimed to promote the realist aspects of Pre-Raphaelitism at the expense of the historicist component. A sharp, hard-edged realism, rather than the distortions and abstractions of the early, medievalising works, became the dominant component of Pre-Raphaelitism for the next few years.

Following the publication of this letter, Millais made contact with Ruskin, who soon became acquainted with all the Pre-Raphaelite circle. Later that summer, their resolve redoubled by meeting the critic, Millais and Holman Hunt began painting from nature in Ewell, Surrey. The resulting works were not, however, landscapes. Millais chose a subject from Shakespeare based on the description in Act iv of *Hamlet* of the death of Ophelia. The passage is rich in natural imagery:

40. CHARLES ALLSTON COLLINS *Convent Thoughts*, 1850–1. Oil on canvas, 32½ x 22¾" (82.6 x 57.8 cm). Ashmolean Museum, Oxford.

Collins's work is a particularly vivid example of the combination of historicism and realism. The nun, an unchanging figure who could belong to the Middle Ages or to the present day, carries a brightly coloured illuminated manuscript. The natural details of the garden in which she stands are transcribed with brilliant fidelity.

41. JOHN EVERETT MILLAIS
Ophelia, 1851–2. Oil on
canvas, 30 x 44" (76.2 x
111.8 cm). The Tate
Gallery, London.

The pale body of Ophelia,
laid out like a corpse, but
still singing her songs of
madness, contrasts with the
richness and fecundity of
nature surrounding her. The
claustrophobic composition
and lack of direct sunshine
underscore the work's
tragic message.

There is a willow grows aslant a brook,
That shows his hoar leaves in the glassy stream;
There with fantastic garlands did she come
Of crow-flowers, nettles, daisies and long purples …

Ophelia (FIG. 41), Millais's evocation of one of the most poignant
moments in Shakespeare's tragedy, contains myriad identifiable
species of plants. Not only are the flowers in Ophelia's garland
true to Shakespeare's text; other plants appear which, for the Vic-
torian public, carried a specific symbolic association. The fritil-
lary, floating in the bottom right-hand corner, stood for sorrow;
a poppy, by Ophelia's right hand, for death; the name of the
forget-me-nots is self-explanatory. Millais painted the scene

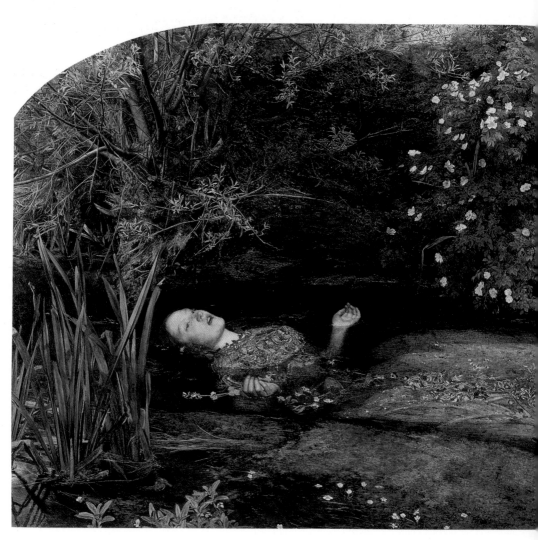

42. WILLIAM HOLMAN HUNT *Our English Coasts*, 1852. Oil on canvas, 17 x 23" (43.2 x 58.4 cm). The Tate Gallery, London.

Hunt meticulously chronicles the low evening sun across the fields and the precise effect of clouds shadowed on the sea. The bright sunlight shining through the thin flesh of the sheep's ears has been faithfully recorded: not even these tiny blood vessels escape the artist's attention.

with obsessive accuracy on the banks of the Hogsmill River in Ewell, adding the figure, drawn from Elizabeth Siddall, in the studio later.

Hunt, meanwhile, was painting in the nearby Ewell meadows, where he painstakingly completed the landscape sections of his major work, *The Hireling Shepherd* (see FIG. 3). The breakthrough here was Hunt's rejection of the careful balancing of areas of light and shade (*chiaroscuro*) which landscape painters from Claude to John Constable (1776–1837) had employed to provide an underlying, artificial, structure for their landscape compositions. Like Madox Brown in *The Seeds and Fruits of English Poetry* (see FIG. 16), Hunt attempted to paint the entire canvas as it would appear in nature, lit by the sun, with shadows falling naturally. This was, as Stephens put it, 'an entirely new thing in art'.

The much smaller painting, *Our English Coasts, 1852* (FIG. 42), painted by Hunt at Fairlight, near Hastings, is ostensibly a pure landscape characterised by a fanatical detailing of optical effects. Hunt's extraordinary daring lay in his decision to abandon all artistic conventions and to replicate instead every colour he actually saw in nature, using the full range of modern pigments available to him. He insisted on painting every detail – leaf, butterfly, rock – in isolation, with its own particular colour ('local colour') irrespective of the overall effect. The result is richly chromatic, even garish. However, as with *The Hireling Shepherd*, pure realism is not enough: there is also a symbolic dimension. Are we looking at the Christian flock, unguided and becoming tangled among

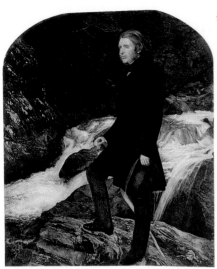

43. JOHN EVERETT MILLAIS
John Ruskin, 1854. Oil on
canvas, 31 x 26¾" (78.7 x
68 cm). Private collection.

Millais's portrait of Ruskin is
effectively a painted
manifesto for the critic's
ideas. 'Millais has chosen
his place,' wrote Ruskin, 'a
lovely piece of worn rock,
with foaming water, and
weeds, and moss, and a
noble overhanging bank of
dark crag – and I am to be
standing looking quietly
down the stream – just the
sort of thing I used to do for
hours together.' As the
landscape painstakingly
emerged, Ruskin became
ever more enthusiastic: 'the
lichens are coming out
upon the purple rocks like
silver chasing on a purple
robe and the water – which
I was nervous about is quite
perfect – truly such as was
never painted before.'

the brambles? Or is Hunt's title, as Stephens suggested in 1852, 'a satire on the defenceless state of the country against foreign invasion' in the light of the new and potentially hostile regime of Napoleon III in France? Hunt seems to have shifted from a political to a religious reading of the work himself, diplomatically changing the title to *Strayed Sheep* when the painting was exhibited, with great success, at the Exposition Universelle in Paris in 1855.

Despite Hunt's rigid adherence to Ruskinian precepts, it was Millais whom Ruskin adopted as a protégé. He saw Millais, with his effortless virtuosity and swift assimilation of advice and influence, as a potential successor to Turner whose death in December 1851 coincided with Ruskin's recognition of Millais's talents. Ruskin was critical of the Pre-Raphaelites' fondness for what he considered the nondescript landscape of Surrey (a county he described as a 'rascally wirefenced garden-rolled-nursery-maid's paradise'). He preferred the sublime or picturesque scenery of more traditional sketching grounds, such as the Highlands of Scotland, the Lake District, or the Alps, and suggested that he should accompany Millais on a trip to Switzerland. However, it was not until 1853 that the critic was able to turn the young painter's attention to subject matter that he considered more worthy. This Ruskin achieved by commissioning Millais to paint his portrait at Brig o'Turk, at the mouth of Glenfinlas in Scotland, with a landscape background (FIG. 43). While Millais worked, Ruskin himself began a drawing which he described in geological terminology as *Gneiss Rock, Glenfinlas* (FIG. 44). Ruskin's study of the rock exposes its geological structure and (to the expert eye) its historical origins, as surely as does Millais's. Indeed, the setting is of far greater importance in Millais's than in earlier portraits. He inverts the Reynoldsian convention whereby portraits were set in a sketchy, indistinct landscape. The rock outcrop in the Ruskin portrait is studied with as much care as the face and hands of the critic, its ostensible subject. Another Glenfinlas sketch by Millais (FIG. 45), less finished but superbly atmospheric, incorporates at its margin the figure of a woman sewing. She was Euphemia Gray, Ruskin's wife since 1848, with whom Millais fell desperately in love at Glenfinlas. This event, which has overshadowed the entire Ruskin historiography, led to the annulment of the marriage in 1854. In the summer of 1855, Effie was married to Millais and Ruskin's position as mentor to the young artist became untenable.

44. JOHN RUSKIN
Gneiss Rock, Glenfinlas, 1853. Pen, wash and bodycolour, 18¾ x 12¾" (47.6 x 32.2 cm). Ashmolean Museum, Oxford.

Paintings of rocks, Ruskin argued, should document not only the present condition but also the geological past, and contain a hint of their eventual destruction at the day of judgement – all of which he had found in Turner's *Bolton Abbey*.

45. JOHN EVERETT MILLAIS
A Waterfall in Glenfinlas, 1853. Oil on panel, 10½ x 12½" (26.7 x 31.8 cm). Delaware Art Museum, Wilmington.

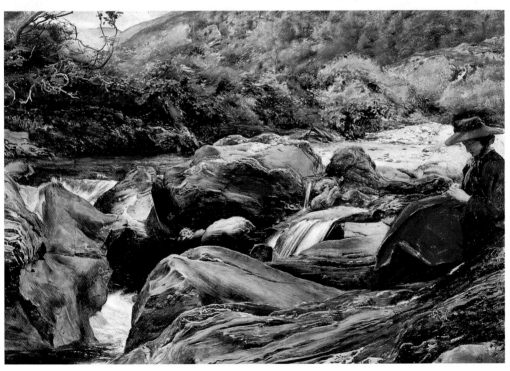

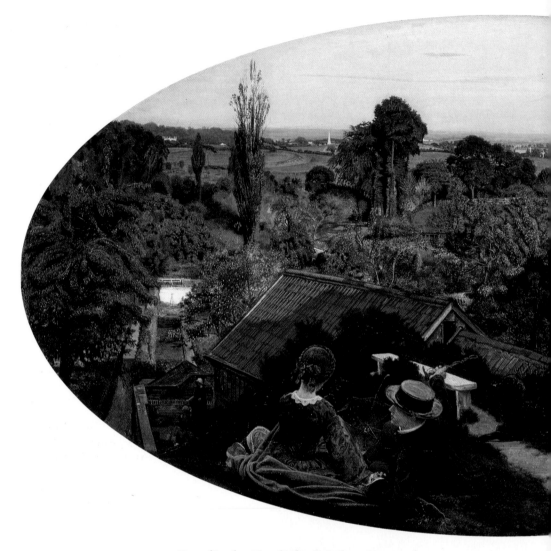

Peculiarly English: Madox Brown's View from the Suburbs

The Pre-Raphaelite landscape finds its most complete and satisfactory realisation in the work of an artist whose entire training and early career had been devoted to figurative and historical painting, and who, strangely, was personally antagonistic to Ruskin – Ford Madox Brown. Brown showed relatively little interest in landscape until the 1850s, when he produced a series of views which abandon picturesque and sublime subject matter. Such scenery – abbeys, castles and rivers, mountains and waterfalls – had been the staple of landscape painting since the eighteenth century, and Ruskin continued to promote it in *Modern Painters* as the

46. FORD MADOX BROWN
*An English Autumn
Afternoon, Hampstead –
Scenery in 1853*, 1852–4.
Oil on canvas, 28¼ x 53"
(71.7 x 134.6 cm).
Birmingham Museum and
Art Gallery.

This supremely evocative
London landscape was
painted directly from
nature. The artist later wrote
of it that 'It is a literal
transcript of the scenery
around London, as looked
at from Hampstead. The
smoke of London is seen
rising half way above the
fantastic shaped, small
distant cumuli, which
accompany particularly fine
weather. The upper portion
of the sky would be blue as
seen reflected in the youth's
hat: the grey mist of autumn
only rising a certain height.
The time is 3 PM, when late
in October the shadows
already lie long, and the
sun's rays (coming from
behind us in this work) are
preternaturally glowing, as
in rivalry of the foliage.'

proper object of the artist's attention. Brown painted nondescript
stretches of landscape often found within walking distance of
his home in north London, at Hendon, Finchley and Hamp-
stead. He celebrated the quiet beauty of the urban hinterland in
one of the consummate achievements of nineteenth-century paint-
ing, *An English Autumn Afternoon* (FIG. 46), begun in a period
of extraordinary creative energy in 1852. The painting was intended
as an experiment in seeing, its oval shape drawing attention to the
optical process, perhaps even alluding to the shape of the eye. But
Brown moves far beyond a wish to comprehend optical effects,
Ruskin's project for young artists. The landscape is not merely
one of botanical, climatic and topographical facts: it is a social land-
scape, full of human life, and replete with personal associations

for Brown. The view is from the first floor back window of a house in which Brown lodged in Hampstead High Street, and looks north-east towards the neighbouring suburb of Highgate, where Emma Hill, the working-class woman he had secretly married, was domiciled. Although the whole canvas seems to have been painted directly from the motif, with no intervening sketches or studies, the foreground must have been executed in a separate location and the linkage to the middle ground is not altogether convincing. The foreground passages are, however, essential to the meaning of the painting. Two figures are enjoying the suburban idyll: it is through their eyes that we perceive the scene, catch the chill in the autumn air, and smell the damp earth and a hint of the smoke from a distant bonfire. Brown rejects a sentimental narrative – these are 'hardly lovers, more…neighbours and friends', he tells us – but plays on the memories and sensibilities of his viewers, drawing on their recollections of autumn afternoons, walks in the country, or merely of youth itself, which contrasts with the autumnal season.

Within the couple's field of vision is a great deal of other human activity: the haze over London to the right indicates the mass of humanity, hard at work, while small figures dotted across the gardens and allotments in the foreground perform their regular tasks: a woman feeds hens to the left; a group is picking apples in the centre. This sense of the image comprehending a whole society indicates that the suburb is the meeting of country and city, of past and present, of tradition and modernity.

Hampstead Heath had been portrayed many times, notably by Constable. But *An English Autumn Afternoon* differs from its predecessors in being radically anti-picturesque. It refuses all the compositional devices which artists such as Constable and Turner had used to maintain order and structure. Constable, for example, while claiming to be a 'natural painter' nonetheless organised nature according to inherited conventions, with the vertical emphasis of *repoussoir* trees at one side of the composition framing a central vista with a low horizon. Madox Brown creates the illusion of depth by carefully distinguishing range after range of foliage receding into the distance. The image was altogether too radical for Ruskin. A much-quoted passage in Brown's ill-spelled diary from 13 July 1855, describing a tea party at Rossetti's house, reveals the level of personal animosity between the two. Brown found Ruskin talking

divers nonsense about art, hurriedly in shrill flippant tones –
I answer him civilly – then resume my coat & prepare to leave.

Suddenly upon this he sais 'Mr Brown will you tell me why you chose such a very ugly subject for your last picture [*An English Autumn Afternoon*] … it was a pitty for there was some *nice* painting in it'. I … being satisfied that he meant impertinence, replied contemptuously 'Because it lay out of a back window' & turning on my heel took my hat & wished Gabriel goodbuy.

This mutual antagonism cost Brown dear: Ruskin rarely mentioned his work in reviews and encouraged patrons instead to support Rossetti and Millais. *An English Autumn Afternoon* encapsulated the modern experience of the suburban landscape precisely because its subject was mundane and appeared out of a back window. It was, perhaps, the uncompromising modernity of Brown's image, surely so close to Ruskin's own experiences as a child growing up in the suburbs of south London, which disconcerted the critic.

Brown never painted another landscape of such scale or ambition. But the agricultural hinterland of London provided subjects for small landscape paintings which encapsulate even more vividly the combination of heightened verisimilitude with an imaginative response to nature. On 21 July 1855, a week after his altercation with Ruskin, Brown went on a nocturnal walk with his wife and one of their daughters: 'What wonderful effects I have seen this evening in the hay fields, the warmth of the uncut grass, the greeny greyness of the unmade hay in furrows or tufts, with lovely violet shadows & long shades of the trees thrown athwart all & melting away one tint into another impercept- ible, & one moment more & cloud passes & all magic is gone.' *The Hayfield* (FIG. 47) emblematises the artist as the observer of the nat- ural world. Like the farmer (just visible on horseback at the left margin) and his labourers, an artist has spent a hard day at work in the field. Clutching his palette, with stool, um- brella and paintbox around him, the artist fulfils the same function as the

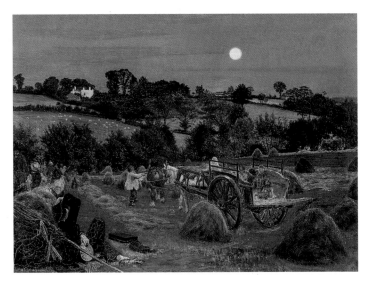

47. FORD MADOX BROWN *The Hayfield*, 1855–6. Oil on panel, 9½ x 13″ (24 x 33.2 cm). The Tate Gallery, London.

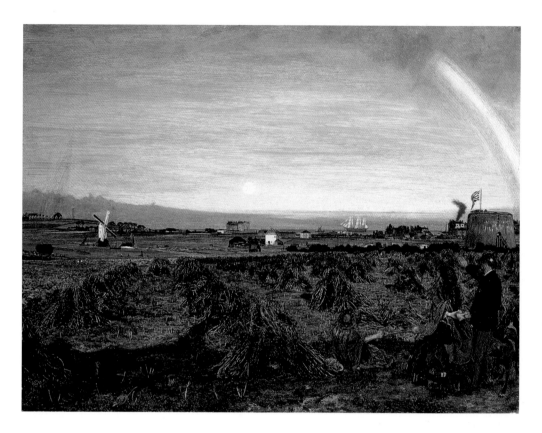

48. FORD MADOX BROWN
Walton-on-the-Naze,
1859–60. Oil on canvas,
12½x 16½″ (31.7 x 42 cm).
Birmingham Museum and
Art Gallery.

The painting is the most
extreme of Brown's anti-
picturesque statements: the
natural landscape is
compromised by
modernity: agriculture,
shipping and building have
colonised every inch of the
terrain. Groups of angular
modern buildings, probably
hotels and boarding houses,
jarring to picturesque taste,
are seen on the horizon.

young couple in *An English Autumn Afternoon*; through him
we appreciate the beauty of the glowing colours of dusk, the risen
moon illuminating the hayfields at the end of an exhausting day's
labour.

Yet there was a paradox implicit in the attempt to paint
such scenes: their very momentary and fugitive nature made
Pre-Raphaelite techniques of notation impossible. Only the rapid
sketching of immediate impressions, practised to perfection by
Turner in watercolour and Constable in oil sketches, could cap-
ture such fleeting effects. From the late 1860s, the French Impres-
sionists were to take up this challenge, adopting a looser and swifter
technique than the Pre-Raphaelites in an attempt to capture fugi-
tive effects of light. Madox Brown mused on this problem, exclaim-
ing 'How despairing it is to view the loveliness of nature towards
sunset & know the impossibility of imitating it, at least in a sat-
isfactory manner as one could do would it only remain long
enough ...' Despite the paradox of their slow and laboured pro-
duction, however, Brown's hard-won images of the suburban
landscape maintain a spontaneity and intensity which has rarely
been equalled.

Madox Brown represented himself strolling with wife and daughter, in the luminescent *Walton-on-the-Naze* (FIG. 48). Affectionately holding the hand of his wife, the *paterfamilias* expounds the beauties of the scene. Through Brown's intervention as interpreter, the urban hinterland is transformed into a place of limitless visual delight and intellectual fascination. Walton-on-the-Naze, a small seaside town in Essex, once a favourite resort of the gentry, was easily accessible by steamer from London. Madox Brown and his family were typical of the respectable but not wealthy holidaymakers who might have been found there in the 1850s, in search of sea air and coastal scenery.

The work stands apart from the history of landscape painting: a flat horizon exactly bisects the canvas in contravention of established convention. Even the passing allusions to pastoral traditions which linger in *The Hayfield* have all but vanished (although a minuscule harvest wagon can be discerned to the extreme left). The landscape is, instead, a catalogue of individual objects and features – windmill, rainbow, ship, figures, corn stooks, fieldmouse, union flag – each seen in perfect focus and with its own local colour. Yet *Walton-on-the-Naze* is also a meditation on national identity, another aspect of the Englishness which Brown had poignantly captured in the evening light over Hampstead in *An English Autumn Afternoon*. Here there are more obvious symbols of English history: the Naze Tower beacon of 1720, a lighthouse warning the merchant marine away from the shore, can be seen to the left, catching the pink of the sunset; a Martello tower, built in 1810–12 for the defence of England against Napoleonic invasion, appears to the right of the composition, evidently still in use and surmounted by the British flag. A tiny dot of red paint suggests the uniform of a soldier staffing the garrison. There is, too, an imaginative, even mystic, dimension to the image: as the art historian Allen Staley remarks, the old-fashioned wooden ship on the horizon, glowing in the dusk, and the rainbow and moon enhance the dream quality of the painting, recalling the work of the German Romantic landscapist Caspar David Friedrich (1774–1840).

Young Ruskinians: Brett and Inchbold

If Brown's suburban naturalism departed from Ruskin's project for landscape, many younger artists, inspired by reading *Modern Painters*, were keen to follow its precepts to the letter. Among them was the Yorkshireman John William Inchbold (1830–98), son of the proprietor of the *Leeds Intelligencer*, who was sent to

49. JOHN WILLIAM
INCHBOLD
The Chapel, Bolton, 1853.
Oil on canvas, 20 x 27" (50
x 68.4 cm). Northampton
Museum and Art Gallery.

The painting exemplifies
the Pre-Raphaelite
landscape: painted on the
spot, it is precise in its
rendering of detail, from the
flowers in the foreground
(each species clearly
identifiable) to the blocks of
ancient masonry of the
ruined cloister in the
foreground. The
composition is bold and
unconventional, with the
dominant architectural
element receding from left
to right, and the distant
view closed off by trees.

London in the late 1840s to learn the techniques of lithography.
He also studied watercolour with the established topographical
artist Louis Haghe, but the exact circumstances of his conver-
sion to a Pre-Raphaelite style, already evident in *The Chapel, Bolton*
of 1853 (FIG. 49), are not known. The radicalism of Inchbold's treat-
ment becomes clear when it is compared with a more conventional
landscape, *Bolton Abbey – Morning* (FIG. 50), by Richard Redgrave.
Much admired by Queen Victoria, Redgrave's painting, more nat-
uralistic than many in approach, is allusive rather than precisely
descriptive: the artist has privileged an overall colour scheme
and atmospheric effect above the delineation of individual objects
and their local colour.

Bolton Abbey, by the 1850s a favourite destination for day-
trippers from the city of Leeds fifteen miles away, had a rich
history of associations with Romantic literature and art. Artists
such as Thomas Girtin (1775–1802), David Cox (1783–1859) and
Edwin Landseer (see FIG. 11) had painted the Abbey, and we
have already discussed Ruskin's account of Turner's water-
colour of the same subject in *Modern Painters* IV (1856). As Ruskin
acknowledged, the area was notable not only for its natural beauty

but also through its association with Wordsworth's poem 'The White Doe of Rylstone' (1815). While carrying out a programme of Pre-Raphaelite realism, Inchbold aimed also to emulate this Romantic heritage. In the Royal Academy catalogue he quoted Wordsworth's lines, 'Nature softening and concealing/And busy with a hand of healing'. Ivy, lichen and weeds were gradually encroaching on the semi-ruined priory, offering the painter varied materials for close natural observation. For Stephens, Inchbold's painting was, like Wordsworth's poetry, 'grave and beautiful … a masterpiece of sentiment, with intense realism'. Ruskin had inscribed a quotation from Wordsworth on the title page of *Modern Painters*, and described him as one of the 'thoroughly great men … who, in a word, have never despised anything, however small, of God's making'. It was Wordsworth's intense observation of natural detail, as well as his poetic response to nature, which Inchbold hoped to emulate in paint. Despite the haunting quality of his work, Inchbold, shy and brusque by nature, alienated patrons and artists alike and met with little success during his later career as landscape painter and poet. Both Ruskin and Millais, however, recognised in him a considerable talent.

Volume IV of Ruskin's *Modern Painters* is subtitled 'Of Mountain Beauty'. It contains magnificent prose passages evoking the mysterious grandeur of Alpine scenery. Ruskin had tried and failed to persuade Millais to accompany him to Switzerland, and Inchbold emerged as his new protégé. Possibly on Ruskin's invitation, Inchbold travelled to the Alps soon after the book appeared. Certainly, he was Ruskin's guest later that year at Lauterbrunnen, which commands fine views of the Jungfrau. The resulting painting, *Jungfrau, from the Wengern Alps,* is lost, but we have a record of its impact on John Brett, another young devotee of Ruskin who met Inchbold in Switzerland in 1856. Brett was

50. RICHARD REDGRAVE *Bolton Abbey, Morning,* 1847. Oil on canvas, 12½ x 30½" (31.7 x 77.5 cm). Victoria and Albert Museum, London.

Although Redgrave's painting shows close observation of nature, it cannot match the radical realism of Inchbold's treatment of the same subject from a different angle.

the son of an army officer, who entered the Royal Academy Schools in 1854. As early as 1853 he had written 'I am going on fast towards Preraphaelitism – Millais and Hunt are fine fellows.' So impressed was Brett by Inchbold's painting of the Jungfrau that he resolved to abandon the traditional disciplines of his education and (following Ruskin's advice to young painters) 'thenceforward attempted in a reasonable way to paint all I could see.'

Brett's first exhibited painting, *The Glacier of Rosenlaui* (FIG. 51), is unusual in being dated with day and month as well as year – 23 August 1856, an annotation which implies scientific precision in documenting natural phenomena. It is, like Millais's portrait of Ruskin, and even more like Ruskin's study of the gneiss rock, a study of foreground alone, so radically does it depart from compositional norms. Cold, clinical and geological, it is a fascinating, but also rather menacing, study. However meticulous the foreground study, with each pebble clearly delineated and seen with its own local pallor, Brett meets an intractable problem in his attempt to convey space and distance. The tiny detail of distant fir trees in the upper left of the painting creates an uncomfortable ambivalence of scale, and the attempt at a 'sublime' effect of an Alpine storm in the distance is not wholly convincing.

51. JOHN BRETT
The Glacier of Rosenlaui, 1856. Oil on canvas, 17½ x 16½" (44.5 x 41.9 cm). The Tate Gallery, London.

In Brett's next important work, *The Stonebreaker* (FIG. 52), an idyllic sunlit Surrey landscape contrasts with the labour of a pauper boy breaking flints in the foreground. Although the painting would seem, like Hunt and Millais's work from Ewell, to exemplify Ruskinian fidelity to nature, Ruskin predictably insisted that Brett should abandon 'Surrey downs and railway-traversed vales'. This remark typifies both the critic's preference for the sublimities of Alpine landscape to the more mundane scenery of the Home Counties, and his attention to minute detail. Visible in the landscape of *The Stonebreaker,* though only to

the most careful observer, is the outline of a distant railway cutting; it intersects with the boy's head just above his left ear. Ruskin proposed instead that Brett should paint the chestnut groves of the Val d'Aosta above Turin. With Ruskin's encouragement, Brett did indeed travel to the Italian Alpine valley and produced *Val d'Aosta* (see FIG. 36), one of the most single-minded and fastidious achievements of Victorian landscape painting. Here Brett offers a solution to the disparities of scale and effect which had marred *The Glacier of Rosenlaui*. His topographical precision and sharp focus dispense with the need for aerial perspective: the viewer follows the painting into the distance, almost as one might trace a footpath on a map. On seeing the finished work, Ruskin exclaimed:

> Yes, here we have it at last ... historical landscape, properly so called, landscape painting with a meaning and a use. We have had hitherto plenty of industry, precision quite unlimited – but all useless, or nearly so, being wasted in scenes of no majesty or enduring interest. Here is, at last, a scene worth painting – painted with all our might (not quite with all our heart perhaps, but with might of hand and eye).

52. JOHN BRETT
The Stonebreaker, 1857–8.
Oil on canvas, 19¾ x 26¾″
(50 x 68 cm). Walker Art
Gallery, Liverpool.

After a long description of the painting, noting the precision of every detail down to the leaves of the poplar tree, Ruskin admitted:

> A notable picture, truly ... Yet not ... a noble picture. It has a strange fault, considering the school to which it belongs – it seems to me wholly emotionless. I cannot find from it that the painter loved, or feared, anything in all that wonderful piece of the world ... I never saw the mirror so held up to Nature – but it is Mirror's work, not Man's.

In his zeal to fulfil Ruskin's invocation to young painters to paint accurately, Brett had misjudged the Romantic, nature-worshipping urge which underpinned Ruskin's thought. In perfecting what Ruskin had recommended for young artists, he had failed to appreciate that, like Turner, the really great landscapist must also be an imaginative, transformative genius.

A number of artists outside the London-based Pre-Raphaelite circle gradually began to adopt a Ruskinian view of landscape painting, and attempted to emulate the intense, vividly coloured works of Holman Hunt, Madox Brown, Brett and Inchbold, some of which were widely exhibited. The Liverpool artist Daniel Alexander Williamson (1823–1903) spent the period from 1847 to 1860 in London, though he does not seem to have met the Pre-Raphaelites. Only after he moved in 1861 to a small village in Lancashire (now Cumbria) at the southern extreme of the Lake District did his work begin to demonstrate a sympathy for Pre-Raphaelitism. *Coniston Old Man from Warton Crag* (FIG. 53) carries the principle of local colour to the limits, though the effect is hallucinatory and over-intense, as if expressing some inner psychological crisis, rather than merely attempting to match in paint a referent in the outside world. In Williamson's *Coniston*, a rabbit, frozen in the right foreground, possibly recalls the inquisitive fieldmouse of *Walton-on-the-Naze*, but the artist is not interested, as Brown was, in the minute delineation of objects. In a move which anticipates the dominant trend of later Victorian painting, he prefers the evocation of nature through the creation of a decorative, polychromatic surface, to the policy of recording the chaotic juxtaposition of things which characterised Pre-Raphaelitism's most radical period.

Another artist to attempt the application of the Pre-Raphaelite landscape idiom to new subjects was Thomas Charles Farrer (1839–91). A British expatriate artist in New York, Farrer was at the centre of a group calling itself The Association for the

53. DANIEL ALEXANDER
WILLIAMSON
*Coniston Old Man from
Warton Crag*, 1863. Oil on
canvas, 10¾ x 16″ (27 x
40.6 cm). Walker Art
Gallery, Liverpool.

The distant hill capped with
angry clouds, the Old Man of
Coniston, casts a dark
shadow over Brantwood, the
house where John Ruskin
was to spend his last years,
suffering for much of the time
from severe mental illness.

Advancement of Truth in Art, which in 1863 began to produce
a journal, *The New Path*, self-consciously Ruskinian in its sym-
pathies. The critic Clarence Cook announced in the first issue that
'The Future of Art in America is not without hope.' American
artists 'are nearly all young men; they are not hampered by too
many traditions, and they enjoy the almost inestimable advantage
of having no past, no masters and no schools.' Ruskin's theo-
ries and Pre-Raphaelite painting were becoming increasingly well-
known in America in the late 1850s and early 1860s. *Modern Painters*
was 'just out then and in every landscape painter's hand', accord-
ing to the landscape painter Thomas Worthington Whittredge
(1820–1910), and leading literary and artistic journals, such as *The
Crayon*, reprinted extracts from Ruskin's work. In 1857–8 an exhi-
bition of English painting toured American cities, including such

important Pre-Raphaelite works as Holman Hunt's *Light of the World*, Brett's *The Glacier at Rosenlaui*, and Brown's *An English Autumn Afternoon*.

 Farrer was a genuine product of the Pre-Raphaelite movement, having been trained at the Working Men's College in Red Lion Square, where Madox Brown, Ruskin and Rossetti were all among the teaching staff. An enthusiast for Ruskin's methods of teaching, Farrer pioneered their introduction to the USA as art instructor at the Cooper Union in New York City from 1861 to 1865. In addition to some interesting figure studies, Farrer produced a number of landscapes which attempted to capture the vastness of the American landscape with the same intensity that the Pre-Raphaelites had recorded London's hinterlands. An earlier generation of artists, including Thomas Cole (1801–48), had employed the visual vocabulary of the Turnerian sublime to explore, often in massive canvases, the overwhelming magnitude of the new continent. Farrer, however, concentrated on deserted stillness in *Mount Tom* (FIG. 54). Painted during the summer of 1865 near Northampton, Massachusetts, the work envisions America as a paradise: the leisured figure of an angler in the foreground and signs of cultivation on the far shore of the lake are the only indications of human presence. The critic of the *New York Times* found the Pre-Raphaelite influence too pervasive: 'the

leaves of the near trees stand hard and black against the sky, as if cut out of sheet iron'. Yet Farrer's vision is relatively soft-grained, allowing the distant forests to appear as a delicate filigree rather than a collection of individually specified trees.

Time, Mood and Nostalgia: Victorian Landscape after Pre-Raphaelitism

The impact of Pre-Raphaelitism's analytical gaze and its enamelled surfaces can be discerned in William Dyce's *Pegwell Bay: A Recollection of October 5th, 1858* (FIG. 55), among the most powerful of all Victorian images of landscape. Dyce, whose Westminster frescoes set an important precedent for Pre-Raphaelitism, was in turn influenced by the achievements of the younger artists. Like Madox Brown's subject at Walton-on-the-Naze, Pegwell Bay in Kent was easily accessible from London for a middle-class family holiday. The bracing sea air provided a healthy contrast with the smog and pollution of Victorian London. *Pegwell Bay* can be seen, superficially, as a memento of a holiday taken by the artist, who lived in Streatham in south London. A figure carrying an artist's portfolio, to the right, perhaps represents Dyce himself. In the foreground we see his son, his wife and her two sisters collecting fossils and shells on an autumn evening, with the chalk cliffs rising behind them. Through the meticulous representation of an everyday scene, Dyce raises profound issues. As the art historian Marcia Pointon has indicated, the painting meditates on the question of time. In addition to the timescale of human life indicated in the foreground, and the unusual insistence on a particular date in the work's title, geological time is evident in the strata of the chalk cliffs. The search for fossils, too, a favourite Victorian pastime, hinted at a distant, prehistoric era. Scientific evidence presented a profound challenge to a literal reading of the Bible, which claimed that creation had occurred only a matter of thousands of years ago. Dyce was painting at around the time of publication of Charles Darwin's *Origin of Species* in 1859, when this issue lay at the heart of a bitter controversy. Darwin's theory of evolution implicitly challenged a literal understanding of the biblical account of creation, and in so doing destabilised one of the central beliefs of Western culture. In the pale dusk sky can be discerned the tail of Donati's comet, whose appearance in 1858 had caused extensive comment in the press. Although this could be read as an echo of the star which guided kings and shepherds to the infant Christ at Bethlehem, it seems more likely that the painting hints at human frailty in the context of a

55. WILLIAM DYCE
Pegwell Bay: A Recollection of
October 5th, 1858,
?1858–60. Oil on canvas,
25 x 35″ (63.5 x 88.9 cm).
The Tate Gallery, London.

vast universe and a hugely expanded framework of historical time.

In *Pegwell Bay* Dyce employs the hard-edged realism typical of Pre-Raphaelite landscapes of the 1850s, delineating every detail of the scene with an unerring precision. However, when the painting was exhibited at the Royal Academy in 1860, some viewers considered the pale, muted colours, and a certain flattening of the image, to be reminiscent of the new technology of photography, which had been developing since 1839. Among Dyce's friends was David Octavius Hill (1802–70), the pioneer photographer, and the artist was certainly aware of the latest developments in the medium. Dyce, nonetheless, seems to have based the painting on watercolour studies made on the spot. There are, however, hints of the camera's indiscriminate capturing of its subject in the poses of the figures. While these allusions to photography underscore the painting's modernity, its evocation of mood and its underlying philosophical grandeur single it out as one of the supreme imaginative achievements of Victorian art. As such it accords with Ruskin's claim that 'historical landscape painting' could rise above mere topographical representation to explore the profoundest themes.

The corpus of Pre-Raphaelite landscape paintings is relatively small but the impact of Ruskin's writings, and of those who followed him, affected British landscape painting for the rest of the nineteenth century. Landscape had by this time become the dominant genre of British art, and the walls of the many exhibitions were crowded with images of the countryside. Many of them, like *Harvest Time: Painted on Holmbury Hill, Surrey* (FIG. 56) by George Vicat Cole (1833–93), bore the imprint of Pre-Raphaelite realism. It is particularly evident in the meticulous rendering of the ears of corn in the foreground. The Society for the Encouragement of the Fine Arts and Manufactures awarded the artist a silver medal for the work, citing its 'truth to nature, breadth of handling, and general harmonious colouring'. The phrase 'breadth of handling', suggesting

quite the opposite of the particularised intensity of Madox Brown, Brett or Dyce, indicates how superficially Pre-Raphaelitism had affected an artist who became a highly successful Academician in the late Victorian period. Cole chose to depict an idyllic rural world untouched by the processes of industrialisation and urbanisation. Unlike the more challenging Pre-Raphaelite landscapes, *Harvest Time* eschews any hint of modernity, of social flux or economic change, despite being painted on the spot. Surrey displayed what an agricultural writer in 1851 described as 'a state of rural management as completely neglected as [anyone] is likely to meet in the remotest parts of the island'. In the absence of new, highly capitalised, methods of farming, Surrey seemed a reassuring idyll standing outside time. This kind of landscape provided a nostalgic evocation of 'Englishness' which became increasingly popular in the late nineteenth century.

Partly as a response to this rise in popularity, Millais himself returned in 1870 to landscape painting. *Chill October* (FIG. 57) was the first of several large, broadly painted landscapes which appealed as poetic evocations of mood. Lacking the hallucinatory intensity and detail of the works of the early 1850s, these later landscapes, usually devoid of human interest or association, offer an elegiac portrayal of nature. Millais wrote that he 'chose the subject for the sentiment it always conveyed to my mind'. His melancholy, autumnal vision of a backwater of the River Tay in Scotland, seen in overcast weather, is organised as a series of decorative planes,

56. GEORGE VICAT COLE *Harvest Time: Painted on Holmbury Hill, Surrey,* 1860. Oil on canvas, 37¾ x 59¾" (95.9 x 151.7 cm). Bristol City Art Gallery.

Painted from a specially erected hut on Holmsbury Hill in Surrey, *Harvest Time* made the artist's reputation. Although not acquainted with members of the Brotherhood, Cole is typical of a generation of young painters who adopted something of the precision and foreground detail of the Pre-Raphaelites.

receding from the gossamer veil of grasses in the foreground, through silvery water and dark foliage to the distant blue mountains: truth to the details of nature has been sacrificed to overall aesthetic effect. Even here, however, modern technology was an unavoidable presence at the site: Millais was standing only yards from a busy railway line when he sketched *Chill October*. But modernity is disavowed in this image. Melancholy withdrawal into a mythical, deserted wilderness has replaced the urgent exploration of humanity's interaction with nature, and the interpenetration of city and country, which characterised the finest Pre-Raphaelite landscapes of the 1850s.

57. JOHN EVERETT MILLAIS *Chill October*, 1870. Oil on canvas, 4'7½" x 6'1½" (1.41 x 1.87 m). Private Collection, England.

THREE

Modern Life

P aintings of modern life in the Victorian city constitute the most radical achievement of the Pre-Raphaelite Brotherhood and their associates. Even before Ruskin penned his defence of Pre-Raphaelitism in 1851, praising its preference for 'stern facts' over 'fair pictures', the Brotherhood's journal *The Germ* had published an article demanding that artists should paint subjects from everyday life. This text, by the sculptor John Lucas Tupper, can serve as a manifesto for almost every work discussed in this chapter:

> If, as every poet, every painter, every sculptor will acknowledge, his best and most original ideas are derived from his own time: if his great lessonings to piety, truth, charity, love, honour, honesty, gallantry, generosity, courage, are derived from the same source; why transfer them to distant periods, and make them *not things of to-day*? Why teach us to revere saints of old, and not our own family-worshippers? Why to admire the lance-armed knight and not the patience-armed hero of misfortune? Why to draw a sword we do not wear to aid an oppressed damsel, and not a purse which we do wear to rescue an erring one? … And why teach us to hate a Nero or an Appius, and not an underselling oppressor of workmen and betrayer of women and children?

In looking at the paintings which took up Tupper's challenge, I draw on a body of recent scholarship, mainly produced by feminist art historians, that interprets images as actively political and ideological statements, which had a genuine impact on society when they were exhibited. These paintings engage with the major debates of their period, about the role of men and women in society, about class and labour, about emigration, and prostitution. As such they can only be understood in the context of

58. William Holman Hunt *The Children's Holiday*, 1864. Oil on canvas, 6'¼" x 4'9½" (2.14 x 1.47 m). Torbay Borough on permanent loan to Torre Abbey, Torquay.

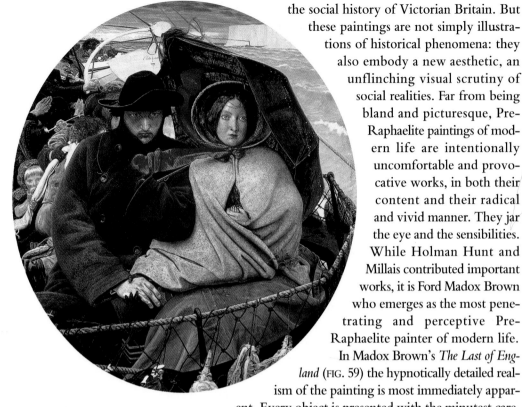

the social history of Victorian Britain. But these paintings are not simply illustrations of historical phenomena: they also embody a new aesthetic, an unflinching visual scrutiny of social realities. Far from being bland and picturesque, Pre-Raphaelite paintings of modern life are intentionally uncomfortable and provocative works, in both their content and their radical and vivid manner. They jar the eye and the sensibilities. While Holman Hunt and Millais contributed important works, it is Ford Madox Brown who emerges as the most penetrating and perceptive Pre-Raphaelite painter of modern life. In Madox Brown's *The Last of England* (FIG. 59) the hypnotically detailed realism of the painting is most immediately apparent. Every object is presented with the minutest care, from the cabbages in the foreground, to the drips of water on the umbrella, each individually documented. It seems as if every stitch in the woman's checked shawl is visible and her scarf has been laboriously imitated, capturing not only its colour and texture but an exact effect of wind and light.

59. FORD MADOX BROWN, *The Last of England*, 1852–5. Oil on oval panel, 32½ x 29½" (82.5 x 75 cm). Birmingham Museum and Art Gallery.

Madox Brown's procedures in making the painting were every bit as rigorous as its final appearance implies: he noted that in order 'to insure the peculiar look of *light all round* which objects have on a dull day at sea, it was painted for the most part in the open air on dull days, and when the flesh was being painted, on cold days'.

The immediate stimulus for the work was the departure of Thomas Woolner, the sculptor among the Pre-Raphaelite Brothers, for the gold-fields of Australia, who had given up his artistic career in desperation. While the painting reflects on emigration as a major historical and demographic trend, it also had personal resonances for Madox Brown. Woolner's reason for leaving England was his failure to gain commissions as an artist: at the time he began *The Last of England*, Madox Brown himself was 'most of the time intensely miserable, very hard up, & a little mad'. In a telling phrase, Brown described himself as a 'regular Haydon at pawning', a reference to the destitution and eventual suicide of Benjamin Robert Haydon (1786–1846), one of the few British artists to attempt to make a living from large-scale historical paintings. Haydon's cartoons, like Madox Brown's and Woolner's, had been rejected in the competition for frescoes to

redecorate the Palace of Westminster. At this time equally unsuccessful in his career, Brown could sympathise with Woolner's despair, and spoke of emigration to India himself. As it turned out, Brown laboured on *The Last of England* for so long – three years – that by the time of its completion Woolner was back in England, his dreams of colonial prosperity shattered. Perhaps it is for this reason that in the final version, Brown replaced the text 'White Horse Line of Australia' which appears on the lifeboat just above the emigrant's head in earlier studies, with the name 'Eldorado', the mythical lost city of gold. Woolner and his wife were, of course, not available for the lengthy period of sitting as models which Madox Brown's obsessive realism demanded; rather, underlining the personal significance of the image, Madox Brown drew the main figures from himself and his wife Emma. The image of the talented artist forced to leave his homeland through the indifference of the public and critics encapsulates the sense of angry rebellion and alienation from society which was an important aspect of artistic identity in the nineteenth century. This underlying motif identifies *The Last of England* as a Romantic as well as a realist work.

The fact that the emigrant/artist is not seen alone, but with his wife, also has a personal significance. Emma Hill had modelled for Madox Brown from 1849, when she was working as a domestic servant, and he continued a secret relationship with her which issued in an illegitimate child, Catherine, born in 1850. When Brown met her, Emma was an illiterate countrywoman, but, although he seems to have been attracted to her precisely because she did not conform to Victorian conventions of respectable femininity, it was only after her education at a school for young ladies in Highgate that Madox Brown was prepared to acknowledge her publicly. Personal histories often indicate wider historical issues: this chapter moves on to discuss the questions of class, gender and work which were so troubling to Madox Brown in 1852.

Modern Life and Genre

Paintings such as *The Last of England* are dedicated to serious themes of a type rarely explored by earlier painters of genre. This term was applied to scenes from everyday life, which occupied a lowly place in the traditional artistic hierarchy, above landscape but beneath portraiture and history painting. Even when issues of class and social standing were explored, it was often in a lighthearted or celebratory vein. William Collins's *Rustic Civility* (FIG. 60) is typical: the narrative is clear enough, with a barefoot peasant boy

60. WILLIAM COLLINS
Rustic Civility, 1833. Oil on
panel, 18 x 24″ (45.6 x 61
cm). Victoria and Albert
Museum, London.

doffing his forelock to a passing
landowner, whose top-hatted
shadow can be seen in the fore-
ground. The painting is set in a
more or less arcadian version of
the English countryside; the boy's
poverty is picturesque rather
than shocking; the brushwork is
allusive rather than documentary.
The effect of the painting is
warmly comical and reassuring
to the patron: in the countryside
of old England the rich are still
treated with proper respect by
their social inferiors. Implicit
in this claim is the idea that in the modern city, deference may not
be such a powerful force. A large version of this image was indeed
purchased by the Duke of Devonshire for the great aristocratic
collection at Chatsworth, while the purchaser of the smaller replica
(illustrated here) was John Sheepshanks, the middle-class son of a
Leeds textile manufacturer. Such genre scenes, with their vision
of an unchanging rural world, could appeal to any patron with
a vested interest in maintaining the status quo.

Madox Brown's *The Last of England*, far more ambitious in
scope and composition, belongs to a different category, as he insisted
in his catalogue: 'The picture is in the strictest sense historical.
It treats of the great emigration movement which attained its
culminating point in 1852.' He documents a historical event,
the campaign to persuade the excess population of Britain, and
especially skilled members of the middle class, to move to the
under-populated imperial territories. Appropriately for such an
important theme, Brown claims a place in the hierarchies of art
more elevated than that of genre. The grouping of the figures into
an oval shape has overtones of the tondo forms of the Renaissance,
which often portrayed the Holy Family or the Virgin and Child.
This reference to an elevated precedent in the history of art
indicates that Brown believed that modern subjects were import-
ant enough to justify the title of history paintings, acknowledged
since the Renaissance as the most elevated category of art. The
painting's large size, too, indicates its superior status.

The most significant predecessors of the modern-life sub-
jects of Victorian Britain were the 'modern moral subjects' of
William Hogarth (1697–1764), and it is not surprising that the critic
of the *Athenaeum* detected in *The Last of England* a 'Hogarth

fertility of thought'. In works such as the satirical series 'Marriage-a-la-Mode' (FIG. 61) Hogarth had produced images of modern life which were both based on the study of nature and dense with symbolic references. Brown made a pilgrimage to Hogarth's house in Chiswick and his tomb, which he was horrified to find overgrown with weeds. In 1858, the Pre-Raphaelites and a number of their associates founded the Hogarth Club, an independent exhibiting society, intended, in Hunt's words, 'to do homage to the stalwart founder of modern British art'.

61. WILLIAM HOGARTH
After the Marriage,
'Marriage-a-la-Mode' No. 2,
1743. Oil on canvas, 27½ x
35¾″ (69.9 x 90.8 cm).
National Gallery, London.

As in Pre-Raphaelite modern life painting, Hogarth presents complex narrative clues which add up to provide a broad, social critique. Here the dissipated and unfaithful couple are recovering from separate entertainments on the previous evening: the wife's card party is indicated by the disorder in the adjoining room; the rakish husband's infidelity and brawling by the presence of his mistress's underwear in his pocket (examined by the dog) and the broken sword. A further satirical element is the addition of a pious and hypocritical Methodist steward leaving with the unpaid bills.

As so often in Hogarth's works, Brown in *The Last of England* offers a complex and satirical view of the whole of society. Among the emigrants in the margins of the picture, we confront a group of very different types – indeed, their elaboration threatens to unravel into a chaos of hands and heads. Closest to the main figures is what Brown calls 'an honest family of the greengrocer kind', representatives of the lower middle class, patriots who nevertheless have chosen to seek their fortune in the dominions. The mother clings protectively to her young son, whose tousled hair is painted with extraordinary fidelity. 'All the red headed boys in Finchley came here today' noted Brown in his diary for 14 March 1855, as he strove to find the perfect model even for this subsidiary character. Behind them, a grotesque, caricatured figure is seen shaking his fist at the White Cliffs of Dover in the distance. Madox Brown described him as a 'reprobate [who] … curses at the land of his birth as though that were answerable for *his* want of success'. This man's failure in the sphere of work is, as we can tell from his physiognomy, the result of drink, and consequently he does not deserve our sympathy. His old mother 'reproves him for his foul-mouthed profanity' while his drinking partner, 'got up in nautical togs for the voyage, signifies drunken approbation'.

Separate Spheres

These subsidiary figures form a comic sideshow which contrasts with the melancholy central grouping in *The Last of England*. Brown's catalogue entry argues that:

The educated are bound to their country by quite other ties than the illiterate man, whose chief concern is food and physical comfort. I have, therefore, in order to present the parting scene in its fullest, tragic development, singled out a couple from the middle classes, high enough, through education and refinement to appreciate all they are now giving up, and yet depressed enough in means, to have to put up with the discomforts and humiliations incident to a vessel 'all one class'.

Class and respectability are clearly the keynote of the image, and man, woman and child (whose tiny fingers can be seen emerging from the mother's shawl) form a kind of tragic holy family grouping. The family was the central unit of Victorian society, and social norms laid down very specific and separate roles for the husband and wife. Ruskin in his book *Sesame and Lilies* (1865) sketched out these stereotypical, complementary roles of man and woman:

> The man's power is active, progressive, defensive. He is eminently the doer, the creator, the discoverer and defender. His intellect is for speculation and invention, his energy for adventure, for war and for conquest, wherever war is just, wherever conquest necessary. But the woman's power is for rule, not for battle – and her intellect is not for invention or creation, but for sweet ordering, arrangement, and decision.

In *The Last of England* the mother resembles the Virgin Mary, her bonnet suggesting a halo and her gaze turned heavenward, even if it is more melancholy than rapturous. The ideal Victorian middle-class wife was expected to maintain the double role of motherhood and a child-like chastity. Madox Brown's catalogue entry continues: 'The husband broods over blighted hopes and severance from all he has been striving for. The young wife's grief is of a less cankerous sort, probably confined to the sorrow of parting with a few friends of early years. The circle of her love moves with her.'

These, then, are the separate spheres which define middle-class men and women articulated by Madox Brown: masculine interests lie in the outside world of work, of serious thought and aspiration, while the woman's role is confined to the family circle and the home. Her duties, according to this dominant stereotype, are neatly summarised in the titles of three paintings exhibited in 1863 by George Elgar Hicks (1824–1914), under the general title 'Woman's Mission' – *Guide to Childhood*, *Companion of Manhood* and *Comfort of Old Age*. Each aspect of the woman's duties,

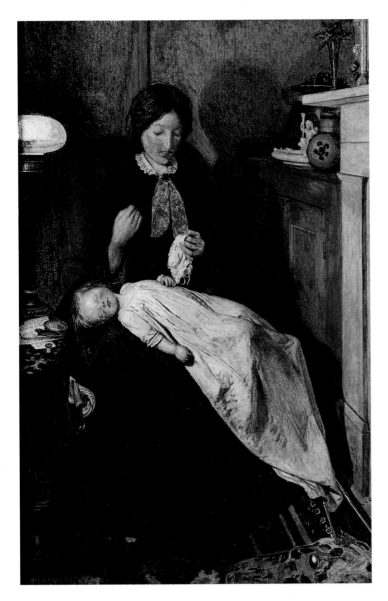

62. FORD MADOX BROWN
Waiting: An English Fireside of 1854–5, 1855. Oil on oak panel, 12 x 7¾" (30.5 x 20 cm). Walker Art Gallery, Liverpool.

Madox Brown's representation of the domestic idyll with mother and child in a cosy, fireside setting, is completed by a reference to the father, an officer away in the Crimea – the portrait miniature on top of a pile of his letters to the left. The workbag at her feet testifies to her domestic virtue, while the clutter on the cupboard by the fireplace includes a 'Bride's Inkstand', one of 'Felix Summerly's Manufactures' made by the Victorian design reformer Henry Cole. Although the painting refers to the traditional iconography of the Madonna and Child, any risk of sentimentality is dispelled by the cadaverous position of the infant, and the alarmingly blood-like effect of the fire on her white robe. It is possible that anxieties about child mortality, a common tragedy in the period, entered even this most reassuring of domestic images.

according to this stereotypical account, took place in the home and was defined by a submissive relationship to a male family member: son, husband, father.

Madox Brown meditated on this theme of the middle-class woman's role in a small painting, made from studies of his wife Emma and their baby Catherine, which was his first modern life subject, begun in 1851 (FIG. 62). Here Brown explores the effect of lamplight to create the cosy atmosphere of home, suggested also by the bric-a-brac on the mantelpiece and the fireside setting. The subject was modified in 1854 when he changed the title to

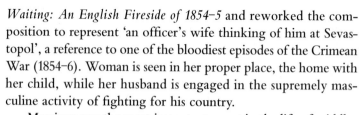

Waiting: An English Fireside of 1854–5 and reworked the composition to represent 'an officer's wife thinking of him at Sevastopol', a reference to one of the bloodiest episodes of the Crimean War (1854–6). Woman is seen in her proper place, the home with her child, while her husband is engaged in the supremely masculine activity of fighting for his country.

Marriage was the most important event in the life of middle-class women in Victorian Britain, a transition from virginity to motherhood, from girl to woman. Millais's *The Bridesmaid* (FIG. 63) captures the anxiety of this moment. A young woman is acting out the folk tale that if a bridesmaid passes a piece of the wedding cake through the ring nine times, she will have a vision of her future lover or husband. While the orange blossom pinned to her chest is a symbol of chastity, the woman is contemplating with fear and fascination future sexual consummation. This is hinted at by the phallic shape of the sugar caster on the table before her, disrupting the work's symmetrical composition, a symbol (though presumably not a conscious one on Millais's part) of the man whom she is hoping to visualise. This same studio prop appears on the shrine table in Millais's *Mariana* (see FIG. 25), in which sexual fulfilment is denied. The bridesmaid's flowing hair suggests a private location, perhaps indicating that her meal is being taken alone in a bedroom. The expression of self-examination, as if in a mirror, captures the intensity of adolescent experience.

Victorian women not attaining the state of matrimony were considered either unfortunate or eccentric; indeed, in 1862 the manufacturer W. R. Greg argued that women 'who remain unmarried constitute the problem to be solved, the evil and anomaly to be cured.' Yet the supposed ideal state, with a husband supporting an unworking wife, was not easy to attain: it relied on a steady male income. *The Long Engagement* (FIG. 64) by Arthur Hughes, an early follower

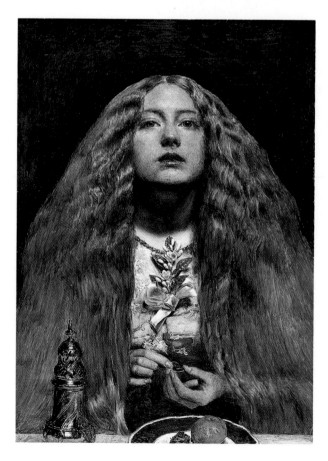

63. JOHN EVERETT MILLAIS *The Bridesmaid*, 1851. Oil on panel, 11 x 8″ (27.9 x 20.3 cm.) Fitzwilliam Museum, Cambridge.

Visually striking despite its small scale, *The Bridesmaid* is constructed from blocks of intense colour arranged across its enamelled surface.

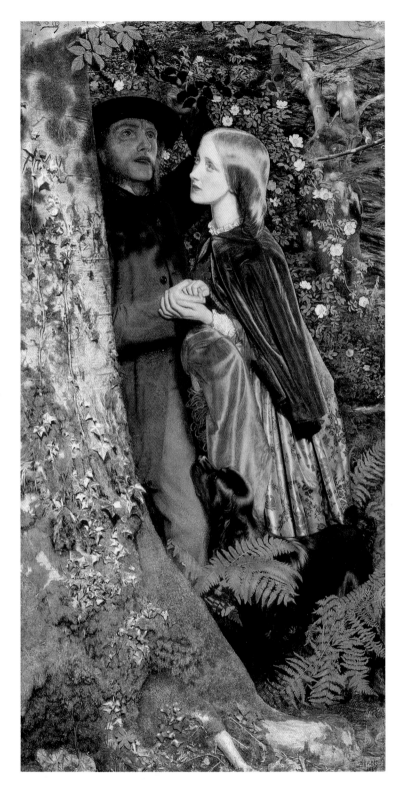

64. ARTHUR HUGHES
The Long Engagement,
1854–9. Oil on canvas,
41½ x 20½" (105.4 x
52.1 cm). Birmingham
Museum and Art Gallery.

Visual evidence of the
length of the couple's
engagement can be found
in the image: her name –
Amy – carved by her poor
curate fiancé in the bark
of the tree, is now grown
over with ivy. Ivy itself
functions as a symbol of
the female role, clinging
and decorative, while the
mature tree, symbol of
strength and power, is
associated with stoic,
manly virtues.

of the Pre-Raphaelites, began life as a Shakespearean subject, 'Orlando in the Forest of Arden'. Painted laboriously from nature – Hughes wrote 'a great bee exasperated me to a pitch of madness' – the landscape was successful, but the artist modified his subject to draw attention to a Victorian social problem. Here a curate, the junior and notoriously poorly paid rank of cleric in the Church of England, stares despairingly into the heavens, waiting for an appropriate living to come vacant. Meanwhile, his fiancée waits patiently, unable to assume the 'natural' role of wife and mother, while nature indulges in a spectacular display of fecundity all around.

The Fallen Woman

Idealised images of middle-class women, chaste but maternal, submissive but supportive, have their dialectical opposite in the stereotype of the prostitute, the unmarried woman whose un-natural lusts lead to the destruction of families and the spread-ing of disease. It was not the men who frequented prostitutes who stood condemned by society; rather, by a widely accepted double standard, it was the prostitute herself who was held responsible. Although we routinely think of the Victorian era as one in which discussion of matters of sex and sexuality was strictly circumscribed, even forbidden, historians have recently pointed out that there was obsessive concern with this subject in medical, legal, moral and religious writing. Likewise, a cluster of images in Victorian visual culture, including several highly significant Pre-Raphaelite works, represent fallen women and their patrons, or prostitutes and their clients. The most challenging is Holman Hunt's *The Awakening Conscience* (FIG. 65), which, like *The Last of England*, is at once elaborately symbolic and obsessively realistic, and requires a detailed reading. A kept woman is seen with her lover in the interior of a garishly furnished apartment. Hunt actually rented a room in a 'maison de convenance' in order to ensure the cor-rectness of every detail. His heightened visual awareness, and obses-sive documentation of the scene parallels that of the Victorian anthropologist (or 'ethnologist') in a distant country, fascinated and horrified by what he sees. We see the fallen woman at the moment when, inspired by the sunshine through the trees in front of her (and reflected in the mirror) she realises the errors of her ways: her conscience is awakening. A wealth of visual clues provides a commentary on the characters. For example, the song on the piano, *Oft in the Stilly Night*, might also have been a cause of her revelation:

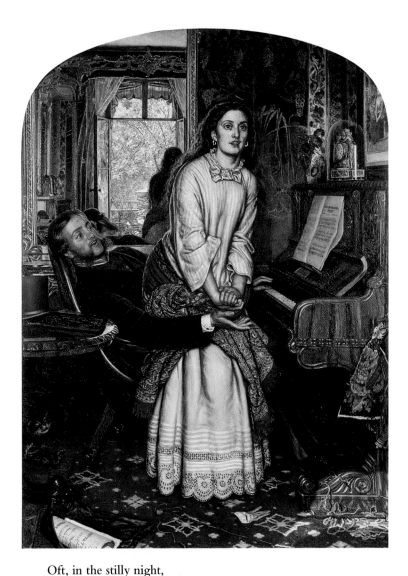

65. William Holman
Hunt
*The Awakening
Conscience*, 1853–4.
Oil on canvas, 30 x 22″
(76.2 x 55.9 cm). The
Tate Gallery, London.

Oft, in the stilly night,
Ere slumber's chain has bound me,
Fond Memory brings the light
Of other days around me;
The smiles, the tears,
Of boyhood's years,
The words of love then spoken
The eyes that shone,
Now dimm'd and gone,
The Cheerful hearts now broken!
Thus, in the stilly night,
Ere slumber's chain has bound me,
Sad memory brings the light
Of other days around me.

Recollections of a happier and purer past contrast with her present situation, caught like the wounded bird attempting to escape from the predatory cat under the table.

The painting was bought by the Manchester textile manufacturer Thomas Fairbairn, a significant patron of the Pre-Raphaelites who emerged as a leader of the employers in a bitter industrial dispute with the Amalgamated Society of Engineers, a powerful early trade union, in 1852. Fairbairn bought other paintings from Holman Hunt, including *Valentine Rescuing Sylvia* (see FIG. 27) and *The Children's Holiday* (see FIG. 58), which is a portrait of Fairbairn's wife and their children. Mrs Fairbairn and her brood are archetypal figures of bourgeois respectability, surrounded by the trappings of opulence, including a fashionable samovar and tea service. As the art historian Caroline Arscott has pointed out, although the Fairbairns would have been horrified by this idea, *The Children's Holiday* and *The Awakening Conscience* represent paired opposites: the feminine ideal and its antitype; wife and whore; madonna and magdalene. Clothing and accoutrements are superficially similar, but subtly different. The image of the kept woman, clad in a loose undergarment, concentrates on sexuality without reproduction; Mrs Fairbairn, her body encased in steely satin, seems to indicate the Victorian ideal of fecundity without sexuality.

66. DANTE GABRIEL ROSSETTI *Found*, c. 1854–5. Pen and black ink, 9¼ x 8½" (23.5 x 21.8 cm). Birmingham Museum and Art Gallery.

Ruskin was inspired to write a letter to *The Times* in 1854 because he felt that Hunt's *The Awakening Conscience* was not understood: 'People gaze at it in a blank wonder and leave it hopelessly.' His vivid description of the painting interprets not only the narrative but also interior in which it is set. His claim was that 'There is not a single object in all that room, common, modern, vulgar ... but it becomes tragical, if rightly read.' Ruskin asked 'That furniture so carefully painted, even to the last vein of rosewood – is there nothing to be learnt from the terrible lustre of it, from its fatal newness; nothing there that has the old thoughts of home upon it, or that is ever to become a part of home?' The interior is intended to appal us for its gaudiness and vulgarity, just as the grotesque interiors of Hogarth's 'Marriage-a-la-Mode' (see FIG. 61) betray the tastelessness of the protagonists. The setting of *The Awakening Conscience* is mere accommodation not a home, and it contrasts jarringly with the natural scene beyond the window. Perhaps it is too late for escape. Hunt's title implies

that 'the still small voice speaks to a human soul in the turmoil of life' and therefore this woman may return to the path of righteousness. But Ruskin reads a darker message from the details of the painting, while admiring their execution: 'the very hem of the poor girl's dress, which the painter has laboured so closely, thread by thread, has story in it, if we think how soon its pure whiteness may be soiled with dust and rain, her outcast feet falling in the street.' When her seducer tires of her, Ruskin warns, the woman will be reduced to street prostitution, the future of the hem of her dress serving as a cruel metonym (the part standing for the whole) for the future of the woman herself.

Such prostitution was the subject of Rossetti's only attempt at modern-life painting, *Found*, which was conceived in 1853. The painting was left incomplete at the time of Rossetti's death, though the composition exists in several versions. Under the design of 1854–5 (FIG. 66) is inscribed a text from the book of Jeremiah: 'I remember thee; the kindness of thy youth, the love of thy betrothal.' In Rossetti's words, 'A drover has left his cart standing in the middle of a road … and has run a little way after a girl who has passed him, wandering in the streets. He had just come up with her and she, recognising him, has sunk under her shame upon her knees.' She is his first love, now corrupted by the city, pulling away from him into the darkness, shrinking from the daylight. The calf, caught up in a mesh of rope, and on the inexorable road to slaughter, is a symbol of her fate but also of her fundamental innocence. The figure of the drover, clad in an improbably medievalised rustic smock and hat, contrasts with the brash modernity of the woman's dress and the haunting, gas-lit streets of Victorian London. It is dawn, the time when figures of the night meet those of the day; the corruption of the city meets the purity of the country.

The paired opposites of wife and whore indicate the polarities of Victorian ideology, rather than the compromises and negotiations of real life. Madox Brown, characteristically, entered more ambivalent moral terrain in the unfinished *Take Your Son, Sir!* (FIG. 67). The painting raises more questions than it answers; clearly referring to van Eyck's *The Marriage of Giovanni Arnolfini* (see FIG. 22), on display in the National Gallery since 1842 and one of the early works most admired by the Pre-Raphaelites, *Take*

67. FORD MADOX BROWN
Take Your Son, Sir!,
?1851–92. Oil on canvas,
27¾ x 15″ (70.5 x 38.1 cm).
The Tate Gallery, London.

68. FORD MADOX BROWN
Work, 1852–65. Oil on canvas, 4′6″ x 6′5¾″ (1.37 x 1.97 m). Manchester City Art Galleries.

In this most complex of all Pre-Raphaelite paintings, even the dogs contribute to Brown's social analysis. A pugnacious puppy in the foreground, a working dog who kills rats for the navvies, is confronting the middle-class lady's lapdog, which has disturbed a pile of sand. A shaggy mongrel belongs to the urchins in the foreground, sharing their social status, while at the rear, a hunting dog can just be discerned, in front of its aristocratic mistress's horse, gasping in the heat.

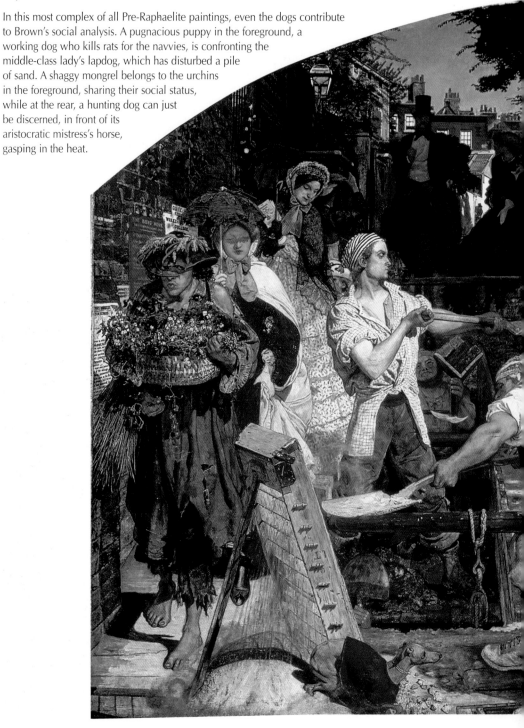

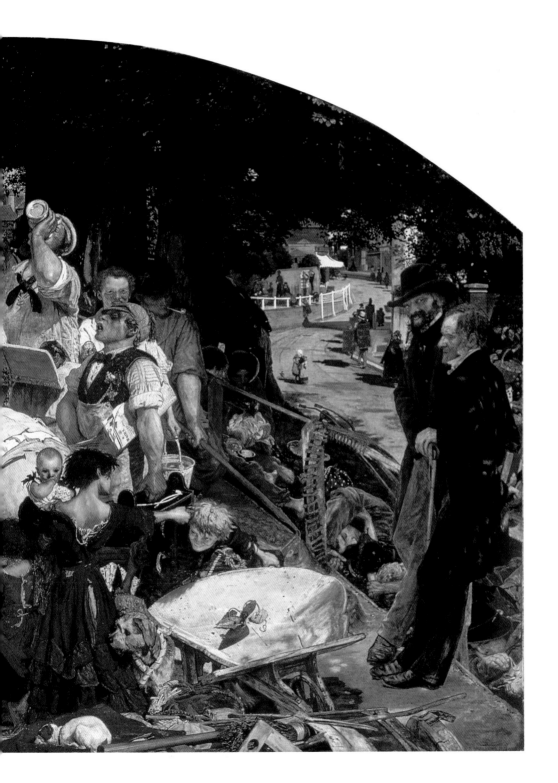

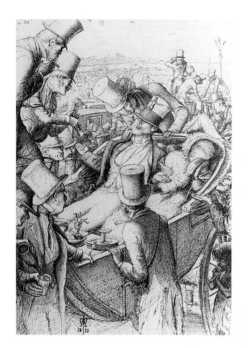

69. JOHN EVERETT MILLAIS
The Race Meeting, 1853.
Pen and black ink with
sepia, 10 x 7" (25.4 x 17.8
cm). Ashmolean Museum,
Oxford.

Millais had observed this
episode in real life at Epsom
in 1853, which combined
the sins of drunkenness,
sexual impropriety and
gambling, as he recorded in
a letter to Collins: 'Such
tragic scenes I saw on the
course … in another
carriage I saw a woman
crying bitterly evidently a
paramour of the man who
was languidly lolling back
on the cushions flushed with
drink and trying to look
unconcerned at the
woman's grief. This was
probably caused by a notice
that his losses that day
obliged him to do without
her society for the future.

Your Son, Sir! is resolutely contemporary (as
was the van Eyck in its time). The mother, painted
once again from Emma Brown, is haloed like
the Virgin Mary by a modern convex mirror, and
hands a new-born baby to the father, who resem-
bles Brown himself. By her side is a cot, with a
wetnurse arranging the pillows. The interior,
reflected in the mirror, is modest and domestic.
Yet the painting has often been read as an image
of a kept woman, a magdalene handing her bas-
tard son to its father, with the blunt command:
'Take your son, Sir!' Is this, then, an icon of the
sacredness of motherhood, or a Hogarthian satire
on prostitution and the birth of illegitimate chil-
dren in Victorian England? Perhaps it moves beyond
the terrain of social comment to reflect more pro-
foundly on the theme of procreation. As the art
historian Marcia Pointon has noted, the baby emerg-
ing from the folds of drapery resembles anatom-
ical drawings of the foetus in the womb, a type
of imagery in which Madox Brown, from an eminent medical
family, would have been well versed. The van Eyckian device
of the mirror allows Brown to explore (as in the Arnolfini por-
trait) the theme of fecundity and reproduction. While the image
deifies the woman as the Virgin Mary, it identifies her repro-
ductive role, symbolised by the womb, as her essential feature.

Men at Work

In all these Pre-Raphaelite images, women are defined in rela-
tion to their male counterparts, as husband or lover, protector
or seducer. Images of men in the public world of work provide
the other, matching cluster of Pre-Raphaelite modern-life paint-
ings. Victorian ideas of work were most distinctively articu-
lated by the social critic and self-styled prophet Thomas Carlyle
(1795–1881). Carlyle appears, with a snarl suggesting his biting wit,
in the right foreground of Madox Brown's *Work* (FIG. 68), the
most significant Victorian image of labour. Carlyle's well-known
epithet in *Past and Present*, published in 1843, 'For there is a
perennial nobleness, and even sacredness, in work' removed work
from the sphere of necessity and presented it instead as an expres-
sion of inner character or moral worth. The Protestant work ethic,
a belief in the moral value of labour, is one of the defining
creeds of the Victorian middle class. This concept was central

to the artistic identity of the Pre-Raphaelites: the obsessively detailed finish of early Pre-Raphaelite works testifies to a massive commitment of time and labour. For all their radicalism in artistic matters, in this regard the Pre-Raphaelites of the 1850s conformed to the orthodox ideology of their age, wishing to be seen as hardworking members of the middle class rather than wayward geniuses or bohemian outcasts. In Madox Brown's *Work*, which occupied him for a period of eleven years, labour conquers all. Labour is linked in the image with manliness and the healthy body, as Brown indicated in the sonnet which he wrote to accompany the painting. It begins: 'Work! Which beads the brow and tans the flesh/Of lusty manhood, casting out its devils!'

The visual logic of the painting is very complex, but the essence of it is the organisation of social types into hierarchies. The most obvious hierarchy places the rich at the top and the poor at the bottom of the composition. Types in the painting can be identified with reference to Madox Brown's description, published in the catalogue of the solo exhibition he held in 1865. At the apex of the composition is a Member of Parliament, probably from the gentry, if not the younger son of an aristocrat, who, Madox Brown informs us, is worth £15,000 a year. However, far from endorsing a traditional social hierarchy, Madox Brown is indulging in a Hogarthian satire. Relegated to a shadowy position at the rear of the composition, unable to participate in the useful work in the foreground, the aristocracy is judged irrelevant.

The Pre-Raphaelites, like most Victorian artists, were firmly located in the middle class, and seem to have subscribed to the widely held belief in the decadence and 'moral incompetence' of much of the aristocracy. Millais had summed up this critique in a pen and ink drawing, *The Race Meeting* (FIG. 69), whose sharpness of line parallels its critical tone. A drunken aristocratic swell has lost his fortune gambling at the Derby, and is surrounded by his insincere cronies, happy to bleed him dry. Another Pre-Raphaelite work, by Robert Braithwaite Martineau (1826–69), a pupil of Holman Hunt, elaborated this critique of the upper classes. In *The Last Day in the Old Home* (FIG. 70) the interior is as heavily symbolic as that in *The Awakening Conscience*; here an aristocrat has drunk and gambled away the family fortune. His weeping mother hands over the deeds of the ancestral home, while auctioneers (a catalogue of the sale is in the right foreground) and bailiffs (seen through the door to the right) are taking away the family heirlooms to cover unpaid debts. Meanwhile the aristocrat, still neglecting his manly duties, is inculcating his son in the same habits of decadence.

70. ROBERT BRAITHWAITE
MARTINEAU
*The Last Day in the Old
Home*, 1862. Oil on
canvas, 3′6″ x 3′9¼″ (1.07
x 1.15 m). The Tate Gallery,
London.

In this Hogarthian satire on
the aristocracy, Martineau
provides an elaborate series
of narrative clues
chronicling the reasons for
the family's decline and fall
through gambling and
drink. The idea of separate
spheres is evident in the
contrast between the man
of the house, who fails in
his duty to work and be a
responsible father, and his
wife who attempts to
prevent her son following
in his father's footsteps.

Leaving the aristocrat in the shade, we can turn in Madox
Brown's *Work* to the spotlit central group of navvies, digging a
trench to accommodate a new water supply in Hampstead. These
mighty working men emerge as heroes around whom the
composition is built, catching the full force of the July sun
which reflects harshly from their bared forearms. Taken together
with the biblical quotations on the frame, and the altarpiece shape
of the painting, the direct glare of sunlight can be understood
as a metaphor for the divine grace bestowed by work, as described
by Carlyle.

A further antithesis in the painting distinguishes between
the masculine and feminine. *Work* glorifies the physique of the
working men: the muscular, sinuous navvy shovelling soil was
described by Brown as being 'in the pride of manly health and
beauty'. A contrast to this working, masculine, central group,
is found to the left, where two women walk by, heavily draped
and conventionally feminine in appearance. One avoids work alto-
gether – the lady with the blue parasol – another is engaged in
an attempt at philanthropy, whose futility is signified by the
fluttering of an unread tract past the sneering face of a half sub-
merged navvy bearing a hod of bricks. For Brown, the fact that
this tract distributor is female automatically renders her work not

only futile but also comical. The tract is entitled 'The Hodman's Haven, or, Drink for Thirsty Souls' but its pro-temperance stance, insisted upon by the painting's original patron, the Evangelical Leeds stockbroker, Thomas Plint (1823–61), is ridiculed by the prominence of the beer seller and the relish with which the healthy bricklayer behind him is draining his tankard.

Women's work, which ought to be the object of the evangelical lady's energies, is indicated by the tiny face and yellow hat of her young daughter who clings to her mother's skirts. The imagery of the natural bond of mother and child appears three times in *Work*; balancing the lady with the tracts are the migrant farmworker and his family, seen in the shade on the grassy bank. Poor and homeless through no fault of their own, they are responsible parents and the sacred bond between mother and child is intact. As in *The Last of England* (see FIG. 59), a bonnet echoes the shape of a halo. Most noticeable, however, is the street urchin girl in the central foreground, holding a baby, comforting a younger sister and disciplining her unruly brother. Madox Brown's text assimilates this group into the morality of separate spheres, reading the girl's efforts as another indication of the hidden, household work permitted under the sexual division of labour. Visual clues provide the narrative details; the baby's black armband indicates the recent death of the mother, whose role the eldest daughter has through necessity taken on. The text (couched in Madox Brown's unorthodox language) urges us to accept the moral, claiming that 'a germ or rudiment of good houswiffery seems to pierce through her disordered envelope, for the younger ones are taken care of and nestle to her as to a mother'. Brown invokes a future narrative in which she will eventually withdraw from the public arena of work and carry out wifely and motherly duties in respectable privacy. But the painting itself indicates an opposite narrative: although only a child, small and thin with ragged hair, she bears the signs of a mature female, notably in the battered velvet dress, too long for her and falling off her shoulders. Here we should remember Ruskin's remarks on the 'hem of the poor girl's dress' in *The Awakening Conscience*. The urchin girl's dress, her bared shoulders and her shameless proximity to the labouring men prophesy a future life of poverty leading to prostitution, the oldest profession, the most notorious form of female work. Her fall, already prefigured by her premature assumption of the duties of womanhood, and suggested by her position literally in the gutter, is foreshadowed in that of the dress itself; once modest, laced up and fashionable, like that of the lady with the parasol to the left, it has been dragged in the dirt and

now exposes as vulnerable that which it was meant to protect, the female body.

Evidence of the effects of the failure to fulfil the duty of work among men is most conspicuous in the character at the extreme left carrying a basket of flowers. In earlier compositional studies (FIG. 71), this figure appeared as a jaunty dogseller in bright check trousers. But in the finished painting, this figure is a far more troubling presence. In his book *Victorian Panorama*, Christopher Wood identifies him as 'a girl flowerseller', and although this figure, with ragged coat and hat, is recognisably male, Wood's misrecognition is significant in pointing out the links between social position, work and gender which this figure presents. Within Brown's scheme, the category he represents is the 'ragged wretch who has never been taught to work': this crucial absence results in a loss of masculinity. The visual signs which stake out his effeminacy are the exact reverse of those which assert the manliness of the navvy with whom he is juxtaposed: the flowerseller's covered, presumably weak forearms, hunched stance, shifty glance and ambiguous clothing, as well as his literally weedy activity of collecting and selling 'singular plants', point up the absence of that masculine sexuality – direct, forceful and instrumental – which is the stuff of work.

71. FORD MADOX BROWN Preparatory study for *Work*, 1852?–64. Watercolour over pencil, 7¾ x 11" (19.7 x 28 cm). Manchester City Art Galleries.

Here Brown includes a man on the right twirling his cane, who can be identified as 'the artist'. Alarmed at the idea of seeming idle, he removed this figure, replacing him with those of the philosopher Thomas Carlyle and the churchman F. D. Maurice.

There are several significant absences in Madox Brown's apparently comprehensive representation of labour in Victorian Britain. Although he finds a place for the intellectuals Carlyle and (next to him) the Reverend Frederick Denison Maurice, the Christian Socialist clergyman, carrying a Bible, there is no one to exemplify middle-class men of commerce and industry like Thomas Plint, who commissioned the painting. If muscular action is the sign of a good workman, exemplified by the heroic navvies, what of the desk-bound professional? James Leathart (1820–95), a Newcastle lead manufacturer, was so impressed by Madox Brown's painting that he commissioned a small replica of it, insisting that Brown replace the face of the young lady with a parasol with that of his wife. A commission to paint Leathart's portrait (FIG. 72) provided Madox

72. FORD MADOX BROWN
Portrait of James Leathart,
c. 1863–4. 13½ x 11″ (34.2 x 28 cm). Family collection.

James Leathart was a self-made man who assembled a major collection of Pre-Raphaelite paintings.

Brown with an opportunity to represent middle-class work. Concentrating on Leathart's pensive facial expression, Brown portrays him, literally and figuratively, as the head of the company, whose factory can be seen through the window across the leaden water of the Tyne. As if to emphasise the links between Leathart and the idea of labour, the corner of the frame of Madox Brown's small version of *Work* can be seen over his left shoulder.

Madox Brown's painting, however, does not portray the kind of mechanised, factory labour which was gradually becoming the dominant experience for millions of industrial workers. Images of industrial labour are rare in nineteenth-century painting: *Iron and Coal: The Nineteenth Century* (FIG. 73) by William Bell Scott (1811–90) is a unique example from the Pre-Raphaelite circle. A poet as well as a painter, and a friend of Rossetti, Bell Scott was employed as head of the Government School of Art in Newcastle from 1846 to 1863, and the painting was part of a series of large paintings (1856–60) illustrating the history of Northumberland commissioned for Wallington Hall by Sir Walter Trevelyan. It was the culmination of a sequence beginning in Roman Britain, recording how (in the words of Lady Pauline Trevelyan) 'In the nineteenth century, the Northumbrians show the world what can be done with iron and coal'. In celebration of the technological modernity of the industrial city, a steam locomotive is seen crossing Newcastle's celebrated High Level Bridge (completed in 1849) and a design for it is visible in the foreground, while

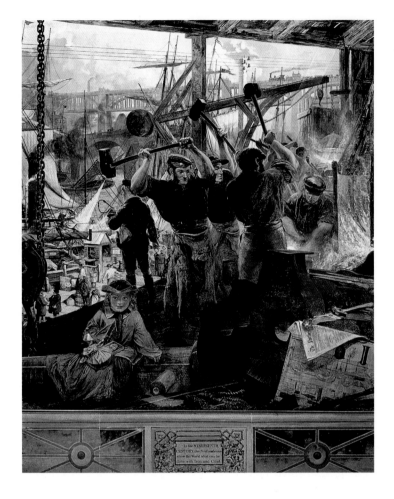

telegraph wires, a photographer and steam-powered barges can all
be deciphered among the chaotic details of the distant scene. In
the foreground, figures no less heroic than Madox Brown's are
engaged in making guns and shells in a scene based on the ord-
nance factory of Sir William Armstrong.

Even a casual examination of the social history of Victo-
rian Britain reveals that Bell Scott and Madox Brown's shared
vision of labour was hopelessly unrealistic. These grand, rhetori-
cal paintings, built up of a wealth of observed details, articulate
ideologically charged conceptions rather than historical reali-
ties. Manual labourers in the 1850s worked cruelly long hours for
very poor pay, often in conditions of extreme physical danger.
Henry Wallis (1746–1813) provided a rare exposé of the tragedy
of labour in modern society. His *Stonebreaker* (FIG. 74) was sub-
titled with a less celebratory quote from Carlyle than those selected
by Madox Brown:

Hardly-entreated Brother! For us was thy back so bent, for us were thy straight limbs and fingers so deformed: thou wert our Conscript, on whom the lot fell, and fighting our battles wert so marred. For in thee too lay a god-created Form, but it was not to be unfolded: encrusted must it stand with the thick adhesions and defacements of labour: and thy body, like thy soul, was not to know freedom.

The stonebreaker is himself broken and as the day falls into night, we realise that he is not just resting but dead; the body is so still that a stoat has dared to climb on his foot. This was the body ill-used by society; stonebreaking was the forced labour meted out to the able-bodied poor under the terms of the Poor Law Amendment Act of 1834 in order to qualify for food and accommodation in the workhouse. Wallis's painting offers a tragic corrective to the idealisation of labour offered by Madox Brown and Bell Scott.

It is important to emphasise that real Victorian men and women did not live out their lives according to these stereotypes of identity and behaviour: paintings do not offer a reliable indication of social history, no matter what their claims to realism. Rather than reflecting an existing reality, images in wide circulation – as these were through public exhibitions and reproductive engravings – can cumulatively affect society and behaviour, by presenting certain body types or forms of behaviour as the norm, and castigating others as deviant. Pre-Raphaelite images of modern life go even further than merely replicating or promoting widely held ideals. The Pre-Raphaelites created paintings which were not simply passive in their engagement with the everyday world or conventional ideology: they were campaigning works which exposed the emotional tragedy of emigration, condemned the evils of prostitution, or hymned the virtues of labour. Pre-Raphaelite modern-life paintings are, ultimately, Hogarthian moralities, laying bare the underlying beliefs of the society which produced them, and applying a gaze of fierce intensity to what Ruskin called the 'stern facts', which other artists avoided.

74. HENRY WALLIS *The Stonebreaker*, 1857. Oil on canvas, 25¾ x 31″ (64 x 79 cm). Birmingham Museum and Art Gallery.

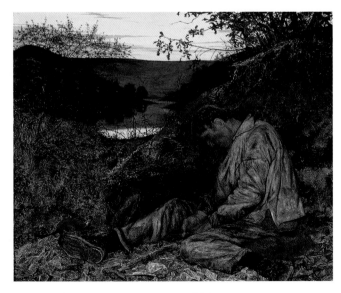

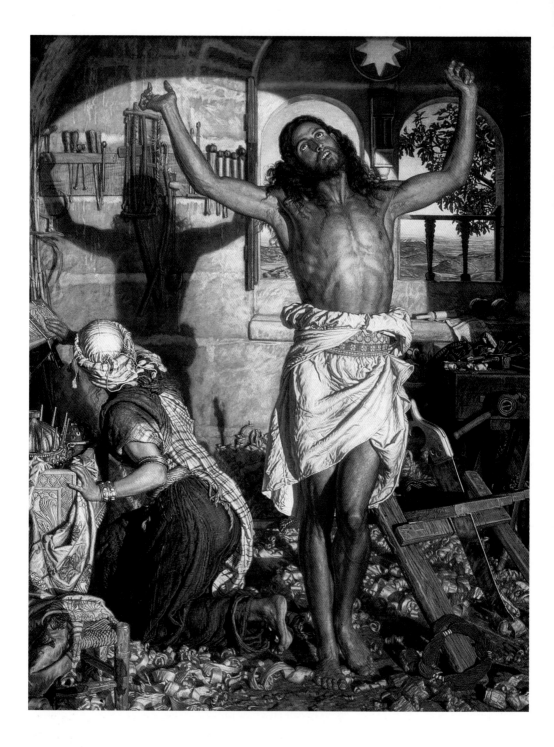

FOUR

Art, Religion and Empire

Despite the mounting challenges to orthodox religion from modern science and a gradual secularisation of many aspects of life, the Victorian age remained profoundly Christian. Protestantism was central to English national identity, and the established Church of England (the Anglican Church), headed by the monarch, which had been founded at the Reformation, continued to be the dominant force in religion. The other Protestant churches, such as the Methodists, Unitarians and Baptists (known collectively as 'Nonconformists') also wielded considerable influence. Following the Catholic Emancipation Act of 1829, most of the restrictions on the participation of Catholics in national life were lifted. The growth of Catholicism, which provided commissions for the architect A. W. N. Pugin (see FIG. 12), was fuelled by increasing immigration from Ireland, where the majority of the population had retained their affiliations to the Roman Church. In 1850 Pope Pius IX re-established the Roman Catholic hierarchy in England, causing widespread anxiety among English Protestants, and popular unrest in the form of 'No Popery' riots.

Anglicanism, which had always sustained within it a multiplicity of conflicting views, became increasingly polarised during the Victorian period. At one extreme – known as the 'High Church' – was the Oxford Movement, which reinstated many aspects of Catholicism into the Anglican Church, notably by emphasising the importance of Communion. The series of publications, *Tracts for the Times*, through which these opinions were circulated, gave rise to the name 'Tractarian', widely applied to the Oxford Movement and its sympathisers. In 1845, John Henry Newman (1801–90) became the most celebrated of a group of Anglican clergymen to convert to Roman Catholicism; others, such

75. WILLIAM HOLMAN HUNT
The Shadow of Death, 1870–73. Oil on canvas, 7'¼" x 5'6¼" (2.14 x 1.68 m). Manchester City Art Galleries.

as E. B. Pusey (1800–82), a leader of the Oxford Movement, remained within the Anglican Church but promoted High Church practices. Greater attention was paid to ritual and High Anglicanism adopted a more sensuous and mystical approach to religion than had been seen since the Reformation. The personal asceticism of the priest was also considered to be highly important: celibacy, fasting and long periods of solitary prayer were advocated. Many High Anglicans concerned themselves particularly with the relationship between religion and the visual arts and architecture; their periodical, *The Ecclesiologist*, advocated that the fabric of churches should be highly decorated.

The Evangelical Movement, on the other hand, associated with 'Low Church' Anglicanism, upheld the primacy of the Bible and therefore valued the verbal more highly than the visual. Low Church tastes accordingly accepted very little decoration in churches. Emphasising atonement for original sin, and preoccupied with the imperative of saving souls, Evangelicals believed in the strict regulation of personal conduct. Especially popular in Evangelical circles were ideas of work as an act of atonement and of the separate spheres of men and women's work (see Chapter Three). A further grouping, the 'Broad Church' party, occupied a position between these extremes, believing in an active ministry, especially among the working classes, and emphasising the power of religion to heal social problems. Broad Churchmen – such as the Reverend F. D. Maurice, who appears in Madox Brown's *Work* (see FIG. 68) – tended to emphasise the direct appeal of Christ to all believers, rather than to insist on mediation through elaborate church services.

Holman Hunt's allegory on the effects of religious controversy, *The Hireling Shepherd* (see FIG. 3) has already been discussed: as Hunt implied, there was a real danger of the flock being forgotten amid the complexities of religious division. The Pre-Raphaelites were acutely aware of these often bitter controversies and, like all educated Victorians, agonised over their own religious affiliations. There was no question of the Brotherhood and its associates sharing a single coherent religious position: rather, the views of each of the major religious factions – the Oxford Movement, 'Broad Church' and Evangelical groups – can in turn be associated with particular Pre-Raphaelite works.

Tractarian Tendencies

There was a widespread belief during the early years of Pre-Raphaelitism that the Brotherhood – a quasi-monastic organisa-

tion including among its members one with an Italian name, Rossetti – was sympathetic towards either the Catholic Church or the Oxford Movement. The Oxford Movement idealised the role of all-male, celibate communities for religious devotion, and the Pre-Raphaelites, in their early years, could at first sight have been mistaken for such a group. The art critic of *The Times*, for example, referred to the Brotherhood's 'monkish follies', while Ruskin, in his letter to the same newspaper in 1851, distanced himself from what he perceived to be the Brotherhood's 'Tractarian tendencies' before supporting their work. Charles Allston Collins, an associate rather than a member of the PRB, was a High Anglican and the subject of his *Convent Thoughts* (see FIG. 40) suggested an association with the Catholic religion through its portrayal of a nun. The passion flower she holds refers to the passion of Christ, through the cross formed by its stamens, though it could also be read as a reference to those physical passions beyond the wall of the convent which the nun has forsworn. Central to the painting is the idea of virginity: the medieval illuminated manuscript which she holds represents the Virgin Mary (considered only as the human mother of God in the Low Church, but venerated by High Anglicans and Catholics), and Collins appended the following quotation from *A Midsummer Night's Dream* to the painting's title in the Royal Academy catalogue in 1851: 'Thrice blessed they, that master so their blood/To undergo such maiden pilgrimage.'

Millais presents a more ambivalent case. Like Collins, he worshipped at St Andrew's, Wells Street in London, renowned for its ritualistic services, and he had extensive contacts with the Oxford Movement through his friend Thomas Combe (1797–1872). Combe, a major Pre-Raphaelite patron, was head of the Clarendon Press in Oxford and a friend of leading theologians in the Movement. Holman Hunt insisted that the idea for the early Pre-Raphaelite work *Christ in the House of His Parents* (see FIG. 23) derived from a sermon which Millais had heard in Oxford in 1849, probably given by Pusey. The painting was originally exhibited at the Royal Academy in 1850 with a biblical quotation in place of a title: 'And one shall say unto him, What are these wounds in thine hands? Then he shall answer, Those with which I was wounded in the house of my friends' (Zechariah 13.6). Pusey himself understood this passage to relate to the Passion of Christ, although, curiously, its biblical context makes clear that the wounds in question were part of the attempts of a false prophet to deceive those around him. The art historian Alastair Grieve has argued that the painting relates specifically to High Church practices, and

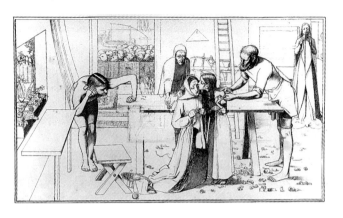

76. JOHN EVERETT MILLAIS
Study for Christ in the House of His Parents,
1849. Pen and ink, pencil and wash, 7 x 13" (17.6 x 33 cm). The Tate Gallery, London.

that the composition makes detailed and specific references to the layout of churches proposed in *The Ecclesiologist*. In this reading, the carpenter's shop represents the view from the east end of a church to the west; the back wall becomes a rood screen (favoured by Ecclesiologists) separating the priest from the congregation; and the table occupies the place of the altar. The sheep, representing the congregation or flock, are kept far away from the holy persons at the altar, also typical of High Church practice. Especially visible in the pen and ink study of 1849 (FIG. 76) is a well, seen behind the sheep in the background, which Grieve links to the font, a feature which the Ecclesiologists unconventionally placed at the west end of churches. The blood of Christ is literally present in the image, alluding to the supremacy given to the Sacrament of Communion by the Oxford Movement. The painting explicitly refers to the Trinity of God, Son and Holy Spirit through the triangular carpenter's set-square on the back wall. The dove, seen here perching on a ladder, is the traditional symbol of the Holy Spirit.

It seems unlikely that Grieve's ingenious reading would have made a great deal of sense to most of Millais's contemporaries. *Christ in the House of His Parents* was purchased by the Nonconformist stockbroker Thomas Plint, who was secretary to the Deacons of East Parade Chapel in Leeds, the opposite end of the religious spectrum from the Oxford Movement. Plint was more concerned with Evangelical work in the community. The ritualistic quality and other-worldliness of the Oxford Movement would have been anathema to him: we can speculate that he saw the painting rather as enshrining the idea of Christ as a working man, implying an active social ministry, a very acceptable notion in Broad Church, Evangelical and Nonconformist circles. *Christ in the House of His Parents* was, then, susceptible to both High and Low Church interpretations: perhaps this ambivalence contributed to the vehemence of the critical response.

Christ in the House of His Parents was first drawn to Ruskin's attention at the Royal Academy exhibition of 1850 by William Dyce, himself an Anglican High Churchman who fervently supported and practised the revival of medieval styles of church decoration and was fascinated by pre-Reformation liturgical

practices and church music. In Dyce's later work, Pre-Raphaelite and High Church influences are blended. Alongside *Pegwell Bay* (see FIG. 55) at the Royal Academy of 1860, Dyce exhibited *The Man of Sorrows* (FIG. 77) and quoted in the catalogue and on the frame lines from a poem, 'Ash Wednesday', by his friend, the Oxford Movement cleric John Keble:

> As, when upon His drooping head
> His Father's light was pour'd from heaven,
> What time, unsheltered and unfed,
> Far in the wild his steps were driven,
> High thoughts were with Him in that hour,
> Untold, unspeakable on earth.

Keble's poem refers to Christ's forty days and forty nights of fasting in the wilderness, and perhaps alludes specifically to his temptation: 'And when the tempter came to him, he said, if thou be the Son of God, command that these stones be made bread. But he answered and said, It is written, Man shall not live by bread alone, but by every word that proceedeth out of the mouth of God' (Matthew 4.3–4). This narrative emphasises the spiritual over the physical, associating Christ with passive suffering rather

77. WILLIAM DYCE
The Man of Sorrows, c. 1860. Oil on millboard, 13½ x 19½" (34.3 x 49.5 cm). National Galleries of Scotland, Edinburgh.

It has been suggested that, as in *Pegwell Bay*, Dyce deployed a rocky landscape to suggest the challenges to a Christian interpretation of creation presented by the new, scientific understanding of geological time. Certainly, Dyce was concerned to allow his viewers to identify with Christ's sufferings and the landscape of windswept and deserted granite hillsides provided a local and recognisable equivalent of the barrenness of the biblical wilderness.

than active agency. The radical gesture of placing Christ in a recognisable British context (echoing Blake's vision of Christ walking 'upon England's pastures green') may result from Dyce's knowledge of fifteenth-century Italian art, where the life of Christ is routinely located in contemporary settings. Yet the juxtaposition of the long, flowing robe, as seen in Fra Angelico's *Coronation of the Virgin* (see FIG. 21), with the localised Scottish landscape reads as an unresolved paradox. The landscape's convincing claims to realism are undercut by the artifice of the figure: materialism and spirituality are placed in troubling proximity.

Muscular Christianity

Other Pre-Raphaelite painters, of Broad Church and Evangelical sympathies, paid much attention in the 1850s to the portrayal of a Christ who could appeal widely to the Victorian public. Ford Madox Brown was associated with a group of Broad Church Anglican thinkers known as 'Christian Socialists' because of their wish to reach directly the working classes, especially through educational projects. Brown paid homage to the leader of this group, F. D. Maurice, by portraying him alongside Carlyle in *Work*, and taught art at the Working Men's College of which Maurice was the Principal. For Maurice, Christ was a type of manliness, the 'one protection of nations and men against sloth, effeminacy, baseness and tyranny'. The body of Christ, seen as a muscular workman, became an important icon, emphasising the incarnation of God as a man, rather than the mystical and heavenly vision preferred by the Oxford Movement. Brown provided a bold, unconventional image of this manly Christ in *Jesus washing Peter's Feet* (FIG. 78), illustrating the passage from St John's Gospel describing the Last Supper:

> He riseth from supper and laid aside his garments; and took
> a towel and girded himself. After that he poureth water into
> a basin, and began to wash the disciples' feet, and to wipe them
> with the towel wherein he was girded. For I have given you
> an example, that ye should do as I have done to thee.

True to the biblical account, Madox Brown initially represented the Christ figure semi-nude, because (as he noted in a letter) 'Jesus took upon himself the appearance of a slave as a lesson of the deepest humility'. Predictably, as Brown continues, 'People ... could not see the poetry of my conception, & were shocked at it & would not buy the work – & I getting sick of it painted clothes upon the

figure.' If the composition owes something to the Nazarene frescoes which Brown had admired, and retains some traditional elements such as the gold nimbus around Christ's head, the figure of Christ (though clothed in the traditional flowing robes as a concession to conventional taste) remains unusual. Powerfully muscular and seen in profile, he undertakes the humble work of cleaning with genuine vigour. The heads of the disciples, unconventionally placed in a frieze just below the upper margin, were painted from Brown's friends, including Holman Hunt and Rossetti. Judas's money bag can be seen on the table to the left. The radicalism of the work probably accounts for the fact that it was hung 'high above the line in a most unworthy place' at the Royal Academy in 1852. Francis Grant, an Academician on the selection committee, told Brown that the work had been much admired, but hung very high because it had arrived at the Academy with the paint still wet – a result of Brown's perfectionism. The critical response to the painting was largely negative: a passage from

78. FORD MADOX BROWN
Jesus washing Peter's Feet, 1851–6. Oil on canvas, 3'10" x 4'2¼" (1.17 x 1.34 m). The Tate Gallery, London.

the *Art Journal* indicates how provocative and perplexing Pre-Raphaelite religious painting could be:

> We care not whether the exhibitor affect pre- or post-Raffaellism, but we contend that coarseness and indignity in painting are always objectionable. It is possible that the feet of Peter were not like those of Apollo, but it is also probable, if severe truth be insisted upon, that they were proportionable to the figure. It is not the office of Art to present us with truths of an offensive kind.

By insisting on such 'truths', Brown had indicated some of the ways in which Pre-Raphaelite religious painting could break away from tradition, offering a new characterisation of Christ in accord with mid-Victorian religious thought.

The Light of the World

Holman Hunt's profound religious convictions permeate every aspect of his work. An atheist as a young man, he underwent a dramatic conversion in 1851, whereupon he became a deeply convinced Protestant. Clearly sympathetic to Broad Church notions of Christ as a real, living presence, he seems to have been most strongly attracted to Evangelicalism, with its emphasis on a literal reading of scripture. *The Light of the World* (FIG. 79), which Hunt linked with his own conversion, was described by Ruskin as 'one of the noblest works of sacred art produced in this or any other age', a view which endured for the rest of the Victorian era. Far from presenting a realistic image of Christ incarnate as a man, however, Hunt's mystic vision of the risen Christ knocking at the door of the human soul was suggested by a text from Revelation (3.20), reprinted in the catalogue when the painting appeared at the Royal Academy in 1854: 'Behold, I stand at the door, and knock; if any man hear my voice, and open the door, I will come in to him, and will sup with him and he with me.' The painting is richly symbolic but does not draw on existing iconographic conventions. It demands from the viewer an elaborate process of decoding by reference to numerous biblical passages, rather than to a knowledge of the traditions of religious art. In a letter to *The Times* of 5 May 1854, Ruskin provided just such a reading, interpreting the painting in the way that a clergyman might approach a biblical text in a sermon. As Ruskin explained, Christ here is not a man, but the resurrected deity: the stigmata of his crucifixion can be discerned on his hand, and he is dressed as the King of

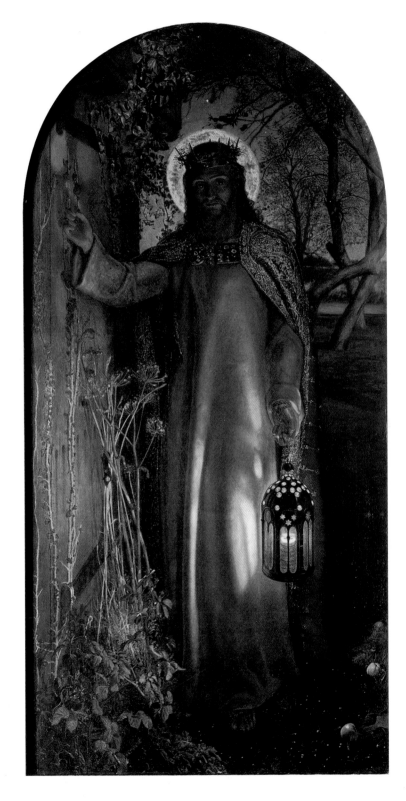

79. WILLIAM HOLMAN HUNT
The Light of the World,
1851–3. 49½ x 23½"
(125.5 x 60 cm). Keble
College, Oxford.

Along with the heavy
symbolic weight carried
by the work, Hunt also
strove for 'truth to
nature'. Most striking is
the dawn light (in
Stephens's words) 'a
strange, mystic time,
between night and morn,
while the light of the
sinking moon lingers,
mingling with the pale
shine of the stars, which
coming day cannot yet
overpower'. The apple
trees in the background,
representing 'Adam's
garden', were painted at
Worcester Park Farm,
Ewell, site also of *The
Hireling Shepherd*. Hunt
went to inordinate
lengths to capture
moonlight and lamplight,
painting from 9 PM to 5 AM
from a temporary hut
made of straw.

Heaven. Further symbolic elements include the light of the lantern, indicating spiritual enlightenment, and the closed door representing the human soul: 'its bars and nails are rusty; it is knitted and bound to its stanchions by creeping tendrils of ivy showing that it has never been opened.' Such neglect of the message of Christianity on the part of humanity has resulted in the door becoming overgrown: 'a bat hovers above it; its threshold is overgrown with brambles, nettles and fruitless corn'. Stephens suggested that the image is one of hope: although 'the ivy of indolence' bars the door, 'there are marks of the axe and saw upon the trees', a sign of mankind's potential for redemption through labour. As Hunt himself explained: 'the music of the still small voice was the summons to the sluggard to awaken and become a zealous labourer under the Divine Master.' What might at first seem an ethereal and mystic vision of Christ turns out to be a restatement of the Protestant work ethic, an Evangelical call to arms.

Although *The Light of the World* was received frostily at the Royal Academy in 1854, it came to be accepted as one of the great religious images of the nineteenth century. Perhaps surprisingly, the original painting was purchased by Thomas Combe, and his widow presented it to Keble College, Oxford, in 1873. Combe's Oxford Movement affiliations do not seem to have diminished his admiration for a work I have characterised as Evangelical in its sympathies: as with *Christ in the House of His Parents*, the painting could appeal across sectarian divisions. Engravings of *The Light of the World* achieved massive sales across the world: widely disseminated, the image entered popular culture. In 1899 Hunt began a larger version which toured the British colonies in 1905–7 and was presented to St Paul's Cathedral, London, in 1908, attaining a place as an official icon of English Protestantism.

Religion, Race and Empire: Holman Hunt in the Holy Land

The Light of the World was celebrated as a genuinely English religious painting which owed little to the Catholic traditions of the European masters and employed a visual equivalent of the verbal language of English Protestantism. Its emotive effect on Victorian viewers, since decried as sentimentality, seems to have been profound. In rejecting the religious iconography of earlier painters promoted by the Royal Academy, Hunt, Madox Brown and Millais had carried out one part of the Pre-Raphaelite programme in the field of religious painting. It seemed as if they effected a kind of visual Reformation, replacing the Catholic with

the Protestant, the old faith of replicating the Old Masters with the new creed of 'truth to nature'. But how could Pre-Raphaelite naturalism be achieved in a figurative, religious art, without creating the kind of uncomfortable juxtaposition of real and symbolic we have noted in Dyce's later *The Man of Sorrows* and in *The Light of the World*?

The only solution seemed to be to visit the sites of Christ's life, to study biblical history and observe the habits and customs of the present inhabitants, the landscape and light of the Holy Land. This might make it possible to apply to religious painting the Pre-Raphaelite determination (as Ruskin had put it in 1851) to 'draw either what they see, or what they suppose might have been the actual facts of the scene they desire to represent', the actual facts in this case being those of the life of Christ. For several years Hunt had wished to visit the Holy Land, following the precedents of the British artists David Roberts (in 1839–40) and David Wilkie (in 1841). Although his intention was to visit 'all the scenes of Biblical interest', his desire to see the East conforms to the general pattern of nineteenth-century Orientalism. This Western habit of thought, described by the literary theorist and historian Edward Said, divides the world into two – Orient and Occident, East and West – and ascribes particular, and generally negative, characteristics to the Oriental. The Orient and its inhabitants are lumped together as an 'other' to Western civilisation, a mirror image of the virtues of the modern Englishman. Passive rather than active, childlike rather than mature, feminine rather than masculine, timeless and not a part of the progress of history, the character of the Oriental is considered static and easily identifiable. Hunt left England for Egypt in 1854, and Stephens's description of the early days of his expedition conforms precisely to Said's definition of Orientalism:

> In the first case, he went to Egypt as the best portal to the regions of the Orient ... [He] remained in Egypt several months familiarising himself with the Oriental character, studying Eastern life as it was to be found round about him, and visiting many historically famous localities ... he made studies of the people, at one time in the cities, and at another in the desert. This afforded leisure ... if we may so phrase it, to Orientalize himself.

Stephens presents Hunt as an ethnographer, the sympathetic student of the habits and customs of an inferior people. The artist's diaries and letters, however, are far more condemnatory and patro-

80. WILLIAM HOLMAN HUNT
The Afterglow in Egypt,
1854, 1860–3. Oil on
canvas, 73 x 34" (185.4 x
86.3 cm). Southampton City
Art Gallery.

The opulence of Hunt's
evening image, with its
saturated colours and
sensuous portrayal of a
Bedouin woman, is
emphasised by the splendid
frame made to the artist's
designs. Although his subject
was not a Muslim, Hunt uses
various Islamic designs in the
frame, drawn from Owen
Jones's lavishly illustrated
book *The Grammar of
Ornament* (1856).

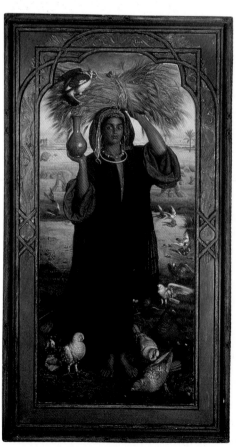

nising in their responses to all that he met, Arabs and Jews. Hunt regularly uses the term 'savage', the most powerful descriptor of the 'otherness' of non-Western peoples during the nineteenth century. Such a position does not prohibit the colonial viewer being attracted, aesthetically or sexually, to the object of his superior gaze. Hunt's most opulent Orientalist canvas, *The Afterglow in Egypt* (FIG. 80), begun at Giza in 1854, is just such a fantasy of colonial plenty. The landscape is bountiful in crops and thus perfect for colonial appropriation. The figure of a Bedouin woman (unlike the Islamic Arabs, unveiled and willing to model) presents an image exactly opposite to those of Victorian ladies discussed in Chapter Three: her glowing dark skin contrasts with their powdered whiteness; her labour in the fields with their endless leisure in the home; her loose-fitting gown (with a hint of the left breast visible) with their tightly corseted form. But while the painting is charged with coded sexual desire, it also restates the rhetoric of colonial domination. Appearing as an 'Egyptian Ceres' (the goddess of the harvest), the figure was understood by one critic as a symbol of the collapse of Egyptian culture. Ancient Egypt, once a great civilisation (sometimes compared with the British Empire), is now reduced to a peasant economy reliant on female labour and natural abundance. As Hunt put it in 1886, though 'the meridian glory of ancient Egypt has passed away, there is still a poetic reflection of this in the aspect of life there.'

Hunt's accounts of his journey to Palestine via France and Egypt, both in his diaries and in his book *Pre-Raphaelitism and the Pre-Raphaelite Brotherhood* (1905), as Pointon notes, were grounded in British imperialism. The boat from Marseilles to Malta was full of 'Indian officials and ladies', providing Hunt with 'a tangible illustration of the greatness of the British Empire' and its influence throughout the world. At the time of Hunt's first trip in 1854, the Middle East was rapidly becoming a focus of attention for the European powers. As Hunt arrived, Ferdinand de Lesseps was beginning to cut a canal through the Suez isthmus. The canal, which opened in 1869, offered a dramatically faster route to India, the most significant British colony, and there ensued a bitter struggle between England and France for control of it.

At the very beginning of his travels in 1854, Hunt began a small painting, *A Street Scene in Cairo: The Lantern Maker's Courtship* (FIG. 81), which he hoped would serve 'as an illustration of modern egyptian [sic] life'. Painters, like ethnographers, he suggested 'could cease the uselessness of their employment hitherto and devote themselves to spreading knowledge'. Hunt thus linked this image with such publications as E. W. Lane's *An Account of the Manners and Customs of the Modern Egyptians* (1837) from which he probably derived several details in the image. In the Royal Academy catalogue in 1861, Hunt added an explanatory note for the Westerner unaware of Islamic tradition: 'The wearing of the burks, or face veil is common to all the respectable classes in Cairo', adding a quotation from E. W. Lane, an earlier visitor: 'The bridegroom can scarcely ever obtain even a surreptitious glance at the features of his bride, until he finds her in his absolute possession.' The practice of veiling was a major point of difference between Islamic and Christian cultures, but Hunt's painting goes beyond mere documentation: it is a satire on what Hunt would have considered the primitive or backward custom of wearing the veil. It is also a humorous genre painting, transposing the theme of young love and stolen glances, typical early-Victorian subject matter, into an Oriental context. The Oriental male is characterised as lazy and workshy (compare his posture to the images of labourers discussed in Chapter Three) and the potentially comic unveiling of the bride might even hint at the possibility of premarital sex. The congested area to the right of the composition conveys, perhaps, what Hunt thought of as the chaotic state of the Egyptian city: a camel adds an exotic detail, but most significant is the small figure of a British visitor, dressed in black with a top hat possibly about to whip an Arab who shies away in horror. Modelled by Millais on Hunt's return to England in 1856, this surely represents Hunt's own idealised self-image. Throughout his written accounts he constantly reiterates his identity as an Englishman; a letter of March 1854 to Millais asserts: 'my nationality … is worth every other pretension one travels with, it finds one in cringing obedience and fear from every native, even a dog'. Although passages in the diary make clear that he often found himself powerless, lonely and frightened, the rhetoric

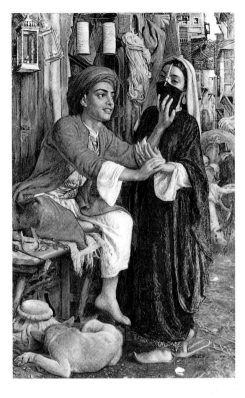

81. WILLIAM HOLMAN HUNT *A Street Scene in Cairo: The Lantern Maker's Courtship,* 1854–61. Oil on canvas, 21½ x 13¾" (54.6 x 35 cm). Birmingham Museum and Art Gallery.

The painting, as ever with Hunt, is based on meticulously observed details, from the architectural settings to the small folding lanterns made of waxed cloth hanging above the boy's head.

of his published writings implies that throughout the trip he asserted an effortless imperial superiority.

As Roberts had demonstrated, the landscapes of the Holy Land were still richly endowed with monuments from biblical times. Nineteenth-century archaeology (exemplified by the American scholar Edward Robinson's expedition of 1838) was rapidly unearthing new physical evidence in Jerusalem and elsewhere. The scenery against which the life of Christ had been enacted seemed almost unchanged, and a scrupulous Pre-Raphaelite style of landscape painting presented the perfect medium for its representation. Just as to paint nature was to follow 'the finger of God', so to paint the settings of Christ's life could be a devotional act. Thomas Seddon (1821–56), the aspiring follower of the PRB who joined Hunt at Jerusalem in June 1854, attempted such a work in *Jerusalem and the Valley of Jehoshaphat from the Hill of Evil Counsel* (FIG. 82). A committed Christian, Seddon's portrayal of 'the very ground our Saviour so often trod' took on personal meaning: he described it as the place where Christ 'endured so much suffering and agony for me'. Although there is no doubt-

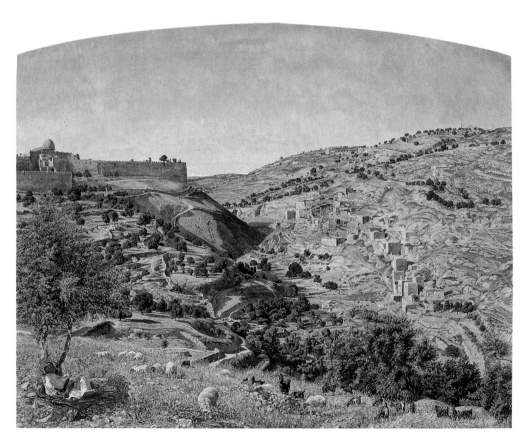

ing the sincerity of Seddon's feelings or the painful intensity of his observation, the painting could easily be mistaken for a mere topographical view: the dozing Arab shepherd under a tree in the minutely detailed foreground adds a picturesque, Orientalist touch. But the so-called 'Valley of Jehoshaphat' was traditionally identified as the future site of the Last Judgement, and there is little in Seddon's meticulously observed landscape, with its calm archaeological and pastoral overtones, to anticipate or allude to such a dramatic event.

Hunt's project was far more ambitious. He felt that Pre-Raphaelitism, at the forefront of modern British painting, could displace the canonical (and thus Roman Catholic) imagery of the Western tradition with a more empirical and authentic (and thus Evangelical) version of biblical events, achieving the kind of 'truths' which earlier Pre-Raphaelite religious paintings had aimed to capture. According to Stephens, underlying Hunt's *The Finding of the Saviour in the Temple* (FIG. 83) was a British maxim redolent of empirical science: 'the national idea of thorough examination and study before an undeviating and unflinching execution of principles thence arrived at'. The painting represents the passage from St Luke (2.45–6) in which Mary and Joseph return to Jerusalem to look for the young Jesus who has gone missing:

And it came to pass, that after three days they found him in the temple, sitting in the midst of the doctors, both hearing them, and asking them questions. And all that heard him were astonished at his understanding and answers. And when they saw him, they were amazed: and his mother said unto him, Son, why hast thou thus dealt with us? Behold, thy father and I have sought thee sorrowing. And he said unto them, How is it that ye sought me? Wist ye not that I must be about my Father's business?

Hunt recreates the scene with a garish vividness. Comparison with earlier biblical paintings – including those of Madox Brown, Dyce and Hunt himself – reveals a major difference in the clothing of the figures. 'Discarding the old-fashioned blanket draperies' typical of all earlier paintings, Stephens explains, Hunt's 'actors are therefore costumed in various and brilliant fabrics of Oriental character'. The temple itself is elaborately reconstructed, but although Hunt referred to new archaeological discoveries in Jerusalem, much of the design was taken after his return to London in 1856 from Owen Jones's replica of the Alhambra at Granada, which was installed at the Crystal Palace in south London. To elide

82. THOMAS SEDDON *Jerusalem and the Valley of Jehoshaphat from the Hill of Evil Counsel*, 1854–5. Oil on canvas, 26½ x 32¾" (67.3 x 83.2 cm). The Tate Gallery, London.

Painted from Aceldama, to the south of Jerusalem, the central feature of the landscape is the Mount of Olives, scene of Christ's agony before his final arrest. A long catalogue entry by the artist, published when the work was exhibited at the Liverpool Academy in 1856, enumerated a host of other features with biblical significance. Seddon conceived of the painstaking observation of the actual valley as a religious act, as his brother later recalled: 'It was undertaken as a labour of love, in consequence of the subject ... He felt its undertaking to be a duty, but a sacrifice as well.'

83. WILLIAM HOLMAN HUNT
The Finding of the Saviour in the Temple, 1854–5. Oil on
canvas, 33¾ x 55½″ (85.7 x 141 cm). Birmingham Museum
and Art Gallery.

The composition consists of two contrasting masses: the
chaotic and in parts grotesque group of rabbis on the left and
the simple pyramid of the Holy Family on the right. Victorian
viewers would have linked this polarity with the symbolic
importance of this story as the meeting of the old and new
dispensations, the Jewish world of the Old Testament with
the Christian world of the New Testament.

124 *Art, Religion and Empire*

Moorish architecture in Spain with a Jewish building of more than a millennium earlier drastically contravened archaeological accuracy, but conformed to Orientalist ideas of 'the East' as unchanging and undifferentiated.

Hunt makes every effort to indicate through the figures of the rabbis what he considered to be the outmoded and blinkered nature of their faith (although Luke's account merely records their surprise at Christ's penetrating questions). Underlying these representations is a current of anti-semitism common in mid-nineteenth-century British culture. Rather than an attempt at documentary reconstruction or portrayal, each figure is a caricature in the Hogarthian tradition. For example, at the extreme left of the seated figures is an old rabbi, wedded to the letter rather than the spirit of the law, who clutches the scrolls of the law. In Stephens's words: 'Blind, imbecile, he cares not to examine the bearer of glad tidings, but clings to the superseded dispensation.' By contrast, the third rabbi from the left, younger and more alert, has been arguing with Christ. He is interrupted while stubbornly quoting from a religious text by the sudden entry of Mary and Joseph. On the right is a lazy and self-satisfied priest, whom Stephens describes as 'a huge sensual stomach of a man … wrapped in a maze of shawls and robes'. Squatting on a low settee, whose green upholstery can be discerned in the lower left, the rabbis are located beneath the level of Christ's head, effortlessly superseded by their superior, even though he is a mere boy. The rabbis are characterised by what Hunt would have considered their sensuous accoutrements, indicating the pleasures of the flesh – lavish, colourful clothing, wine, musical instruments – and by superstitious and excessive religious accessories including phylacteries, or *t'fillin*, small boxes containing scriptural passages and prayers worn strapped to the forehead and arm.

Some of the faces were painted from Jewish men in Jerusalem, but a prohibition on working for Gentiles meant that Hunt had difficulty finding models. Instead, he recruited them from the London Jewish community on his return in 1856. A major problem confronted him in the portrayal of Christ himself: having established such a hostile portrayal of Jewish culture, how could the British viewer identify with the figure of Christ? There was a danger that he might seem merely an Oriental 'other', like the rabbis. Although the light shines with supernatural intensity through his hair, Christ is not portrayed with a halo. Rather, Hunt differentiates Christ through his active posture. According to Stephens, his awkward pose identifies him 'as one who gird up his loins for labour', demonstrating an English virtue, in contrast to the

indolent and supine Oriental rabbis. It appears, however, that in the end Hunt painted the Christ child from an English schoolboy from the élite Eton College, named Cyril Flower. Stephens admired the 'fine Englishness of his idea of the splendid body of our Lord', a 'robust youth': this is the Broad Church conception of a man of action who wishes 'to be about his father's business'. The use of an English, Gentile model of course represents a further digression from the original project of aiming at absolute historical and ethnographic truth, and reveals the ideological nature of Hunt's work. The Holy Family group, a nuclear

family looking far more 'normal' and British, can also be read as a genre scene of the type beloved of the Victorian art market – the anxious parents reunited with their errant son. It was the convincing psychological dynamics of this group which led the *Athenaeum* to comment: 'Thoroughly English and Protestant is the thought of showing the virgin as the *mother* and not as the spiritualised ideality of the early Italian painters, or in the sensuously beautiful type of those who succeeded them.'

Pre-Raphaelitism is portrayed as a reforming force purifying art by rejecting decadent traditions, just as Protestantism had ousted the corrupt faith of the Catholic Church from England during the Reformation. Hunt's painting, widely considered at the time to be his finest work, may have been imperfect as a work of ethnology and archaeology, but it provided a convincing effect of veracity. The scene was historically Jewish and located in Palestine, but its method of representation and explanation was 'thoroughly English and Protestant'. It also rejected the allegory and symbolism of the Catholic Church and of academic tradition. In this way, the painting could claim to present religious truths while also articulating deeply held beliefs about the superiority of English Protestant culture which underpinned the imperial expansion of the second half of the nineteenth century.

Holman Hunt's nationalistic Protestantism is even more marked in his representation of a modern-day scene in Jerusalem, *The Miracle of the Sacred Fire* (FIG. 84), painted almost four decades after Hunt witnessed the ceremony at the Church of the Holy Sepulchre in 1855. The painting is wholly satirical in aim, a Hogarthian critique of the superstition of the Christian pilgrims and the incompetence of the Islamic authorities. The true spiritual flame of the Christian faith is neglected in favour of the search for material evidence of divine activity. The composition, like the events

84. WILLIAM HOLMAN HUNT
The Miracle of the Sacred Fire., 1893–9. Oil and resin on canvas, 36¼ x 49½" (92 x 126 cm). Fogg Art Museum, Harvard University Art Museums, Cambridge MA.

During the ceremony, the Greek patriarch in the city displayed a candle supposedly lit by an angel, the symbol of supremacy among the Churches. Each year, the different Christian sects – Greek, Armenian, Russian and other Orthodox Churches – battled for control of the Holy Sepulchre. They did so, as Hunt recalled, 'with so much unchristian fury and animosity ... [that] they have sometimes proceeded to blows and wounds even at the door of the very sepulchre'. The event was controlled by Turkish troops; the ruler of the city can be seen to the left of centre with his deputy leaning nonchalantly on his sword.

it represents, is chaotic, lacking any central focus and baffling the eye with a plethora of incident and detail. Ultimately, it is illegible and a failure both as a satire and as a work of art. A key detail, however, is the presence in the right corner of an English matron, soberly dressed, shielding her children from the excesses surrounding them. Here at last, Hunt implies, among the chaos, is a figure with whose sound sense we can identify, truly English and Protestant: it is against this English grouping that the otherness of the Eastern spectacle is set. As in Pre-Raphaelite modern-life painting, middle-class Victorian orthodoxies are presented as timeless norms.

Typological Symbolism

The painting of Christ was the central endeavour of Hunt's career. In *The Light of the World* and *The Finding of the Saviour in the Temple* he experimented with two modes – allegory and extreme historical authenticity – which produced startling results. But Hunt pursued still further the possibility of providing a visual analogue for an Evangelical reading and interpretation of the Bible. As the art historian George P. Landow has demonstrated, a key method of biblical interpretation was 'typological symbolism', where biblical events and individuals were understood as prefiguring future and more important events in the scriptures. Thus Samson, who gave his life for God's people, prefigured or became a 'type' of Christ who sacrificed his life for mankind. Typology is not the same as allegory, however, since the event depicted (or signifier) and the event alluded to (or signified) are both true and real. The story of Samson is important and coherent in its own right, as well as providing a pre-echo of the life of Christ. In an allegory such as Christ as the lamb of God, by contrast, the signifier (the lamb) has no 'real' significance but can be cast aside once its meaning (signified) has been identified.

Hunt's most extreme experiment with typological symbolism was *The Scapegoat* (FIG. 85). It refers to the Jewish ritual of atonement for the sins of the people described in the book of Leviticus. Two goats were selected: the first was sacrificed in the temple, but the second 'shall be presented alive before the Lord, to make an atonement with him, and let him go for a scapegoat into the wilderness ... and the goat shall bear upon him all their iniquities unto a land not inhabited' (16.10–22). In Holman Hunt's mind this scene immediately registered as a symbolic prefiguration of Christ's passion, and particularly of a memorable passage of Isaiah (53): 'He is despised and rejected of men ... Surely

85. **WILLIAM HOLMAN HUNT**
The Scapegoat, 1854–5. Oil on canvas, 34½ x 55″ (87 x 139.8 cm). Lady Lever Art Gallery, Port Sunlight, Merseyside.

The landscape itself was redolent with meaning for Hunt, from the distant hills to the salt sediment which the goat stumbles, as he recorded in his journal: 'the Sea is heaven's own blue, like a diamond more lovely in a king's diadem than in the mines of the Indes, but as it gushes up through the broken ice-like salt on the beach, it is black, full of asphalte scum – and in the hand slimy, and smarting as a sting – no-one can stand and say it is not accursed of God.' The frames of Hunt's major works often help to explain the meaning of the image. Here the frame bears two biblical inscriptions drawing attention to the parallel between the sacrifice of the goat and the passion of Christ. On the right side of the frame, a cross made up of circles supports a heartsease, a flower emblematic of the redemptive qualities of Christ, while at the left the dove holding an olive branch recalls God's promise to Noah. The obscure seven-star motif at the top of the frame represents the seven gifts of the Holy Spirit, while the seven-branched menorah on the lower edge symbolises God's mercy to the Jews.

he hath borne our griefs and carried our sorrows; yet we did esteem him stricken, smitten of God, and afflicted. But he was wounded for our transgressions, he was bruised for our iniquities: the chastisement of our peace was upon him: and with his stripes we are healed.' A red woollen band, described in the Talmud, was placed around the scapegoat's horns: if the animal was found alive and the red cloth had turned white, God was considered to have accepted the atonement. In *The Scapegoat* this fillet vividly prefigures Christ's crown of thorns. Hunt sought the rocks of Usdum on the Dead Sea (which he called 'the most desolate place in the world') as the site for *The Scapegoat* because it was thought to be the location of God's destruction of Sodom and Gomorrah, the sinful Cities of the Plain. The skeletons of other animals scattered around indicate the immediate fate both of the goat in this cruel terrain and of Christ on the cross.

The extraordinary exploits of the artist while painting *The Scapegoat* added an important dimension to Hunt's claim to be 'true to nature', and through them he established a new artistic identity for himself. In his published narratives and the private journals, Hunt describes the dangers of the Dead Sea region, among them 'the wildness of the few inhabitants, then the many deaths by fever that had occurred', and recounts numerous skirmishes with armed assailants. His fears, doubts and the nightmares recorded in the journal are suppressed in the heroic, published accounts. A tradition of imperial exploration literature provided the model for Hunt's definitive published account in *Pre-Raphaelitism and the Pre-Raphaelite Brotherhood* (1905). The following scene was recalled by Hunt from his time painting *The Scapegoat*:

> I suspended my painting and looked from beneath my umbrella, until suddenly the deeshman [armed tribesmen] emerged from behind the mountain within half a furlong of me where they all halted. The horsemen had their faces covered with black kufeyiahs, and carried long spears, while the footmen carried guns, swords and clubs ... I continued placidly conveying my paint from palette to canvas, steadying my touch by resting the hand on my double-barrelled gun. I knew that my whole chance depended upon the exhibition of utter unconcern, and I continued as steadily as if in my studio at home.

Hunt portrays himself as the manly, imperial hero, continuing to paint even in a situation of mortal danger. This was the image he promoted in an extraordinary photograph taken many years later, in which he recreated the act of painting *The Scapegoat*, gun

86. Photograph of Holman Hunt in the clothes worn in the Holy Land, c. 1895. Albumen print by an unidentified photographer, 7 x 8¾" (17.5 x 22.5 cm).

This photograph of Holman Hunt re-enacting his work on *The Scapegoat* was taken in the garden of his London house. The aggressive eye contact between Hunt and the viewer recalls Hunt's anecdotes in which hostile natives are seen off purely by the artist's force of character. His intention was clearly to underline the manly vigour and religious zeal of his enterprise in the Holy Land: yet to the post-Freudian viewer, the connotations of gun and brush are absurdly phallic.

under his arm and brush in hand (FIG. 86). But Hunt's work on *The Scapegoat* was not simply an exercise in imperial derring-do. The 1850s had seen the publication of David Livingstone's *Missionary Travels* (1857) and other accounts of religious evangelism in dangerous and unexplored places, and Hunt presented his own work as a religious labour. Ultimately, Hunt's period by the Dead Sea typologically echoes Christ's own withdrawal into the wilderness to endure temptation and search for spiritual truth. Hunt appears to have genuinely believed that he was fulfilling a divine purpose and noted in his diary: 'I commended myself to God's merciful protection from all the dangers ... I believe if I had not had [this] the comfortable assurance of his presence and defence of me – that I should have been overcome and creid [sic] like a child at the misery of my solitary position.'

The Scapegoat is paradoxical in carrying both realism and typological symbolism to the edge of credibility. A goat – traditionally a lowly animal at the fringes of cultivation – involved in an obscure and relatively barbaric ancient Jewish ritual is an extraordinary symbol through which to portray the passion of Christ. In terms of realism, Holman Hunt (having risked his life to do so) fearlessly transcribes the unfamiliar and garish hues of the Dead Sea land-scape at sunset and paints with minute fidelity the appearance of a starving goat. The critics found the difference between signifier (the ritual goat) and signified (Christ's passion) too great. As the *Athenaeum* put it:

The question is simply this, here is a dying goat which as a mere goat has no more interest for us than the sheep that furnished our yesterday's dinner; but it is a type of the Saviour, says Mr Hunt and quotes the Talmud. Here we join issue, for it is impossible to paint a goat though its eyes were upturned with human passion, that could explain any allegory or hidden type.

The painting is the work of an extremist, an artist insistent upon pushing his methods and talents up to and beyond acceptable limits. While it expresses a devotion to the typological interpretation of scripture typical of Victorian Evangelicalism, it commits sacrilege against the Academic canons of artistic good taste. Lurid, bombastic and yet redolent of the integrity of the fundamentalist, it is a deeply unsettling work.

A less extreme but more effective example of typological symbolism in Hunt's work is found in *The Shadow of Death* (see FIG. 75). The young Christ is seen stretching his arms and back after working in the carpenter's shop evoked with elaborate realism. Hunt insisted that it was 'strictly ... *historic* with not a single fact of any kind in it of a supernatural nature'. However, through the eyes of Mary, kneeling in front of a cabinet containing the gifts of the Magi, we see the shadow on the back wall which prefigures Christ's crucifixion, the shadow of death of the painting's title. Unlike Madox Brown in *Jesus washing Peter's Feet* (see FIG. 78), Hunt's completely naturalistic treatment precludes a halo or nimbus, but he suggests one by placing a rounded window behind Christ's head. Through the window can be seen a landscape whose fidelity rivals that of Seddon's *The Valley of Jehoshaphat*.

The Shadow of Death, like *The Scapegoat*, completely disavows traditions of religious representation. Instead, it draws together the Broad Church, and specifically Christian Socialist, ideal of Christ as a working man with the Evangelical obsession with biblical interpretation and exegesis. Hunt's is a manly, active Christ similar in physical type to the heroic navvies of Ford Madox Brown's *Work*. The figure of Christ as a labourer was central to the painting's meaning:

> Morally, [the subject] is this also: the bestowing of Life in trust for future and universal good, rather than for immediate personal joy. Surely there are enough of every class who have felt the burdensomeness of toil, the relief at its cessation; and enough also of those who have battled against the temptation to seek this world's glory at the expense of their peace with the silent father, who may be encouraged to persevere.

132 *Art, Religion and Empire*

Hunt's image reassured the Victorian viewer that heavenly rewards await those who work hard and maintain their integrity: once again a statement of the Protestant work ethic underpins a Pre-Raphaelite painting.

In 1873 the leading art dealers Agnew's exhibited *The Shadow of Death*. The publicity surrounding the work, like that for *The Scapegoat* in 1856 and *The Finding of the Saviour in the Temple* in 1860, made great play of the years of labour, in researching and painting, which Hunt had expended. As with the eleven years spent by Madox Brown on *Work*, Hunt had lived out the morals of his own imagery, an exemplar of the Protestant work ethic, a Pre-Raphaelite missionary. He did not, however, have to wait for heavenly rewards: the dealer Gambart paid him £5,500 for *The Finding of the Saviour* and he received the vast sum of £10,500 for *The Shadow of Death*. The dealers recouped their outlay through ticket receipts from exhibitions and from the sales of engravings. Very large numbers of prints of each image were made and, like those of *The Light of the World*, they circulated internationally. Displayed in schoolrooms and nurseries, church halls and parlours, Holman Hunt's were the most powerful religious images of the Victorian era.

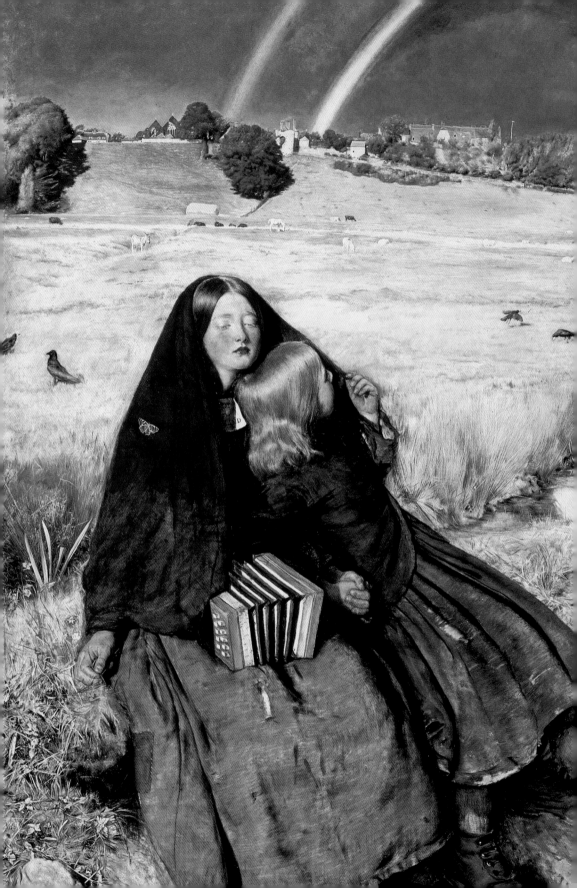

FIVE

Pre-Raphaelites and Aesthetes

T he circle of close friendships which united Millais, Holman Hunt, Madox Brown, Rossetti and Ruskin was of relatively short duration. By 1855, only seven years after the founding of the Brotherhood, each artist had begun to go his own way and the communality of the group was lost. Holman Hunt was travelling in the Middle East; personal antagonisms, such as that caused by the scandal of the annulment of Ruskin's marriage to Effie Gray and her subsequent marriage to Millais, accounted for further schisms. There were also artistic differences: Rossetti showed little concern or aptitude for working directly from nature, preferring fanciful medieval subjects; Millais, elected to Associate membership of the Royal Academy in 1853, appeared to be abandoning his early radicalism. The Brotherhood's disintegration was chronicled in a humorous sonnet by the poet Christina Rossetti, Dante Gabriel's sister:

> The P.R.B. is in its decadence:
> For Woolner in Australia cooks his chops,
> And Hunt is yearning for the land of Cheops;
> D.G. Rossetti shuns the vulgar optic …
> And he at last the champion great Millais,
> Attaining academic opulence,
> Winds up his signature with A.R.A.
> So rivers merge in the perpetual sea;
> So luscious fruit must fall when over-ripe;
> And so the consummated P.R.B.

87. JOHN EVERETT MILLAIS *The Blind Girl*, 1856. Oil on canvas, 32½ x 24½" (82.5 x 62 cm). Birmingham Museum and Art Gallery.

Yet much of the most important and characteristic work of the Brotherhood and its associates was carried out in the second half of the 1850s, with Rossetti, Holman Hunt and Madox Brown

all exploring rich, though separate, veins of imagery. After 1855, Millais entered new territory with figure subjects in landscapes more freely painted than hitherto. Moving away from narrative, he began to create an art which appealed directly to senses, exploring the possibilities of contrived harmonies of colour in place of the jarringly radical realism of earlier years. In the 1860s, Rossetti, having abandoned the Pre-Raphaelite style of his early years, increasingly assumed the leadership of an *avant-garde* circle which included William and Jane Morris, Burne-Jones, Elizabeth Siddall, Frederick Sandys (1829–1904) and Simeon Solomon (1840–1905), as well as literary figures such as Algernon Swinburne. Unlike the Pre-Raphaelite work of the early 1850s, which was controversial and widely discussed, Rossetti's later output was known only to a select group of intimates and patrons: indeed, he exhibited virtually nothing in public after 1850. He became widely known only at the time of the memorial exhibitions, held by the Royal Academy and Burlington Fine Arts Club in 1882–3. Often mistakenly referred to as 'Pre-Raphaelite' in style, works painted during the 1860s by this group of artists loosely connected with Rossetti resist easy categorisation. The broad trend was a move away from the Hogarthian narrative structures and the Ruskinian commitment to truth to nature established by Hunt, Millais and Brown in the 1850s. Other issues began to predominate: the representation of sexual desire and eroticism; the relationship between the arts; and experiments with form, colour and expression. Some themes, however, persisted, notably the medievalism which had stimulated Rossetti's imagination from the first.

Millais in 1856: Evocations of Mood

While Hunt was in the Holy Land, carrying the symbolic realism of the early Pre-Raphaelite period to extremes, Millais, liberated from the influence of Ruskin, moved in different directions. Two paintings he exhibited at the Royal Academy in 1856 indicate a new departure: moving away from narrative and a symbolic structure in which represented objects can be decoded one by one, they turn to the evocation of mood and theme. Each of these paintings – *The Blind Girl* (FIG. 87) and *Autumn Leaves* (FIG. 88) – has an underlying theme, but neither has the kind of narrative which a Victorian patron would expect from a genre painting, or indeed would have found in most of the earlier works of the PRB. *The Blind Girl* could certainly be read as a modern-life painting, drawing attention to the plight of a blind child reduced to poverty. The image could also be under-

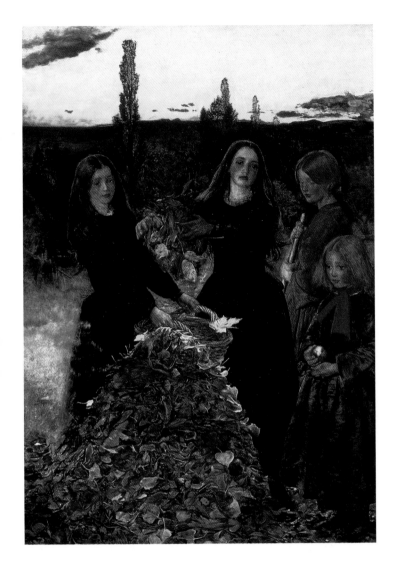

88. JOHN EVERETT MILLAIS *Autumn Leaves*, 1856. Oil on canvas, 41 x 29″ (104.3 x 74 cm). Manchester City Art Galleries.

stood as a luminous and brilliantly coloured study of a land-scape (partly painted outside Winchelsea in Sussex), transcribing the effects of light immediately before an approaching thunderstorm. But its underlying theme can be seen in retrospect to indicate some of the directions in which British art was shortly to develop. This is a painting about the senses: while the blind girl is unable to see the spectacular natural scene, her younger sister turns to enjoy it. The blind girl, however, touches the grass with her right hand, and smells the damp earth. She can also enjoy the natural world through hearing – the cawing of the crows in the background, and the concertina on her lap also hints at her affinity with sound.

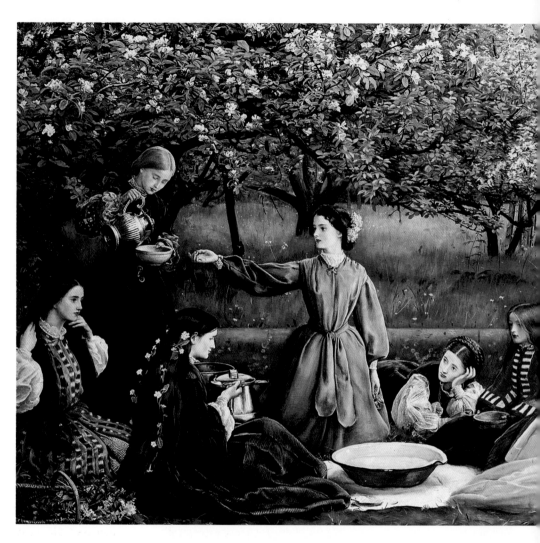

89. JOHN EVERETT MILLAIS
Spring (Apple Blossoms),
1856–9. Oil on canvas,
3'7½" x 5'8" (1.11 x 1.73 m).
Lady Lever Art Gallery, Port
Sunlight, Merseyside.

These aspects of the painting can thus be 'decoded' in the same way as earlier Pre-Raphaelite images of modern life, such as Holman Hunt's *The Awakening Conscience* (see FIG. 65). But it is organised to appeal directly to the senses as a formal arrangement of masses of colour: the deep, burnished orange of the girl's skirt and shawl contrasts with the pale green band of countryside behind, which is itself set off against the stormy purple of the sky. This increased concentration on the values of form and colour, as against the Hogarthian virtues of description and storytelling, mark the later phase of Pre-Raphaelitism.

Autumn Leaves was painted in the garden of Annat Lodge in Perth, where John Everett and Effie Millais set up home after their marriage on 3 July 1855. Undoubtedly the image had its origins in actual perceptions of nature. Holman Hunt later recalled

Millais as having asked: 'Is there any sensation more delicious than that awakened by the odour of burning leaves? To me nothing brings back sweeter memories of the days that are gone; it is the incense offered by departing summer to the sky.' Effie Millais described her husband's aspiration to paint 'a picture full of beauty and without subject', and he conceived of this image of young girls burning leaves in autumn just after sunset as providing a perfect opportunity for the evocation of a dark and reflective mood. The tonality of the painting, with the rich bronzes and reds of the autumn leaves, and the reflected colour of the flames of the bonfire, catching the ruddy complexions of the girls, suggests both youth and mortality. It has no narrative, no action: static, decorative but monumental, the whole composition serves as a metaphor for autumn itself. The season's place in the cycle of the year, its overtones of death and decay, were overlaid with both religious and poetic references. Millais wrote to thank Stephens for a review in which he cited as a relevant text a passage from Isaiah (19.18–19): 'For wickedness burneth as the fire: it shall devour the briers and thorns, and shall kindle on the thickets of the forest: and they shall mount up like the lifting of the smoke.' Millais was delighted at Stephens's recognition that the painting was far more than a mere genre painting of girls in a garden: 'I have always felt insulted when people have regarded the picture as a simple little domestic episode, chosen for effect, and colour, as I intended the picture to awaken by its solemnity the deepest religious reflection.' The only actual symbol in the painting is the apple held by the youngest girl to the right, indicating Eve's temptation of Adam and the Fall. But apples do ripen in the early autumn, and the painting relies for its impact not on the decoding of such symbols but rather on the Tennysonian colouration and mood of the image.

Millais was to hint again at such a theme in the ostensibly cheerful and celebratory *Spring* (FIG. 89), begun in the Annat Lodge garden in 1856 but not completed until 1859. This painting, with its similar cast of characters again including Sophie and Alice Gray, Effie's younger sisters, forms a thematic pendant to *Autumn Leaves*, although it is larger in size and painted in horizontal format. The apple blossoms form a decorative frieze, hinting at the arabesques of the wallpapers William Morris began to produce in the 1860s. Below this is a green band of grass, painted rather

vaguely. Arranged along the bottom of the canvas are the bright blocks of colour formed by the shining dresses of a party of girls. In their early teens, and thus on the verge of sexual maturity, they are surrounded by symbols of natural fecundity and blossoming. Yet the bizarre presence of a scythe at the extreme right of the composition unsettles the viewer. It is menacingly juxtaposed with the unabashed girl in a bright yellow dress, whose pose uncannily echoes that of a funerary statue. The scythe is traditionally a symbol of death, the grim reaper or harvester of souls, indicating that youth and beauty, which promise to last for ever, will always decay into death.

Do these works represent a withdrawal from the intense 'truth to nature' of the earlier Millais? In one sense *Autumn Leaves* clearly does: partly as a result of the waning light of dusk, adding a mysterious quality to the landscape, objects are defined with less precision than they were, for example, in Millais's *Portrait of Ruskin*. Yet, the leaves in the foreground and the silhouettes of the poplar trees etched against the golden glow of the sky, are rendered with startling veracity from actual natural phenomena. *The Blind Girl* and *Spring* also incorporate passages of intense, hard-edged, Pre-Raphaelite detail alongside areas of broader and more allusive brushwork. The trio of paintings begun in 1855–6, astonishing in their sheer visual power, were transitional works. Later, in canvases such as *Chill October* (1870; see FIG. 57), Millais moved towards a more gestural and thickly impasted style of painting, in search of grander effects; there was a gradual lessening of the extraordinary intensity of detailed observation which marked his early work.

Rossetti and Elizabeth Siddall

Rossetti's medievalising watercolours of the 1850s followed a different route to an art which made a direct appeal to the senses. Taking the richly saturated colours and lack of perspectival space of illuminated manuscripts as a starting point, in watercolours such as *The Wedding of St George and Princess Sabra* (see FIG. 28), Rossetti created a decorative and sensuous world of the imagination quite at odds with the aspirations of the other Pre-Raphaelites. In this watercolour, the flattening out of pictorial space and the creation of a decorative surface is combined with the eroticism which came to dominate his later output. Where Ruskin had described Millais and Holman Hunt as painting 'stern facts' instead of making 'fair pictures', Rossetti was doing exactly the opposite. He created visionary images in which the work of art was not

directed towards moral, narrative or descriptive ends, but existed as a thing of beauty, complete in itself. Yet despite Rossetti's apparent disregard for the ideas laid out in *Modern Painters*, Ruskin became close to the artist in the late 1850s, recommending his friends to purchase Rossetti's works and even persuading the artist in 1855 to join him on the teaching staff of the Working Men's College. The critic, like many other acquaintances, was captivated by the poetic intensity of Rossetti's watercolours and also by his personal magnetism.

Ruskin had also become an important patron of Elizabeth Siddall. As the art historians Griselda Pollock and Deborah Cherry noted in 1984, the large literature on Pre-Raphaelitism had marginalised Siddall as an artist, concentrating instead on her role as a model for the Pre-Raphaelites, notably for Millais's *Ophelia* (see FIG. 41), and on her long and tortuous affair with Rossetti which finally ended in their marriage in 1860. Through art history's characterisation of her merely as Rossetti's model, muse, lover and wife, Siddall had 'become merely a cipher for masculine creativity inspired by and fulfilled in love for a beautiful feminine face'. Although its title is a later addition, Rossetti's drawing *The Artist sitting to Elizabeth Siddall* (FIG. 90) raises the interesting question, who is the artist: Rossetti or Siddall? The image emblematises Siddall's dilemma as one who, even while making representations herself, is represented by men.

Siddall became a protégé of Ruskin, who recognised her considerable talents: in return for an allowance of £150 per quarter, he demanded first refusal of her medievalising drawings and watercolours, such as *The Lady of Shalott* (FIG. 91). While this tiny work bears similarities with earlier drawings by the Pre-Raphaelite

90. DANTE GABRIEL ROSSETTI *The Artist sitting to Elizabeth Siddall*, 1853. Pen and brown ink, 4¼ x 6¼" (10.6 x 16.2 cm). Birmingham Museum and Art Gallery.

The early historians of Pre-Raphaelitism were especially reluctant to acknowledge the artistic talents of a woman who was of relatively humble origins. Elizabeth Siddall was born in 1829: her father, a native of Sheffield, ran a cutlery business in London. While his sons followed him into the trade, his daughters, including Elizabeth, or 'Lizzie', went into dressmaking and millinery. After sitting for Millais late in 1851, she gradually joined the Pre-Raphaelite circle and began drawing and painting.

91. ELIZABETH SIDDALL
The Lady of Shalott, 1853.
Pen, black ink, sepia and
pencil on paper, 6½ x 8¾"
(16.5 x 22.3 cm). Private
collection, Sussex.

Brothers (see FIGS 19 and 20), it is revealing of Siddall's independent identity as a woman artist in a male-dominated, largely homosocial environment. It is based on lines from Tennyson's Arthurian poem 'The Lady of Shalott' first published in 1832. The Lady is compelled by a mysterious curse to weave a tapestry depicting scenes reflected in her mirror and never to look into the real world. Siddall herself had begun her working life as a dressmaker and the image of a skilled woman at work weaving a large and thankless textile may well have had personal resonances. The poem replicates in a medieval setting the Victorian ideology of separate spheres: as in Madox Brown's *Waiting: An English Fireside* (see FIG. 62) woman's work is inside the home, while active work in the outside world remains a male preserve. Masculinity is represented in *The Lady of Shalott* by Sir Lancelot, who appears armed and on horseback in the mirror. At this moment the Lady looks out of the window at Camelot, with disastrous consequences:

> Out flew the web and floated wide;
> The mirror crack'd from side to side;
> 'The curse is come upon me', cried
> The Lady of Shalott.

Yet the broken looking-glass and the collapsing loom have no effect on Siddall's Lady. In the poem the Lady is helplessly bound by forces beyond her control; but Siddall selects the one moment when she is in control of her own destiny: in Siddall's drawing, as Deborah Cherry has noted, 'the Lady is represented at the moment of *her* look'. Holman Hunt, in a vast, late oil painting representing the same moment in the story (FIG. 92), shows the Lady recoiling in horror as her world falls apart. Surrounded by cluttered exotica reminiscent of the late Victorian parlour, she has failed to live out the role of the respectable matron (though her samovar resembles that of Mrs Fairbairn in Hunt's *The Children's Holiday*; see FIG. 58). Neither does she have the fortitude of the suffering Victorian spinster unable to achieve the married state (who features in Arthur Hughes's *The Long Engagement*;

92. WILLIAM HOLMAN HUNT
The Lady of Shalott, 1886–1905.
Oil on canvas, 6'2" x 4'9½"
(1.88 x 1.46 m). Wadsworth
Atheneum, Hartford,
Connecticut.

see FIG. 64). Hunt denies her the brief triumph implicit in the calm, empowered gaze of Siddall's Lady; rather, she is pathologised as a madwoman, twirling amid the chaos of her weaving, having partaken of the forbidden fruit by looking where she was not allowed to look. With her hair performing a wild arabesque, her oriental shoes tossed carelessly aside, she is a sensuous figure, a part of the gorgeous, excessive spectacle of Hunt's painting, to be looked at and enjoyed by the male viewer. Unlike Tennyson's poem, which clearly sympathises with the Lady's loneliness and pent-up sexual frustration, Hunt saw her as illustrating 'the failure of a human Soul towards its accepted responsibility'. In his last major work, Hunt preached what he practised – the unswerving adherence to a particular doctrine, in his case that of early Pre-Raphaelitism. Any departure from a stated mission was written off as insanity. By contrast, Siddall's Lady, in control of her tragic destiny, is self-contained and decorous.

Another modest drawing by Siddall, *Pippa Passing the Loose Women* (FIG. 93), illustrates a poem by Robert Browning, set in the Renaissance city of Asolo. Prostitutes sit on some steps discussing their lovers, while the virginal Pippa walks by. As noted in Chapter Three, prostitution was an important social issue of the 1850s. Siddall came from a relatively lowly family and her career as an artist's model potentially compromised her in the eyes of respectable opinion. Some of Rossetti's later circle, including his housekeeper and mistress, Fanny Cornforth, have been associated with prostitution: Siddall, however, seems to have adhered rigidly to Victorian proprieties, for example, by never modelling nude. The image suggests a strong identification with the unimpeachable Pippa, the precise, almost prim, linearity of the drawing underlining its message. Browning was reported to be 'delighted beyond all measure' with a design considered by Rossetti 'in spite of immature execution' to be 'full of very high genius'.

Siddall's relationship with the wayward Rossetti was tempestuous in the extreme, both before and after their marriage in 1860. After being delivered of a stillborn child in 1861, she suffered from what was probably post-natal depression, and became steadily

93. ELIZABETH SIDDALL *Pippa Passing the Loose Women*, 1854. Ink on paper, 4¾ x 3¼" (12.2 x 8.9 cm). Ashmolean Museum, Oxford.

94. DANTE GABRIEL ROSSETTI
Beata Beatrix, 1864–70. Oil
on canvas, 34 x 26″ (86.4 x
66 cm). The Tate Gallery,
London.

Dante's *Vita Nuova*
recorded the poet's
unrequited love for Beatrice
Portinari, and his mourning
after her premature death: it
became especially poignant
for Rossetti after his wife's
death.

more addicted to laudanum, an opiate which was readily available
in Victorian London. Her death of an overdose in 1862 was pos-
sibly a suicide: biographers have dwelled at length on Rossetti's
remorse, and his act of contrition in throwing manuscripts of
his poems into her coffin, only, in a ghoulish scene, to disinter the
body to remove them again in 1869.

Beata Beatrix (FIG. 94) stands as Rossetti's homage to the mem-
ory of his wife: from early in their relationship he had drawn par-
allels between their love and that of Dante and Beatrice, his
own identification with the Italian poet after whom he was named
being especially vivid. Describing *Beata Beatrix*, Rossetti explained
in 1873:

> The picture must of course be viewed not as a representa-
> tion of the incident of the death of Beatrice, but as an ideal of

the subject, symbolised by a trance or sudden spiritual transfigura-
tion. Beatrice is rapt visibly into Heaven, seeing as it were
through her shut lids (as Dante says at the end of Vita Nuova)
'Him who is Blessed throughout all ages': and in sign of the
supreme change, the radiant bird, a messenger of death, drops
the white poppy between her open hands.

The city of Florence can be seen dimly in the background, a golden
glow silhouetting the Ponte Vecchio; the distant figure of Dante,
to the right, catches sight of the departing allegorical figure of
Love, seen in a red gown at the left of the painting; a sundial
to the right records the hour of Beatrice's death. The symbols
are similar to those in Rossetti's medievalising *Dantis Amor* (see
FIG. 30), but the style is radically different. The dreamlike, glow-
ing haze which engulfs the swooning Beatrice in the later paint-
ing could not be further from the heraldic clarity of the earlier.
The poet Algernon Swinburne described *Beata Beatrix* as por-
traying 'death-like trance that is not death', and by it Rossetti
seems to imply a connection between the vision of death and
the state of sexual ecstasy.

Bocca Baciata

In 1859, Rossetti returned to oil painting, a medium in which
he had produced little work since the early 1850s. The small panel
Bocca Baciata (FIG. 95), initially begun as a portrait of Rossetti's
mistress Fanny Cornforth, has been read biographically as a
symbol of the temporary shift in Rossetti's affections away from
Elizabeth Siddall to the very different figure of Cornforth. This
has been interpreted as a move from a spiritual muse to one
more sensual. The painting is intensely physical, placing the figure
in challenging proximity to the viewer and emphasising with a
carefully layered paint surface the three-dimensionality of hands,
neck and facial features. The title, *Bocca Baciata*, 'the kissed mouth',
is taken from a line by Boccaccio, the fourteenth-century Ital-
ian writer. To choose an early Renaissance source was entirely
in keeping with Rossetti's practice as a Romantic revivalist.
But with this painting a new genre emerged which preoccupied
Rossetti for the rest of his career. Neither narrative painting,
literary illustration, nor portrait, *Bocca Baciata* carries elements
of each. The idealised, sensual image of a single female, or group
of females, became the central theme in Rossetti's output. Women
are seen surrounded by luxurious accessories, many of them
from the collections of oriental and medieval objects which

filled Rossetti's Chelsea home. Through these images, Rossetti created icons of woman as the exotic object of sexual desire; however, in contrast to earlier Pre-Raphaelite works, he extended the repertoire of images of femininity to include a self-possessed and self-absorbed sensuality and an increasingly monumental and dominant scale. If 'woman' continued to be a sign of Rossetti's own creativity, then the image of woman which Rossetti

95. DANTE GABRIEL ROSSETTI *Bocca Baciata*, 1859. Oil on panel, 12¾ x 10¾" (32.2 x 27.1 cm). Museum of Fine Arts, Boston.

favoured from 1859 onwards was a more powerful and challenging one than before.

In *Bocca Baciata*, the woman's loose hair, unbuttoned bodice and her association with flowers, exotic jewellery and that symbolic fruit the apple, seem to lead to an interpretation of her as a temptress, a siren who will lead men to their doom. But this reading of the painting contrasts with the line from Boccaccio's *Decameron* inscribed on the reverse of the panel: 'the mouth that has been kissed does not lose its savour, indeed it renews itself just as the moon does'. The forbidden kiss of the adulteress is not poisoned and deadly, it seems, but promises renewed delight, sentiments which completely disregard conventional mid-Victorian morality, however much they may reflect the experiences of Rossetti's life. There is no implied moral condemnation: on the contrary, the painting seems to offer the (male) viewer untroubled erotic pleasure rather than matter for intellectual and moral judgement. In contrast to such a work as Homan Hunt's *The Awakening Conscience* (see FIG. 65), where the meanings of each symbol are spelled out, and the moral position of the artist is clearly delineated, *Bocca Baciata*, overtly sensual in its appeal, can sustain a number of readings: indeed, reading ceases to be an appropriate metaphor for the viewer's relationship to the image. This was deeply troubling to Holman Hunt, among others. Writing in his memoirs years later, Hunt recalled seeing *Bocca Baciata* exhibited at the Hogarth Club in 1860. At the time, he perceived that 'Gabriel ... had now completely changed his philosophy, which he showed in his art, leaving Stoicism for Epicureanism ... He executed heads of women of voluptuous nature with such richness of ornamental trapping and decoration that they were a surprise, coming from the hand which had hitherto indulged in austerities.' This published text contained only coded criticism of Rossetti's increasing sensuality. In a letter to the Pre-Raphaelite patron Thomas Combe, written on 12 February 1860, Hunt was more explicit in his moralistic critique: 'It impresses me as very remarkable in power of execution – but still more remarkable for gross sensuality of a revolting kind, peculiar to foreign prints, that would scarcely pass our English Custom house from France.' Hunt clearly identifies Rossetti's work with pornography, an emerging medium in the 1850s, which he considered to be both foreign and degrading. Notwithstanding the eroticism of some of his own work, such as *The Afterglow in Egypt* (see FIG. 80), Hunt was incensed by what he saw as Rossetti's challenge to the moral aims of art, so central to his own Evangelical project: 'I see Rossetti is advocating as

a principle the mere gratification of the eye if any passion at all – the animal passion to be the aim of art.' To remove the narrative constraints which direct aesthetic pleasure to morally acceptable ends, a central tenet of the early Pre-Raphaelitism of Hunt, Brown and even Millais, is to condone a kind of moral chaos. An art without a controlling narrative offers an unmoralised optical pleasure to the viewer: in Hunt's eyes, it celebrates unrestrained sexuality on the part of both men and women. This is an inversion of the promotion of circumscribed, respectable sexual behaviour attempted by the narrative modern-life paintings discussed in Chapter Three.

In a significant remark to his friend the artist George Price Boyce, who purchased *Bocca Baciata*, Rossetti acknowledged that the painting 'has taken after all a rather Venetian aspect'. The costume alludes to the sixteenth century, and the opulent colouration and brushwork, the attempt at painterliness, is far closer to the example of Venetian sixteenth-century (and thus post-Raphaelite) painters such as Titian and Veronese, than it is to the medieval and early Renaissance sources which had given the Pre-Raphaelites their name. Venetian art was increasingly fashionable from the late 1850s onwards, and the opulence of the Venetian painters increasingly characterised Rossetti's work of the 1860s and 1870s.

The Condition of Music

The idea of art for art's sake, a self-contained art which does not need to refer to the debates and issues or even the appearance of the outside world, emerged as the central doctrine of the Aesthetic movement in the late 1860s. Hardly a coherent movement, less still a Brotherhood with a fixed membership like the Pre-Raphaelites, Aestheticism can be thought of as a shared temper of mind which linked creative artists across a range of disciplines from poetry to painting, the decorative arts and sculpture. Although the idea of *l'art pour l'art* had for some time been promoted by French critics such as Charles Baudelaire, Swinburne may have been the first to use the phrase 'art for art's sake' in English, in his biography of William Blake published in 1868. The phrase was used quite loosely, but it clearly implied that art should not attempt to moralise or evangelise: Swinburne insisted that art must not be the 'handmaid of religion, exponent of duty, servant of fact [or] pioneer of morality'. Art should rather concern itself with beauty, whether of pure form, of bodily sensuality, or of association. These ideas contravene one of the central

tenets of Pre-Raphaelitism, as defined by Holman Hunt, and force-fully restated in 1860 by F. G. Stephens: 'Above all [the PRB] deter-mined that these pictures should at least *mean* something.' Early Pre-Raphaelitism was above all a literary form of art, closely allied with texts including Shakespeare, Tennyson and the Bible and often reliant on a further text to explain the pictorial symbol-ism and detail. The narrative content and moral significance of each work could, likewise, be paraphrased in language. Its mis-sion was to describe and to explain. In the 1860s, by contrast, Ros-setti and his associates preferred to draw analogies with music. A purely abstract form of art, music by and large had neither nar-rative nor meaning, but could nonetheless produce powerful emo-tions in the listener. In 1877, in his essay on Venetian art, 'The School of Giorgione', Walter Pater encapsulated this aesthetic pro-ject in a simple phrase: 'all art constantly aspires towards the condition of music'.

Parallels between art and music can be seen in Rossetti's *The Blue Bower* (FIG. 96) through the gentle motion of the woman's fingers across an oriental instrument. Now identified as a *koto* from Korea, Rossetti almost certainly did not know what it was, but bought it for its appearance and its links with an exotic Far Eastern world. Rossetti in fact had no ear for music, but he nevertheless proposed that the pattern of tones and textures by which it produced aesthetic pleasure provided an exact analogy with what he was trying to do in his paintings. It is as if each of the opulent colours he used represented a note in a chord, the total effect being a rich harmony.

Like *Bocca Baciata*, *The Blue Bower* is a painting of great sensual appeal, again modelled by Fanny Cornforth. It equates the viewer's consumption of the luscious paint surface and opulent colours with the potential sexual availability of the woman por-trayed. A parallel exoticism is indicated by the flowers, remark-able more for the impression they give of a heavy scent than for their symbolism. The passion flowers are explained by their name alone, though their use contrasts vividly with that by Collins in *Convent Thoughts* (see FIG. 40), where the single passion flower symbolises the passion of Christ. Cornflowers in the foreground not only add another lighter shade of blue to the painting's explo-ration of that colour, but also pun on Cornforth's surname. Yet despite these hints of references, *The Blue Bower* is without mean-ing. A ravishing image, it appeals simultaneously to all the senses – vision, hearing, touch and smell. Neither a portrait of a named individual nor a meaningful character study, it exemplifies art for art's sake.

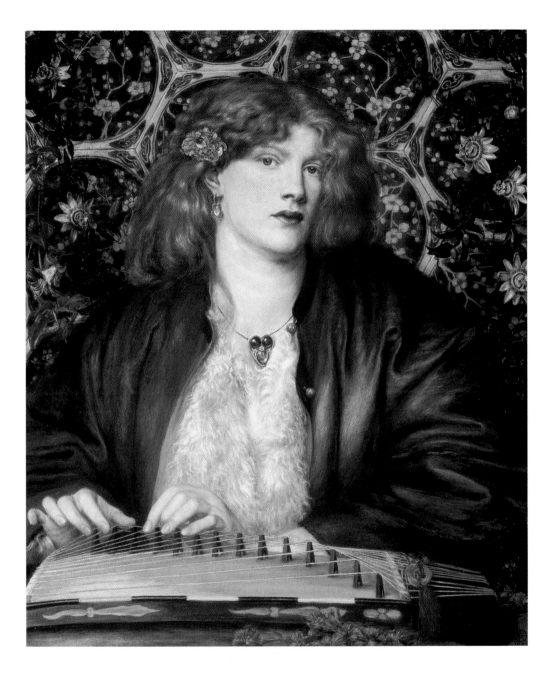

96. Dante Gabriel Rossetti
The Blue Bower, 1865. Oil on canvas, 33 x 27¾" (84 x 70.9 cm). Barber Institute of Fine Arts, University of Birmingham.

The painting is organised around the contrast between the dominant green and blue tonalities of the robe and oriental tiles, and the model's striking light ginger hair.

The atmosphere of sensuality and eroticism is heightened by Rossetti's reference, through the Japanese tiles and the *koto*, to the Orient. A fascination for the Orient was a keynote of the Aesthetic movement, but this interest was not directly allied to the imperial myths of supremacy beloved of Holman Hunt. Rather, the Aesthetes preferred an equally mythical idea of the East as a paradise of sensual delight and refinement (FIG. 97). Japanese objects were a particular focus for the Chelsea set's acquisitive passions. Japan had opened up to European trade under the Treaty of Edo of 1858: Japanese goods became widely available and made an important contribution to the success of the 1862 International Exhibition at South Kensington. In the background of *The Blue Bower* Rossetti may have used as his source the top of a Japanese tea jar – a typical collector's item of the 1860s – rather than real tiles, repeating the pattern to create the correct rhythm.

Rossetti returned to the theme of art and music in *Veronica Veronese* (FIG. 98): in this case, the model was Alexa Wilding, whom Rossetti had 'discovered' in 1866. It was commissioned

97. DANTE GABRIEL ROSSETTI *The Beloved*, 1865–6. 32½ x 30" (82.6 x 76.2 cm). The Tate Gallery, London.

The subject is from the biblical Song of Solomon: the line 'My beloved is mine and I am his' is inscribed on the frame, with other biblical texts alluding to physical attraction and pleasure. Rossetti's Orientalism is apparent in the Japanese kimono worn (incorrectly) by the central figure and her intricate leather headdress, which was Peruvian in origin. The figures in the painting are similarly exotic: the black boy in the foreground is sensuously portrayed and the model for the figure on the right was a gypsy, Keomi, who became the mistress of the artist Frederick Sandys. In a further racial allusion, the figure behind Keomi appears to be Asian. Racial types, characterised by their 'otherness', are presented in the same way as the flowers, textiles, metalwork and jewellery – an exotic spectacle for the delectation of the male viewer.

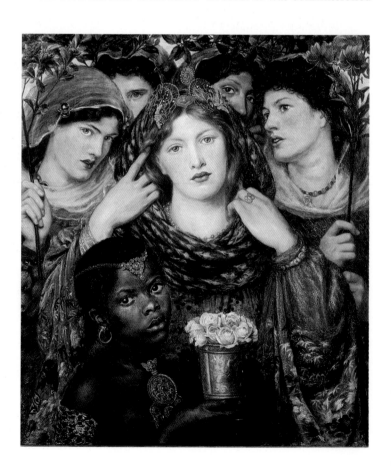

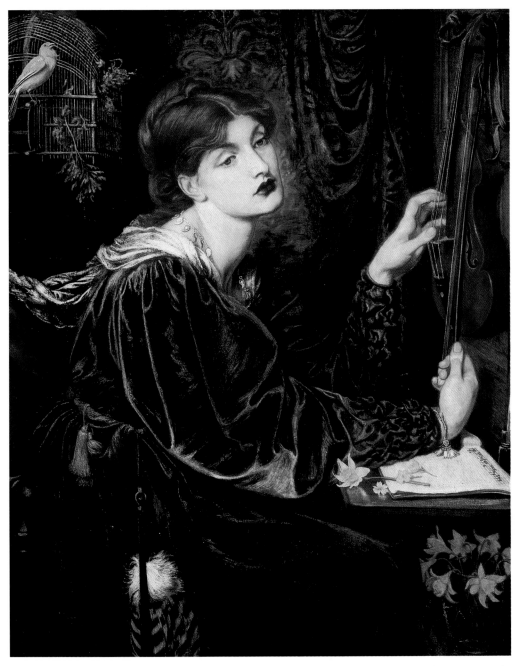

98. Dante Gabriel Rossetti
Veronica Veronese, 1872 (detail). Oil on canvas, 43 x 34¾" (109.2 x 88.8 cm). Delaware Art
Museum, Wilmington.

The painting's title, which simply means 'Veronica from Verona', immediately associates the work
with the great sixteenth-century colourist Veronese, who spent most of his career in Venice. The
luxuriant green and the sheen of the woman's velvet sleeves particularly recall Veronese's work.

99. The Drawing Room, 49 Princes Gate, London, residence of F. R. Leyland in 1892. Photograph by Bedford Lemere.

Frederick Leyland's magnificent collection of the work of Rossetti and Whistler was displayed here at his London residence. Among the works in the drawing room, Rossetti's *Lady Lilith* (1864–8) and *Veronica Veronese* (see FIG. 97) can be seen on the wall to the right. The sumptuous interior provided the perfect setting for these works: Aesthetic taste demanded that paintings should be hung in a single row in place of the double or triple hang of previous generations.

by Frederick Leyland, the Liverpool shipping magnate who assembled an unrivalled collection of Rossetti's images in his opulently decorated residence at 49 Prince's Gate in Kensington, where in 1876-7 Rossetti's friend James McNeill Whistler (1834–1903) decorated the famous 'Peacock Room'. *Veronica Veronese* hung in the drawing room (FIG. 99) as part of a series of Rossetti's images of women. They fitted perfectly into this sophisticated context, where the decorative qualities of objects were considered more important than their meanings. A visitor described the room as 'the shrine of some of the most completely beautiful productions of modern English art'. *Veronica Veronese* carries yet further the concept of the languid female in a painting wholly grounded in a single tonality: indeed, the artist referred to it as 'chiefly a study of varied Greens'. Rossetti described the woman as being 'in a sort of passionate reverie', and again she appears to have given herself over to the sensuous pleasure of sight, touch, smell and sound.

Music is, again, the key to the image. Leyland was a keen amateur musician for whom Aestheticism's parallels between art and music would have been especially significant. The woman listens, enraptured, to the singing of a bird. Our experience as viewers of the opulent beauty of *Veronica Veronese* (the woman and the painting) parallels that of the woman herself listening to the sound of the yellow bird. Rossetti described the title 'Veronica Veronese' as sounding 'like the name of a musical genius' and the woman has been writing music on the page of a blank book in front of her. She has stopped in the act of plucking the strings of the violin before her while the bird's song provides inspiration for her creativity. This returns us to the dilemma of Elizabeth Siddall as a woman artist and a Rossettian ideal beauty. Has Rossetti empowered one of his heroines with the ability to create, rather than simply to be enjoyed? It seems unlikely. Those recognised as musical geniuses have invariably been male, and the fatal hesitation of *Veronica Veronese* condemns her to listen and be looked at, rather than to create.

Bohemianism and the Erotic

Shortly after the death of his wife in 1862, Rossetti moved to Tudor House, on Cheyne Walk in Chelsea, a spacious building by the River Thames, where he gathered around him a group of artists and writers. Some, like the poets Swinburne and George Meredith and the artist Sandys, were periodic residents. Others, including the artist Simeon Solomon and the members of the 'Red House' group, William and Jane Morris and Edward and Georgiana Burne-Jones, were frequent visitors. The culture of Tudor House can be characterised by the term 'Bohemian'. As the art historian Elizabeth Prettejohn notes in her illuminating discussion of Rossetti and his circle, the term derived from a belief that gypsies had migrated from the central European kingdom of Bohemia. Gypsies stood outside conventional morality, were strikingly dressed and associated with sexual freedom and even promiscuity. In nineteenth-century France, the term Bohemian had come to denote artists and writers who disavowed respectability. In 1862 French ideas had entered Tudor House with James McNeill Whistler, a self-confident young American painter who had graced avant-garde circles in Paris before moving to London.

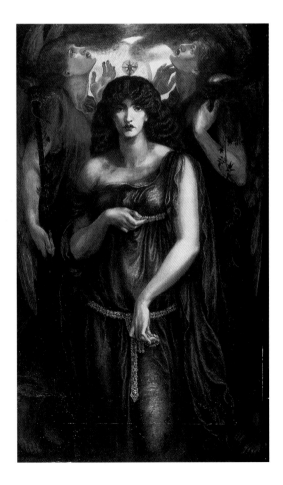

100. DANTE GABRIEL ROSSETTI
Astarte Syriaca, 1875–7. Oil on canvas, 6′ x 3′6″ (1.85 x 1.09 m). Manchester City Art Galleries.

Rossetti's later works carried eroticism to a new intensity. His ambitious and monumental *Astarte Syriaca* (FIG. 100) represents the culmination of his sequence of images of women, representing 'the Syrian Venus with ministering spirits'. He composed a sonnet for the painting:

> Mystery, lo! betwixt the sun and moon
> Astarte of the Syrians: Venus Queen
> Ere Aphrodite was. In silver sheen
> Her twofold girdle clasps the infinite
> boon
> Of bliss whereof the heaven and earth
> commune:
> And from her neck's inclining flower-
> stem lean
> Love-freighted lips and absolute eyes-
> that wean
> The pulse of hearts to the spheres'
> dominant tune.

Torch-bearing, her sweet ministers compel
All thrones of light beyond the sky and sea
The witnesses of Beauty's face to be:
That face, of Love's all-penetrative spell,
Amulet, talisman, and oracle, –
Betwixt the sun and moon a mystery.

The original title of the painting was 'Venus Astarte', alluding to the all-powerful love goddess of ancient Syrian culture of the pre-Greek era, indicating Rossetti's interest in Eastern mythology. The positioning of the hands draws attention to Venus's status as a fertility goddess, while her girdle, which is made up of the shapes of pomegranates and roses, is, according to Rossetti's sonnet, possessed of the power to excite love. The features of this monumental, melancholy temptress derive from those of Jane Burden, wife of William Morris, with whom Rossetti carried on a long and passionate affair. Although recognisable as such, her features have been schematised and her body has been transformed into a figure of massive proportions. By painting a three-quarter-length figure on a six-foot (1.83 m) canvas large enough for a full-length portrayal, Rossetti enlarges *Astarte Syriaca* to become awesome and majestic as well as sensual. She looks down on the supplicant viewer from a magisterial position, inverting the relationship between the viewer and a small, intimate work such as *Bocca Baciata*. Yet, in the context of a psychoanalytic analysis of Rossetti's work, Griselda Pollock has argued that *Astarte Syriaca* is a sign 'not of woman, but of that Other in whose mirror masculinity must define itself'. Rossetti's images of women remain signs of male creativity and virility, and not statements about the independent agency or creativity of 'woman'.

A small circle of painters collaborated closely with Rossetti in the development of a new art of sensual freedom and decorative exuberance. Among them was Sandys, whose *Medea* (FIG. 101) represents the daughter of King Aertes from Greek mythology. Abandoned by Jason in favour of another woman, Glauce, Medea took revenge by preparing a poisoned garment which burst into flames, burning Glauce to death. The sorceress, who went on to kill her own children, is seen in Sandys's image casting her spell on the flaming yarn from which the garment will be made. Like Rossetti, Sandys surrounded his central figure with exotic accessories, not least the ingredients ready for insertion into her miniature cauldron. These include a pair of copulating toads, painted with full Ruskinian truth to nature, and a statuette of the Egyptian goddess Sakhmet. Behind Medea, the background is a

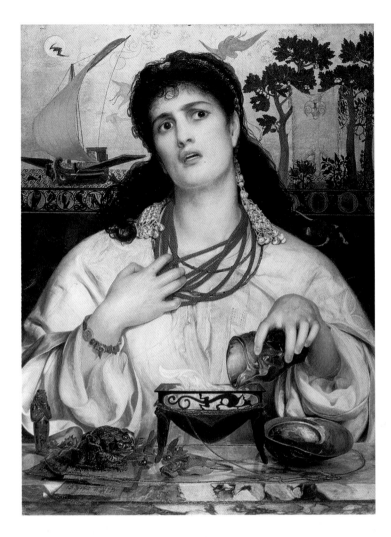

101. FREDERICK SANDYS
Medea, 1864–8. Oil on
wood panel, 24½ x 18¼"
(62.2 x 46.3 cm).
Birmingham Museum and
Art Gallery.

sumptuous golden wallpaper concocted from Japanese prints (a
notable influence on the dragon to the right) and Egyptian motifs.
But most shocking was the passionate face of the sorceress, pos-
sessed by the demon of revenge. Swinburne was captivated by her
transformation from Jason's lover into the vengeful murderer
of his wife, 'Pale as poison, with the blood drawn back from
her lips, agonized in face and limbs with the labour and fierce con-
tention of old love with new'. The model may have been Sandys's
gypsy mistress Keomi (see FIG. 97), a person who provided a
genuinely Bohemian element in the Tudor House ménage.

Perhaps the most interesting variant on the Rossettian image
of the sensual and highly sexualised female figure was presented by
Simeon Solomon. Solomon adapted the Rossetti type in the
light of his homosexual identity to the representation of the

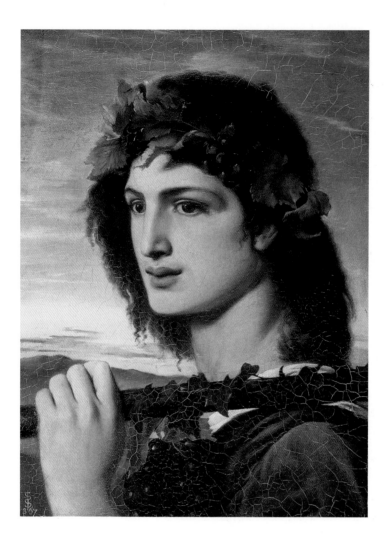

102. SIMEON SOLOMON
Bacchus, 1867. Oil on wood
panel, 20 x 14¾" (50.8 x
37.5 cm). Birmingham
Museum and Art Gallery.

The image of Bacchus is as
erotically charged as
Rossetti's images of women
from the period. Solomon
chose the hedonistic classical
subject of Bacchus, the god
of wine, as a deliberate foil
to the moralising religious
subjects of the original Pre-
Raphaelites, with their manly
Christian imagery. He
visualises an androgynous
ideal of beauty, which was to
attain a wide following later
in the nineteenth century in
the circle of Walter Pater and
Oscar Wilde. Pater admired
the work at the Royal
Academy in 1868, noting in
the figure both the Dionysian
lust for life and a sense of
'the bitterness of wine "of
things too sweet"; the sea
water of Lesbian grapes
become somewhat brackish
in the cup'.

eroticised male or androgynous figure. His *Bacchus* (FIG. 102) is the
very antithesis of those images of muscular Christianity generated
by Madox Brown and Holman Hunt in the early days of Pre-
Raphaelitism; representing a deity given over to the pleasures
of the flesh, the image is sensuous, delicate and suggestively homo-
erotic. Solomon's work was cited in a virulent attack on Ros-
setti and on the poetry of Swinburne, with the title 'The Fleshly
School of Poetry'. Swinburne had appreciatively used the term
'fleshly' in praising Rossetti's work; now it was turned satiri-
cally against him. Through this kind of criticism, Rossetti and his
friends, rather to their delight, became identified as decadent. Even
more than Rossetti, Solomon took pleasure in flouting social con-
ventions, but his conviction in 1873 for homosexual activities
brought an abrupt end to his membership of Rossetti's circle.

Burne-Jones: Pre-Raphaelite to Aesthete

Edward Burne-Jones began his artistic career as an ardent admirer of Rossetti in the 1850s (see Chapter One), but his output is far more rich and varied than was suggested by the selective discussion of his medievalising works in Chapter One. Never a Pre-Raphaelite realist, he yet remained at one remove from the 'fleshliness' of the Tudor House artists. Refinement was always the keynote of his work. *The Mill* (FIG. 103) embodies many of the characteristics we have identified with Aestheticism: renouncing naturalism, it is made up of carefully nuanced harmonies of tone and colour. A trance-like figure to the right plays a dulcimer, alluding once again to the relationship between art and music. The composition is graceful and decorative, replete with allusions to Italian art: the colouring owes a little to Giorgione (favourite of the Aesthetes), while the landscape to the left seems to suggest the influence of earlier painters. The frieze-like shape could be a reference to the painted fronts of Italian marriage chests (*cassoni*) which Burne-Jones would have seen at the South Kensington Museum. The tiny bathing figures in the distant mill-pool are a conscious reminisence of a work he delighted in at the National Gallery, *The Baptism of Christ* by Piero della Francesca (c. 1439–92). Yet Burne-Jones sought in earlier art quite different qualities from the honesty and clarity which the early Pre-Raphaelites strove to emulate: he preferred the soft, burnished *sfumato* and the deep shadows of Leonardo da Vinci to the cool, even light of Piero.

The Mill is enigmatic, resistant to the kind of interpretation demanded by a work of similar complexity by Holman Hunt or Madox Brown. In the foreground are three beautiful women,

103. EDWARD BURNE-JONES *The Mill*, c. 1870. Oil on canvas, 35¾ x 77¾" (90.8 x 197.3 cm). Victoria and Albert Museum, London.

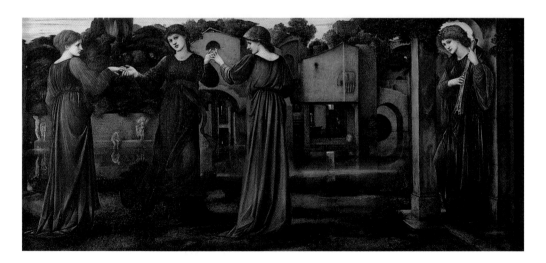

The subject is the German legend of Tannhäuser, the knight errant who arrives at the Venusberg, the realm of the pagan Love goddess, and gives himself over to a life of sensuous delight. The tale was available in numerous English versions: Swinburne had published a richly sensuous poem 'Laus Veneris' in 1866 and the story was incorporated by William Morris as 'The Hill of Venus' in his verse narrative *The Earthly Paradise* of 1868–70.

seemingly modelled from Aglaia Coronio, daughter of the painting's purchaser, Constantine Alexander Ionides; Mary Zambaco and Marie Spartali (in profile on the right). The three, all of Greek extraction, were known among the wealthy Greek community in London as the 'three graces', and this is the form they take in *The Mill*. There is certainly a personal subtext inscribed in the work: in 1867, Burne-Jones had fallen in love with Mary Zambaco, a startlingly beautiful sculptress and heiress, separated from her husband. The ensuing affair caused a considerable scandal and a painful crisis in Burne-Jones's marriage. But what is the broader meaning of this elaborate painting, dominated by the large, almost industrial, building of the watermill in the distance, with tiny figures in punts taking delivery of bags of flour? Far from being a mere pretext for an Aesthetic exploration of mood, form and colour, it seems to reflect the perfect society which William Morris was to describe in his great utopian novel, *News from Nowhere* (1891). Work (in the mill) and play (with men and women in separate groups) have reached a sensible balance in a perfect, unchanging and beautiful world. Burne-Jones has too often been written off as a hopeless escapist, an inhabitant of what Rossetti called 'Dreamland', but his work is far more subtle and multi-dimensional than this implies.

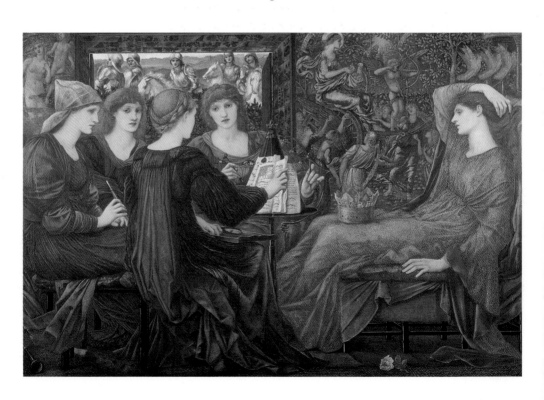

A medievalising watercolour of the early 1860s provided the initial study for the painting *Laus Veneris* (FIG. 104), in which the mature Burne-Jones can be seen at his most exuberant. The painting's use of parallel planes to give the illusion of pictorial space and the bold colours are a natural development from Rossetti's watercolours of the 1850s (see FIG. 28). Once again there is a musical connection: Wagner, whom Burne-Jones admired, had received a hostile reception for the first performance of his opera *Tannhäuser* on the same subject in Paris in 1861, but it was welcomed at Covent Garden in London in 1876.

Later, the remorseful knight Tannhäuser will beg the Pope for absolution, but *Laus Veneris* illustrates the moment of his corruption, when he catches a glimpse through the open window of the sexualised figure of Venus and her attendants. The atmosphere inside the Venusberg is enervated, as if the pleasures of the flesh have palled. Critics in 1878 were unsure whether to praise what one called 'the finest work he has achieved' or to condemn its decadent subject: 'The weariness of satisfied love, and the pain of unsatisfied longing, is hardly a theme, perhaps, to expend such magnificent painting upon.' There is a hint of the later Rossetti in the goddess's gesture as she runs her hand aimlessly through her hair. Once again, personal overtones are possible, since the features of Venus again recall those of Maria Zambaco. Every inch of the painting is richly decorated, producing a tapestry-like surface. The furnishings of the Venusberg are, indeed, close to those produced to Burne-Jones's designs by Morris and Co. The painting itself is an exemplary work of craftsmanship in every detail: the pattern on the robes of Venus was produced by pressing a stamp into the wet paint, after the manner of fourteenth-century Italian art. Like all Burne-Jones's mature works, *Laus Veneris* displays a remarkable interpenetration of art and design.

Although briefly an Associate of the Royal Academy, Burne-Jones was always suspicious of the institution. The Grosvenor Gallery, inaugurated by the amateur artist Sir Coutts Lindsay in 1877, provided a major new exhibition space and a showcase for Aestheticism. Burne-Jones was recognised as perhaps the most significant artist in the exhibitions, though such luminaries of the Victorian art world as Frederic Leighton (1830–96) and George Frederic Watts (1817–1904) also featured, with Whistler taking the role of *enfant terrible*. While there were attacks in the press, many critics, such as Sidney Colvin, were fulsome in praising Burne-Jones's work: 'We have among us a genius, a poet in design and colour, whose like has never been seen before.' *Laus Veneris* was included in the second exhibition of the Grosvenor Gallery,

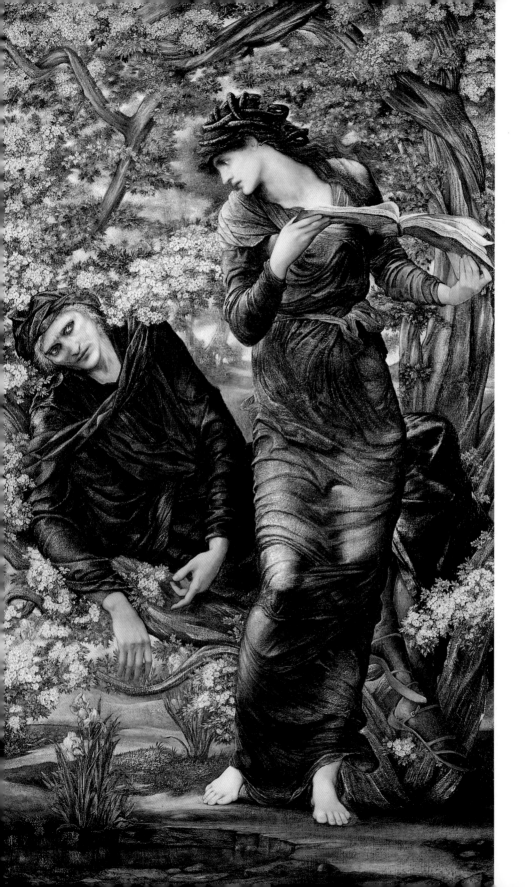

and in the 1870s and 1880s, Burne-Jones's exhibits ranged widely across classical and religious subject matter. His fascination with myth found expression in increasingly confident compositions, often bound together with looping, calligraphic lines. He continued to paint Arthurian subjects, such as *The Beguiling of Merlin* (FIG. 105), though the figures are quite unlike the stylised, Gothic bodies he had inherited from Rossetti's watercolours of the 1850s: they indicate instead an intensive study of classical sculpture.

The decorative qualities of Burne-Jones's later works, with their swirling lines and increasingly muted and subtle colour harmonies, were widely appreciated in Europe and take their place in the ancestry of the Art Nouveau style of the turn of the century. *The Doom Fulfilled (Perseus slaying the Sea Serpent)* (FIG. 106), a remarkably uninhibited study in gouache, derives from a planned decorative scheme commissioned by the Conservative politician Arthur Balfour. Set against a stylised rocky landscape, the combat between effete and androgynous hero and languid, flowing serpent has no hint of realism. Only the female nude – a subject completely lacking from early Pre-Raphaelitism – suggests a referent in reality. The sheer refinement of Burne-Jones's rarefied world

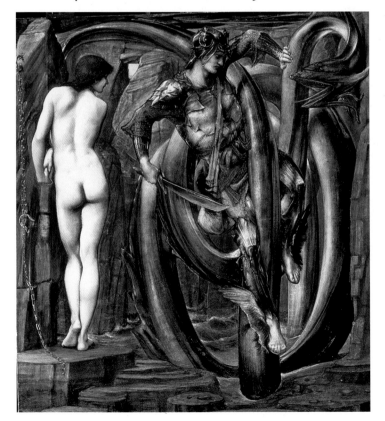

105. EDWARD BURNE-JONES *The Beguiling of Merlin,* 1874. Oil on canvas, 6'1" x 3'8" (1.86 x 1.11 m). Lady Lever Art Gallery, Port Sunlight, Merseyside.

This painting caused a sensation when it was shown at the first Grosvenor Gallery exhibition in 1877. While some proclaimed Burne-Jones a genius, others, such as the critic of the *Illustrated London News,* denounced the 'ultra-sensual school'. Burne-Jones selected a subject from the French medieval version of the Arthurian legend in which the wizard Merlin is lulled to sleep in a hawthorne tree by his pupil Nimuë. She casts one of his own spells upon him and he is imprisoned as if by iron chains. The image of a wicked woman dominating a helpless man recalls earlier fantasies of feminine evil such as Sandys's *Medea* (see FIG. 101).

106. EDWARD BURNE-JONES *The Doom Fulfilled (Perseus slaying the Sea Serpent),* c. 1876. Gouache, 5' x 4'6" (1.52 x 1.37 m). Southampton City Art Gallery.

is achieved at the loss of that radical energy and vitality which characterised Pre-Raphaelitism at its finest.

The Whistler – Ruskin Trial

107. JAMES MCNEILL
WHISTLER
Symphony in White No. 3,
1865–7. Oil on canvas, 20¼
x 30″ (51.1 x 76.8 cm).
Barber Institute of Fine Arts,
University of Birmingham.

As so often with Rossetti,
the model for Whistler's
painting was the artist's
mistress: the red-haired
Irishwoman Joanna
Hiffernan, seated on the
settee, was of lower social
status than Whistler, a form
of 'otherness' which (as with
Rossetti and Fanny
Cornforth) only added to
her fascination.

James McNeill Whistler, by 1877 a leading figure in British Aestheticism and mainstay of the Grosvenor Gallery, had begun his career as a realist in a French idiom. After spending four years based in Paris, he arrived in London in the spring of 1859, where he produced a series of etchings depicting life along the River Thames. The 'Thames Set', completed in 1861, betrays some points of similarity with Pre-Raphaelite realism, notably in passages of minutely detailed observation. In 1862, Whistler became acquainted with Rossetti and Swinburne, adding a Parisian inflection to the Bohemian ménage at Tudor House. He himself moved to Chelsea in December of that year, contributing to the area's rising reputation as a centre for the artistic avant-garde.

An example of Whistler's mature work, *Symphony in White No. 3* (FIG. 107), has much in common with Rossetti's of the same period. Like *The Blue Bower* (see FIG. 96), Whistler's painting eschews narrative. It is a sensual portrayal of two women dreamily whiling away an afternoon in an Aesthetic interior in Chelsea.

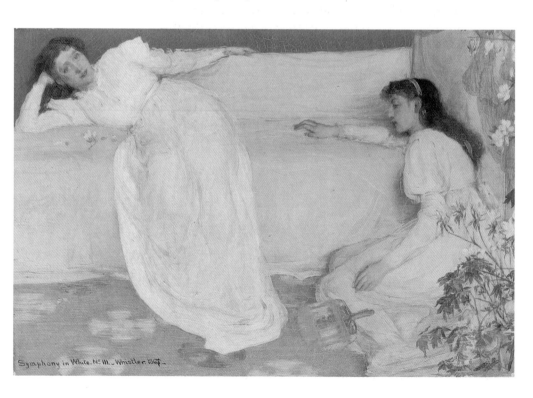

Symphony in White. Nº III. _ Whistler 1867

Oriental influence, so marked in *The Blue Bower*, can be detected in Whistler's Japanese fan, and in the decorative treatment of the white azaleas which enter the composition at the right, as in a Japanese print. Both paintings are premised on the careful combination of colours, though Rossetti's powerful greens and blues contrast with the subtle whites and creams of Whistler's interior, set off against the pale blue of the rug and the flesh tints of the faces and the fan. The harmony of colour and tone in *Symphony in White* can more aptly be compared to Burne-Jones's *The Mill* (see FIG. 103), a veritable symphony in greens. Whistler, more even than Rossetti and Burne-Jones, was concerned to explore the relationships between art and music: this painting was his first to bear a musical title (pointedly inscribed across the bottom of the canvas), though he retrospectively renamed two earlier works *Symphony in White* Nos 1 and 2. The idea that a painting could resemble that most complex of abstract musical forms, the symphony, provoked indignation from contemporary critics. P. G. Hamerton pedantically insisted that the work was 'not precisely a symphony in white' since it contained other hues, pink, blue and green. Whistler's riposte was barbed with his characteristic wit: 'does he then … believe that a symphony in F contains no other note, but shall be a continued repetition of F, F, F?' Ever the *provocateur*, Whistler courted publicity as assiduously as Rossetti avoided it.

Yet Whistler's work could hardly be further from the Pre-Raphaelitism of the early 1850s. Flying in the face of Ruskinian 'stern facts', it radically rejected the notion of the precise rendering of objects observed from nature. Whistler's handling of paint became ever more sketchy and gestural: surface pattern and formal arrangement were privileged over representation and meaning. In his *Nocturne in Black and Gold* (FIG. 108), exhibited at the Grosvenor Gallery in 1877, the smoke and cloud in the background, illuminated by flames, are evoked through swiftly scumbled black and blue paint, while the sparks and flashes of fireworks over Cremorne Gardens are captured in smudges and blobs of impasto. Shadowy forms suggest spectators in the foreground, but there is not a single clearly identifiable object in the field of vision.

The contrast between Whistler's aesthetic position and that of early Pre-Raphaelitism flared into a bitter controversy when Ruskin discussed the Grosvenor exhibition in his serial publication *Fors Clavigera* in 1877. Ruskin opened with a hymn of praise to Burne-Jones's work as 'classic in its kind – the best that has been or could be', but continued with a ferocious attack on Whistler, based on *Nocturne in Black and Gold*:

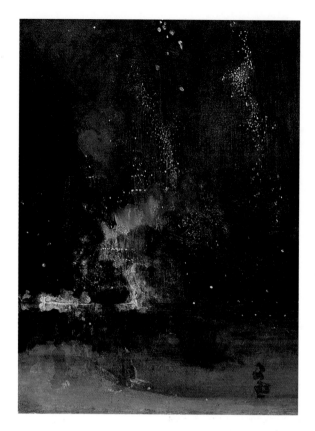

For Mr Whistler's own sake, no less than for that of the purchaser, Sir Coutts Lindsay ought not to have admitted works into the gallery in which the ill-educated conceit of the artist so nearly approached the aspect of wilful imposture. I have seen, and heard, much of Cockney impudence before now; but never expected to hear a coxcomb ask two hundred guineas for flinging a pot of paint in the face of the public.

When this passage was picked up and quoted widely in the press, Whistler sued Ruskin for libel. The resulting trial, a celebrated set-piece in the history of Victorian art, demanded that the legal system should stand in judgement on questions of aesthetic and critical value.

108. JAMES McNEILL WHISTLER
Nocturne in Black and Gold, the Falling Rockets
c. 1875. Oil on wood, 23¾ x 18¼" (60.2 x 46.67 cm). Detroit Institute of Arts, Michigan.

The article from which Ruskin's often-quoted passage derives was an extended discussion of the relationship between labour and money. Intended to be read by the 'workmen and labourers of Great Britain', *Fors Clavigera* provided a medium for Ruskin's ideas on social rather than purely artistic matters. In this context, Ruskin was not primarily concerned to attack Whistler as a stylist (despite the graphic phrase 'flinging a pot of paint in the face of the public') but to question the underlying value of a work which appeared to have been executed swiftly and without effort. At the root of the controversy were conflicting concepts of artistic identity. The triumphant Pre-Raphaelite realism of Madox Brown in Hampstead, Millais in Glenfinlas and Holman Hunt in the Holy Land was achieved through a process of strenuous and consistent labour to which the detailed finish of each canvas eloquently testifies. This finish, and the labour taken to create it, signalled the respectability and manliness of the artist, just as hard work in other walks of life was a guarantee of good character (see Chapter Three). Whistler flouted the notion of the artist as an honest workman, just as he spurned the quasi-religious mission of the artist, as Ruskin conceived it, of painting nature and following 'the finger of God'.

In accordance with his notion of the artist as an avant-garde Bohemian, Whistler's paintings contravened accepted norms and made a virtue of a delicate and sketchy surface, in place of a detailed finish. One famous exchange in the trial saw Sir John Holker, acting for Ruskin, aiming to reveal Whistler as a charlatan, charging large sums for a small amount of labour:

> HOLKER: Did it take you much time to paint Nocturne in Black and Gold? How soon did you knock it off?
>
> WHISTLER: I beg your pardon?
>
> HOLKER: I was using an expression which is rather more applicable to my own profession. (Laughter)
>
> WHISTLER: Thank you for the compliment. (Laughter)
>
> HOLKER: How long do you take to knock off one of your pictures?
>
> WHISTLER: Oh, I 'knock one off' possibly in a couple of days – (Laughter) One day to do the work and another one to finish it.

Whistler's position was thus radically at odds with the tastes and opinions of Britain in the 1850s. But by the late 1870s, the climate had begun to change. After a confusing summary by the judge, and a long period of deliberation, the jury found Ruskin guilty. Whistler's work was widely acknowledged to be of great merit, even by Burne-Jones who testified for Ruskin. Damages were, however, awarded in the derisory amount of a farthing, a quarter of a penny, which Whistler is reputed to have worn on a chain around his neck. Ruskin, horrified by the verdict, resigned from the Slade Professorship at Oxford and never again played a significant role in British art. The personal effects of the trial were less important than the broader shift in aesthetics which it signalled. By 1878 an aesthetic based on the labour of the individual artist, reflected in the painting's surface finish, had come to seem old fashioned. Art for art's sake had displaced the raw realism and pugnacious Hogarthian moralism of the mid-century. In broader terms, the verdict symbolised the dissolution of the intellectual and moral equipoise of mid-Victorian Britain. The historical moment of Pre-Raphaelitism had passed.

Epilogue

By 1905 when Holman Hunt published *Pre-Raphaelitism and the Pre-Raphaelite Brotherhood* the work of the 1850s already seemed to belong to a distant past. An increasing number of young English artists in the late Victorian period had trained in Paris and the contemporary art of the Edwardian era (1901–10) was decisively influenced by French Impressionism. In his old age, Hunt was determined to reassert the 'Englishness' of Pre-Raphaelitism as a corrective to these foreign influences, which he characterised as decadent. (Rossetti, too, had once referred to Impressionism as 'a beastly slop'.) Hunt claimed that the Pre-Raphaelite style, and especially the hard-edged realism which he had always espoused, could be understood as 'the hand-writing of the nation', an authentic expression of the national spirit in paint. Pre-Raphaelite realism, which had begun in the 1850s as radical, modern and exploratory, was restated as a reactionary and nationalistic dogma.

Interest in the stylistic and iconographic heritage of Pre-Raphaelitism did revive in several young artists of the period. Undoubtedly the 'Englishness' of Pre-Raphaelitism was an important part of this appeal. In *Boer War 1900* (FIG. 109), John Byam Liston Shaw (1872–1919) self-consciously adopted a Pre-Raphaelite style in order to address a painful subject from contemporary life. Byam Shaw (as he was known) subtitled the work with a quotation from Christina Rossetti: 'Last Summer green things were greener/Brambles fewer, the blue sky bluer.' The widow or fiancée of a soldier killed in action is unable to perceive through her grief what Shaw's biographer called 'the lovely country-side, decked out in the brilliance of June'. The luminous effect of this canvas clearly recalls Millais's *Ophelia* of 1852 (see FIG. 41), although the application of paint is far freer and the impasto much thicker in the later work. When it first appeared, the naturalism of *Ophelia* was radical and experimental, whereas Byam Shaw's intention was to counter modern French influences with an older, more English style. The tension between modernity and historicism which had characterised the early Pre-Raphaelitism of the 1850s was replaced by nostalgia for the certainties of mid-Victorian England.

Nonetheless, *Boer War* is a notably touching work, an elegy for a vanishing world. As in *Ophelia* the relationship between

the suffering woman and the beauty of nature is the central theme. In the Byam Shaw, however, the troubled female protagonist symbolises a crisis of imperial masculinity. The title refers only to the Boer War (1899–1902), memorialising the heavy defeats of British forces in South Africa by the Boers at the battles of Stormberg and Magersfontein in 1899–1900. Military stalemate and heavy casualties suggested that the British Empire had overstretched itself. It is significant that Byam Shaw chose to deploy the most English and manly of styles – Pre-Raphaelite realism – at a time when national and imperial self-esteem had suffered a severe blow. In representing the Boer War, Byam Shaw chose not a South African landscape, but an image of the heartlands of England at Dorchester on the Thames.

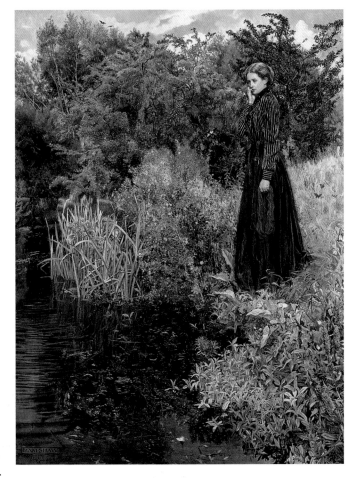

109. JOHN BYAM LISTON SHAW
Boer War 1900, 1901. Oil on canvas, 39½ x 29" (100.2 x 73.7 cm). Birmingham Museum and Art Gallery.

This retrospective view of Pre-Raphaelitism, painted in the last year of Queen Victoria's reign, makes a poignant tribute to a form of realism pioneered five decades earlier.

Byam Shaw's paintings found an appreciative contemporary audience, but by the time of his death in 1919 a catastrophe far greater than the Boer War had effectively put an end to the lingering influence of Pre-Raphaelitism, and to the culture which had brought forward and sustained it. The massive convulsions caused by the First World War (1914–18) radically altered every aspect of British society and culture. Byam Shaw's obituary in *The Sunday Times* recorded that he was 'not a "modern" as the word is now understood: but belonged by temperament to the Pre-Raphaelite period'. After 1918, Modernism came to dominate critical discourse and swept away the memory of its immediate predecessors. Although a small number of British artists in the inter-war period (Stanley Spencer among them) expressed an interest in the movement, it was not until the 1960s that the radicalism and imaginative power of Pre-Raphaelitism was again recognised.

Pre-Raphaelites and Visual arts

1843–7

1843 Ruskin publishes *Modern Painters* I; First Westminster fresco competition

1844 Hunt enters Royal Academy Schools and meets Millais and Stephens; Cartoons by Brown and Woolner fail in Westminster fresco competition

1845 Rossetti enters RA Schools; Brown visits studios of the Nazarene painters Cornelius and Overbeck in Rome

1846 Millais exhibits first work at RA; Ruskin publishes *Modern Painters* II

1847 Hunt reads Ruskin's *Modern Painters*

1848–55

1848 Rossetti briefly instructed by Brown; Pre-Raphaelite Brotherhood founded (September). Members: W. H.Hunt, J. E. Millais, D. G.Rossetti, W. M. Rossetti, T. Woolner, J. Collinson and F. G. Stephens

1849 First paintings initialled "PRB" including Rossetti's *Girlhood of Mary Virgin* exhibited; Rossetti and Hunt visit Paris and the Low Countries

1850 Founding of PRB journal, *The Germ*; Dyce alerts Ruskin to PRB work at RA exhibition, which includes Millais's *Christ in the House of His Parents*; Hunt and Rossetti paint in the open air at Sevenoaks, Kent; Collinson resigns from PRB

1851 Hunt's *Valentine Rescuing Sylvia from Proteus* exhibited at RA; Hostile press response to PRB prompts Ruskin to write to *The Times* and publish the pamphlet *Pre-Raphaelitism*; Hunt and Millais paint in the open air at Ewell, Surrey

1852 Arthur Hughes meets Millais; Brown begins *The Last of England, Work* and *An English Autumn Afternoon* and exhibits *Jesus Washing Peter's Feet*; Woolner emigrates to Australia

1853 Millais travels to Scotland with Ruskin and his wife; Brown ceases to exhibit at RA; PRB meet to draw portraits for Woolner; Burne-Jones and Morris meet at Oxford

1854 Burne-Jones and Morris visit France; Rossetti meets Ruskin; Woolner returns from Australia; Hunt depar for Holy Land (until 1856) and exhibits *The Light of the World* and *The Awakening Conscience* at RA

1855 Ruskin offers Siddall a stipend in return for first refusal of her drawings; Siddall travels to south of Franc for health reasons; Millais marries Effie Gray after the annulment of her marriage to Ruskin

1856–78

1856 Thomas Seddon dies in Egpyt; Brett, Inchbold and Ruskin meet in Switzerland; Burne-Jones taught by Rossetti; Ruskin publishes *Modern Painters* III & IV

1857 Pre-Raphaelite exhibition organised by Brown at 4 Russell Place, Bloomsbury; Rossetti, Burne-Jones, Hughes, Prinsep and Morris decorate Oxford Union with frescoes; British art featuring the Pre-Raphaelites exhibited in New York; Moxon's edition of Tennyson's *Poems* published with illustrations b Rossetti, Hunt and Millais

1858 Solomon exhibits at RA for the first time; Morris publishes poems, *The Defence of Guinevere* Hogarth Club founded by Brown, Rossetti and Hunt

1859 Morris and Jane Burden marry and move to Red House, Bexleyheath; Letter from thirty-nine women artists petitions for opening of RA membership to females

1860 Rossetti marries Elizabeth Siddall; Burne-Jones marries Georgiana Macdonald; Hunt's *Finding of the Saviour in the Temple* exhibited at German Street Gallery and sold for £5,500

1861 Stephens appointed art critic of *Athenaeum* art magazine (continued until 1901); Morris, Marshall, Faulkener & Co founded; Rossetti publishes *Early Italian Poets*

1862 Death of Siddall, 11 February; Rossetti moves to Tudor House, Cheyne Walk, Chelsea; Christina Rossett *Goblin Market*

1863 Millais elected Royal Academician; Death of William Dyce

1864 Burne-Jones elected an Associate of the Old Water Colour Society; Brown holds retrospective of his paintings at 191 Piccadilly, London

1868 Morris publishes The *Earthly Paradise*

1877 Opening of the Grosvenor Gallery, London; Work of Burne-Jones and Whistler prominent

1878 Ruskin–Whistler trial won by Whistler; Millais awarded Légion d'honneur and moves to 2 Palace Gate, London; Frederic Leighton elected President of the Royal Academy

Cultural events	Political events

1843 Thomas Carlyle, *Past and Present*; Charles Dickens, *A Christmas Carol*	1845 Disastrous Irish potato crop leads to famine and mass emigration
1844 Pugin requested by Charles Barry to assist him in work on the Palace of Westminster interiors (completed c.1860)	1846 Repeal of the Corn Laws signals defeat of landed by industrial interests
1845 John Henry Newman converts to Catholicism; Friedrich Engels, *The Condition of the Working Class in England*	1847 Factory Act limits working day for women and children (13-18 years) to ten hours
1846 Consecration of St Giles, Cheadle designed by A. W. N. Pugin	
1847 Charlotte Brontë, *Jane Eyre*; Emily Brontë, *Wuthering Heights*	

1848 John Stuart Mill, *Principles of Political Economy*; Karl Marx and Friedrich Engels, *The Communist Manifesto*; Elizabeth Gaskell, *Mary Barton*	1848 Revolutions in Paris, Vienna, Venice, Berlin, Milan and across Hungary; Last Chartist demonstration, Kennington Common, London; Beginning of Second Sikh War in India
1849 Ruskin, *The Seven Lamps of Architecture*; Charles Kingsley, *Alton Locke*	1849 British annexation of Punjab; Livingstone 'discovers' Lake Ngami
1850 Alfred Tennyson becomes Poet Laureate on the death of Wordsworth	1850 Stephenson's cast-iron railway bridge opened at Newcastle
1851 Death of J. M. W. Turner; Great Exhibition of the Industry of All Nations mounted at the Crystal Palace, Hyde Park; Pugin contributes a medieval court; Ruskin publishes *Stones of Venice* I	1851 British population 20.8 million
	1852 Industrial action by Amalgamated Society of Engineers defeated by a lockout; Manchester employers led by Thomas Fairbairn
1852 Dickens, *Bleak House*; Harriet Beecher Stowe, *Uncle Tom's Cabin*; Death of A. W. N. Pugin	1853 Vaccination against smallpox
1853 Matthew Arnold, *The Scholar-Gypsy*; Charlotte Brontë, *Villette*; Rebuilding of Balmoral Castle for Queen Victoria	1854 Outbreak of Crimean War (continues until 1856); Working Men's College in London founded by Rev F. D. Maurice: Rossetti, Ruskin, Brown and Morris all later teach there
1854 Tennyson, *Charge of the Light Brigade*; Crystal palace re-opened at Sydenham	
1855 Exposition Universelle, Paris (visited by Rossetti); Tennyson, *Maud*; Richard Wagner conducts a series of orchestral concerts in London	1855 Australian colonies become self-governing; Livingstone 'discovers' Victoria Falls

1857 South Kensington (now Victoria and Albert) Museum opened on present site; National Portrait Gallery opens; Thomas Hughes, *Tom Brown's Schooldays*; Hallé Concerts founded in Manchester; Manchester Art Treasures Exhibition	1856 Crimean War ended by Treaty of Paris Second Opium War between Britain and China
1858 Carlyle, *Frederick the Great*	1857 Outbreak of Indian 'Mutiny' or uprising against British Rule; Matrimonial Causes Act eases divorce proceedings
1859 Tennyson, *Idylls of the King*; Charles Darwin, *On the Origin of Species by Natural Selection*; Samuel Smiles, *Self-Help*	1858 British proclaim peace in India; Burton and Speke discover lake Tanganyika and Lake Victoria Nyanza; Palmerston becomes Prime Minister
1860 *Cornhill Magazine*, illustrated literary journal, founded; John Stuart Mill *Considerations on Representative Government*	1859 Suez Canal begun
1861 George Eliot, *Silas Marner*; Mrs Beeton, *Book of Household Management*; Controversial première of Wagner's *Tannhaüser* in Paris	1861 British population 23 million; Death of Prince Albert
	1862 Lancashire cotton famine caused by American Civil War
1862 George Gilbert Scott designs Albert Memorial; Work of Morris & Co exhibited at International Exhibition, South Kensington	1863 London Underground railway under construction
1863 Ruskin writes *Sesame and Lilies*, on social issues (published in 1865)	1868 Gladstone becomes Prime Minister
1868 RA moves to Burlington House, Piccadilly; Matthew Arnold, *Culture and Anarchy*	
1873 Walter Pater, *Studies in the History of the Renaissance*	
1877 Exposition Universelle, Paris; Thomas Hardy, *Return of the Native*	

Bibliography

1. GENERAL

There is no adequate single-volume history of Pre-Raphaelitism. The Tate Gallery exhibition catalogue, *Pre-Raphaelites*, edited by L. Parris (1984), contains useful catalogue entries for individual works, as do catalogues to particular collections, such as the National Museums on Merseyside: M. Bennett, *Artists of the Pre-Raphaelite Circle: The First Generation* (London: Lund Humphries, 1988); and Birmingham: S. Wildman, *Visions of Love and Life: Pre-Raphaelite Art from Birmingham Museums and Art Gallery* (Alexandria, Virginia: Art Services International, 1995). Lighter in tone is J. Treuherz, *Pre-Raphaelite Paintings from Manchester City Art Gallery* (London: Lund Humphries, 1980).

Collections of essays covering diverse aspects of Pre-Raphaelitism are: L. Parris (ed.), *Pre-Raphaelite Papers* (London: The Tate Gallery, 1984); M. Pointon (ed.), *Pre-Raphaelites Re-Viewed* (Manchester: University Press, 1989); M. Warner *et al.*, *The Pre-Raphaelites in Context* (San Marino, California: Henry E. Huntington Library, 1992); E. Harding (ed.), *Re-Framing the Pre-Raphaelites: Historical and Theoretical Essays* (Aldershot: Scolar, 1995) and M. F. Watson (ed.), *Collecting the Pre-Raphaelites: The Anglo-American Enchantment* (Aldershot: Scolar, 1997).

Useful editions of Pre-Raphaelite texts and reviews are: C. Hares-Stryker (ed.), *An Anthology of Pre-Raphaelite Writings* (Sheffield: Academic Press, 1997) and D. Stanford, *Pre-Raphaelite Writing: An Anthology* (London: Dent, 1973). Early Pre-Raphaelite sources are fully documented in W. E. Fredeman, *Pre-Raphaelitism: A Bibliocritical Study* (Cambridge, Mass: Harvard University Press, 1965). The works of Ruskin are available in various editions, among which E. T. Cook and A. Wedderburn's *The Works of John Ruskin*, 39 vols (London: George Allen, 1903–12) is the finest. It has recently become available on CD-ROM.

2. INDIVIDUAL ARTISTS

Ford Madox Brown

BENNETT, M., *Ford Madox Brown 1821-1893*, exh. cat. (Liverpool: Walker Art Gallery, 1964)

MADOX HUEFFER, F., *Ford Madox Brown: A Record of his Life and Work* (London: Longman, 1896)

NEWMAN, T., and R. WATKINSON, *Ford Madox Brown and the Pre-Raphaelite Circle* (London: Chatto and Windus, 1991)

SURTEES, V. (ed.), *The Diary of Ford Madox Brown*

(New Haven and London: Yale University Press, 1981)

William Holman Hunt

AMOR, A. C., *William Holman Hunt: The True Pre-Raphaelite* (London: Constable, 1989)

BENNETT, M., *William Holman Hunt*, exh. cat. (Liverpool: Walker Art Gallery, 1969)

CODELL, J., 'The Artist Colonized: Holman Hunt's "Bio-history", Masculinity, Nationalism and the English School', in E. Harding (ed.), *Re-Framing the Pre-Raphaelites* (Aldershot: Scolar, 1995)

John Everett Millais

BENNETT, M., *PRB, Millais, PRA*, exh. cat. (Liverpool: Walker Art Gallery, 1967)

DONOVAN, C., and J. BUSHNELL, *Millais: A Centenary Exhibition* (Southampton Institute, 1996)

POINTON, M., 'Millais: Histories of Matrimony', in M. Pointon (ed.), *Pre-Raphaelites Re-Viewed* (Manchester University Press, 1989)

WARNER, M., 'John Everett Millais's "Autumn Leaves"', in L. Parris (ed.), *Pre-Raphaelite Papers* (London: The Tate gallery, 1984)

Dante Gabriel Rossetti

DOUGHTY, O., and J. R. WAHL (eds), *The Letters of D.G. Rossetti*, 4 vols (Oxford: Clarendon Press, 1965–7)

FAXON, A. C., *Dante Gabriel Rossetti*, new edn (Oxford: Phaidon, 1994)

GRIEVE, A. I., *The Art of D. G. Rossetti: 1. Found; 2. The Pre-Raphaelite Modern-Life Subject* (Norwich: Real World Press, 1976)

PRETTEJOHN, E., *Rossetti and his Circle* (London: Tate Gallery, 1997)

SURTEES, V., *The Paintings and Drawings of Dante Gabriel Rossetti (1828–1882): A Catalogue Raisonné* (Oxford University Press, 1971)

3. FURTHER READING FOR SPECIFIC CHAPTERS

Chapter 1

ANDREWS, K., *The Nazarenes: A Brotherhood of German Painters in Rome* (Oxford University Press, 1964)

MACARTHY, F., *William Morris: A Life for Our Time* (London: Faber and Faber, 1994)

ORMOND, R., *Sir Edwin Landseer*, exh. cat. (London: The Tate Gallery, 1982)

PARRY, L. (ed.), *William Morris*, exh. cat. (London: Victoria and Albert Museum, 1996)

POINTON, M., *William Dyce (1806–1864)* (Oxford: Clarendon Press, 1979)

VAUGHAN, W., *German Romanticism and English Art* (New Haven and London: Yale University Press, 1979)

WAINWRIGHT, C., and P. Atterbury (eds), *Pugin: A Gothic Passion*, exh. cat. (London: Victoria and Albert Museum, 1994)

Chapter 2

CASTERAS, S. P., *et al.*, *John Ruskin and the Victorian Eye*, exh. cat. (New York: Harry N. Abrams, 1993)

FERBER, L. S., and W. H. Gerdts, *The New Path: Ruskin and the American Pre-Raphaelites*, exh. cat. (Brooklyn, New York: Brooklyn Museum, 1985)

NEWALL, C., *John William Inchbold: Pre-Raphaelite Landscape Artist*, exh. cat. (Leeds City Art Gallery, 1993)

STALEY, A., *The Pre-Raphaelite Landscape* (Oxford: Clarendon Press, 1973)

WILCOX, S., and C. Newall, *Victorian Landscape Watercolours*, exh. cat. (New York: Hudson Hills Press, 1992)

Chapter 3

ARSCOTT, C., 'Employer, Husband, Spectator: Thomas Fairbairn's Commission of *The Awakening Conscience*', in J. Woff and J. Seed (eds), *The Culture of Capital* (Manchester University Press, 1988)

BROWN, FORD MADOX, 'Work', repr. in A. Clayre (ed.), *Nature and Industrialization* (Oxford University Press, 1979)

CASTERAS, S. P., *Images of Victorian Womanhood in English Art* (London and Ontario: Associated University Presses, 1987)

CHERRY, D., 'The Hogarth Club, 1858–1861', *Burlington Magazine*, vol. 122, no. 925, April 1980, pp. 237–44

FLINT, K., 'Reading *The Awakening Conscience* Rightly', in M. Pointon (ed.), *Pre-Raphaelites Re-Viewed* (Manchester University Press, 1989)

LEPPERT, R. (ed.), *The Sight of Sound: Music, Representation and the History of the Body* (Berkeley: University of California Press, 1993)

NEAD, L., *Myths of Sexuality* (Oxford: Basil Blackwell, 1988)

POINTON, M., *Naked Authority: The Body in Western Painting, 1830–1908* (Cambridge University Press, 1990)

SUSSMAN, H., *Victorian Masculinities: Manhood and Masculine Poetics in early Victorian Literature and Art* (Cambridge University Press, 1995)

USHERWOOD, P., 'William Bell Scott's *Iron and Coal*: Northern Readings', in J. Vickers (ed.), *Pre-Raphaelites: Painters and Patrons in the North East* (Newcastle: Laing Art Gallery, 1989)

Chapter 4

BRONKHURST, J., '"An interesting series of adventures to look back upon": William Holman Hunt's Visit to the Dead Sea in November 1854', in L. Parris (ed.), *Pre-Raphaelite Papers* (London: The Tate Gallery, 1984)

GRIEVE, A. I., 'The Pre-Raphaelite Brotherhood and the Anglican High Church', *Burlington Magazine*, vol. 111, no. 794, May 1969, pp. 294–5

LANDOW, G. P., *William Holman Hunt and Typological Symbolism* (New Haven and London: Yale University Press, 1979)

MAAS, J., *William Holman Hunt and 'The Light of the World'* (London and Berkeley: Scolar Press, 1984)

POINTON, M., 'The Artist as Ethnographer: Holman Hunt and the Holy Land', in M. Pointon (ed.), *Pre-Raphaelites Re-Viewed* (Manchester University Press, 1989)

SAID, E., *Orientalism* (New York: Vintage Books, 1978)

Chapter 5

CRUISE, C., '"Lovely Devils": Simeon Solomon and Pre-Raphaelite Masculinity', in E. Harding (ed.), *Re-Framing the Pre-Raphaelites* (Aldershot: Scolar, 1995)

DORMENT, R., and M. F. MACDONALD (eds), *James McNeill Whistler*, exh. cat. (London: The Tate Gallery, 1994)

FITZGERALD, P., *Edward Burne-Jones: A Biography* (London: Hamish Hamilton, 1975)

MARSH, J., and P. GERRISH NUNN, *Women Artists and the Pre-Raphaelite Movement* (London: Virago, 1989)

—, *Pre-Raphaelite Women Artists*, exh. cat. (Manchester City Art Gallery, 1997)

MARSH, J., *Elizabeth Siddal 1829–1862: Pre-Raphaelite Artist*, exh. cat. (Sheffield: Ruskin Gallery, 1991)

MERILL, L., *A Pot of Paint: Aesthetics on Trial in Whistler v. Ruskin* (Washington and London: Smithsonian Institution, 1992)

PEARCE, L., *Woman – Image – Text: Readings in Pre-Raphaelite Art and Literature* (London: Harvester Wheatsheaf, 1991)

POLLOCK, G., *Vision and Difference* (London: Routledge, 1988)

WILTON, A., and R. UPSTONE (eds), *The Age of Rossetti, Burne-Jones and Watts: Symbolism in Britain*, exh. cat. (London: The Tate Gallery, 1997)

Picture Credits

Collections are given in the captions alongside the illustrations. Sources for illustrations not supplied by museums or collections, additional information, and copyright credits are given below. Numbers are figure numbers unless otherwise indicated.

Index